| DATE DUE | | | |
|---|---|---|---|
| | | | |
| | | | |
| | | | |
| | | | |
| | | | |
| | | | |
| | | | |
| | | | |
| | | | |
| | | | |
| | | | |
| | | | |

Underwater Photography and Television for Scientists

Underwater Association Special Volumes

No. 1 *Sublittoral ecology: the ecology of the shallow sublittoral benthos.* Edited by R. Earll and D. G. Erwin (1983)

No. 2 *Underwater photography and television for scientists.* Edited by J. D. George, G. I. Lythgoe, and J. N. Lythgoe

# Underwater Photography and Television for Scientists

*Edited by*

## J. D. GEORGE
*British Museum (Natural History), London*

## G. I. LYTHGOE
*Seaphot Ltd., Bristol*

and

## J. N. LYTHGOE
*University of Bristol*

Underwater Association Special Volume No. 2.

CLARENDON PRESS · OXFORD
1985

Oxford University Press, Walton Street, Oxford OX2 6DP
Oxford New York Toronto
Delhi Bombay Calcutta Madras Karachi
Kuala Lumpur Singapore Hong Kong Tokyo
Nairobi Dar es Salaam Cape Town
Melbourne Auckland
and associated companies in
Beirut Berlin Ibadan Nicosia

Oxford is a trade mark of Oxford University Press

Published in the United States
by Oxford University Press, New York

*778.73*
*2 n2*
*142670*
*nw.1987*

British Library Cataloguing in Publication Data
Underwater photography and television for
scientists.——(Special volume/Underwater
Association; no. 2)
1. Photography, Submarine
I. George, J. D.      II. Lythgoe, G. I.
III. Lythgoe, J. N.      IV. Series
778.7'3      TR800
ISBN 0–19–854141–4

Library of Congress Cataloging in Publication Data
Underwater photography and television for scientists.
(Underwater Association special volume; no. 2)
Includes bibliographies and index.
1. Photography, Submarine.   2. Underwater television.
I. George, J. David (John David)   II. Lythgoe, G. I.
(Gillian I.)   III. Lythgoe, J. N.   IV. Series.
TR800.U513   1985   778.7'3   84–27388
ISBN 0–19–854141–4 (Oxford University Press)

Typeset by Wyvern Typesetting Ltd
Printed in Great Britain by St Edmundsbury Press,
Bury St Edmunds, Suffolk

# Preface

L. Boutan, a biologist from the marine station at Banyuls-sur-Mer, is considered by most to be the father of underwater photography, for he was taking photographs under water in the 1890s, little more than fifty years after the invention of the photographic process. His practical studies culminated in the publication in 1900 of a classic book entitled *La photographie sous-marine et le progrès de la photographie*. This pioneering work inspired commercial cinematographers, such as J. E. Williamson, to make films in the 1920s which featured underwater sequences shot in shallow water, but it was not until the deployment of W. Beebe's bathysphere in the early 1930s that photographs could be taken in the deep ocean. Very few attempts at recording deep-sea images were successful until scientists at the Lamont Geological Laboratory and at Woods Hole Oceanographic Institution began their joint studies of the sea-floor in the early 1940s using remotely operated cameras which were triggered mechanically on reaching the bottom. Since this time the quality (and hence usefulness) of underwater photographs has steadily improved owing, amongst other things, to the use of electronic flash, fully corrected optics on the cameras, and to improvements in the speed and quality of film emulsions.

The increased availability of self-contained underwater breathing apparatus (SCUBA) during the 1960s allowed small research groups on limited budgets to make direct observations in the top 50 m or so of the sublittoral environment without the need for expensive surface-support vessels. In the wake of SCUBA came the rapid development of compact hand-held still and cine cameras, and the 1970s saw a burgeoning of mass-produced cameras and accessories designed to make photography easier for both the layman and the specialist.

Although television was first used under water in the 1940s and developed for marine biological purposes by H. Barnes in the 1950s, it is only now, with the recent development of compact video cameras and video-cassette recorders, that the full potential of this medium is being realized.

It is not surprising in view of the fact that photography and television now play such an important role in the transfer of information in the everyday lives of most of us on land, that these media should also have become powerful tools in the hands of scientists working in the aquatic environment. What is more surprising , perhaps, is the relatively small proportion of these research workers who are as yet skilled in the use of such techniques underwater or who have realized their full research potential. It was with this in mind that the Council of the Underwater Association for Scientific Research (UA) charged one of us (JDG) with the task of organizing a two-

day international symposium at which a number of scientists already experienced in the use of various underwater image-recording techniques were invited to impart their knowledge. The success of this meeting prompted the desire for a permanent record of the proceedings and hence to the production of this volume, which contains most of the presentations made at that conference. The contributions of three speakers have not been reproduced here: P. Rowlands and J. Tapp did not wish to submit manuscripts, and the contribution by R. Holmes has been published elsewhere. However, extended abstracts of these presentations are in Volume 8 of *Progress in Underwater Science*, published by the UA, should readers wish to consult them.

After an introduction to some of the problems faced by those working with image-recording gear under water the book progresses logically, dealing at first with the relatively inexpensive recording equipment and techniques used by divers to aid them in a variety of tasks in coastal waters and in the open ocean. There follow chapters concerned with recording equipment operated remotely from boats and submersibles on the continental shelf and in the deep ocean. We are pleased to be able to conclude with a chapter on the recently discovered animal communities clustered around deep-sea hydrothermal vents in the Pacific Ocean which have so excited marine scientists.

December 1984

J.D.G.
G.I.L.
J.N.L.

# Contents

# Acknowledgements

The present volume is comprised mainly of papers given at the 16th Symposium of the Underwater Association for Scientific Research, held at the British Museum (Natural History), on 19 and 20 March 1982. That the Symposium went so smoothly was due in no small part to the session chairmen and to the organizational skills of Dr H. Platt, Mr P. Clark, and their small band of helpers. It is to them that we owe a considerable vote of thanks. We thank also the Director of the BM(NH) for use of the Lecture Hall and Conversazione Room, and the British Council for generously providing financial support for several overseas speakers. Ms K. Way kindly retyped a number of manuscripts. Finally we would like to thank the editorial staff at Oxford University Press for their skill in seeing the volume through the press.

# Contributors

D. Allan
British Antarctic Survey
Cambridge

M. Buehr
Medical Research Council
London

C. J. Chapman
DAFS Marine Laboratory
Aberdeen

H. Christie
Ministry of Environment
Oslo, Norway

E. P. Collins
Institute of Oceanographic Sciences
Wormley

R. A. Evans
Tromsø Marine Biological Station
Norway

R. R. Hessler
Scripps Institution of Oceanography
La Jolla, USA

N. A. Holme
Marine Biological Association Laboratory
Plymouth

J. N. Lythgoe
University of Bristol

L. P. Madin
Woods Hole Oceanographic Institution
USA

E. J. Moore
Institute of Oceanographic Sciences
Taunton

G. W. N. M. van Moorsel
1790 AB Den Burg
Texel
Netherlands

D. Nicholson
Marine Biological Association Laboratory
Plymouth

B. Picton
Ulster Museum
Belfast

A. L. Rice
Institute of Oceanographic Sciences
Wormley

A. P. Salkield
SIRAD Inc.
Moline, Illinois, USA

O. K. Sandnes
Tromsø Museum
Norway

P. J. Scoones
Underwater Visual Systems
Carshalton

W. M. Smithey, Jr.
Scripps Institution of Oceanography
La Jolla, USA

A. J. Southward
Marine Biological Association Laboratory
Plymouth

A. Svoboda
Ruhr-Universität
Bochum, W. Germany

R. H. Wilkinson
Institute of Oceanographic Sciences
Taunton

# Plates

*(Plates fall between pp. 82 and 83 of the text.)*

*1a.* *Close-up systems can produce detailed pictures of small objects such as this sea anemone.*

*1b.* *A 4-cm-long isopod,* **Antarcturus,** *on seaweed.*

*2a.* *The larvacean* **Megalocercus huxleyi** *in its filtering house, about 3 cm across.*

*2b.* *The larvacean* **Megalocerus huxleyi,** *injected with uranine dye and carmine suspension (red) to delineate both the house outline and the internal filtering structures.*

*3a.* *A ctenophore,* **Lampea pancerina,** *eating a chain of* **Salpa maxima.**

*3b.* *A thecosome pteropod* **Cavolinia** *sp. showing the green mantle extensions which aid the animal in maintaining buoyancy and stability while feeding.*

*4a.* *The squat-lobster* **Munida tenuimana** *at the mouth of its burrow in Sognefjorden off Matsnaes at 1260 m depth.*

*4b.* *Arm stereo photograph taken at the Galapagos vent site. Vestimentiferan tube worms* **Riftia pachyptila,** *the brachyuran crab* **Bathograea thermydron,** *and an undescribed mytilid, mussel.*

# 1 Problems and images

*J. N. Lythgoe*

## Conventions

Over the years a convention has developed that underwater pictures should be packed with colour: the sea should be blue and the animals every shade of red, orange, yellow, and purple. Whatever the justification for this, there is no denying that such pictures can be a lot more interesting than unlit pictures with a pervading blue, green, or brown cast to them where only a restricted spectral band penetrates far through water, blue-green in the open ocean, yellow-green in much fresh water and something in between in inshore and coastal water. Even knowing this, photographers are often disappointed to see that their photographs have an even smaller colour range than they were aware of on the dive. In other words, underwater photographs taken in natural light can be very boring, and that is another way of saying that they contain very little information.

## Problems and solutions

This is a book about scientific photography and aesthetic considerations are not a central theme, but the capacity to collect and retrieve information is. A high-quality colour transparency can store an enormous amount of information; electronic images can store rather less, at least at the moment, but in practice neither of them will provide images as sharp as they theoretically should and this is due to a number of factors such as vibration, grain size in the film, condensation on the lens and focusing errors. Under water there are intractable problems due to light scatter from suspended particles in the water. These degrade contrasts and sometimes blur edges that would be sharp if photographed on land. This blurring is most pronounced in water that contains many floating plankters that are almost transparent, but have a slightly greater refractive index than water. Contrasts can be restored to a certain extent in the photographic processing or by more sophisticated computer-controlled image-restoration techniques such as those in medical radiography and the analysis of satellite images of the earth. These can lead to an improvement in the eye's ability to detect otherwise unnoticed details in an image. The problem of veiling light between the camera and the object can be lessened by arranging that the intervening water is not illuminated by the injudicious placing of the artificial light source. A more advanced technique that in its present form is likely to be hopelessly expensive and cumbersome for most scientific uses, is the range-gated pulse laser. In this

technique, light from the source is emitted as discrete pulses, but is only accepted back on to the light-collecting surface if it has been gone for the time it takes to travel to the subject and return to the camera. Another technique that has worked in the laboratory is to use a circularly polarizing filter over the camera flash, and a similar one over the camera lens. When light is reflected once from a surface it returns 'rotating' in the opposite sense. Thus, a circularly polarizing filter will reject light that has been once reflected, but will pass light if it has been reflected an even number of times. Perhaps not surprisingly, this technique has not worked particularly well in the field. Most photographers rely on the more traditional palliatives of placing the flash so that it illuminates as little of the intervening water as possible, and by using wide-angle lenses that allow the camera to get close to large objects and still include all of them in the picture.

**Colour and light penetration**

Our colour sense is a way of categorizing the relative amount of light at different wavelengths that is emitted or reflected from a surface. A red surface has most radiance in the visible part of the spectrum at wavelengths longer than about 600 nm, blue has most radiance at wavelengths shorter than 500 nm, and green has most of its radiance somewhere between 500 and 600 nm. Provided that the light is bright enough to see colours it does not matter whether the surface is in light or in shade—it still has its characteristic colour. We can, for example, tell whether an apple on a tree is green, or ripe and red, no matter if it is hanging in the shade or in full sunlight. Unaided, the human eye is sensitive to light between about 350 nm (violet) and 750 nm (red); below and above these wavelengths we are into the ultraviolet (UV) and the infra-red (IR) which, by definition, we cannot see. The reason we cannot see into the UV is because our eye, particularly the lens, absorbs UV light before it can get to the retina, and some people who have had the lens removed because of cataracts, are then able to see shorter wavelengths than is normal. The reason why we cannot see further into the infra-red is because there appears to be an upper limit on the wavelengths at which visual pigments can absorb light. In fact, humans who have visual pigments based on vitamin A1 can see rather less far into the infra-red than freshwater fishes whose visual pigments are mostly based on vitamin A2. Under water the wavelengths of light that the human eye can detect are restricted not by the physiological nature of the visual apparatus, but by the wavelengths of light that are actually present. This applies to all aquatic animals with equal force and it is very unlikely that a deep-living fish can compensate for the vanishingly-low levels of red light by increasing the sensitivity of its red-sensitive colour vision channels.

   In very clear ocean water, and the blue water that sometimes surrounds

coral reefs and the Mediterranean coasts, the water is most transparent to blue light, and it is probable that the most sensitive deep-sea fish sees very dimly some light coming from above at almost 1000 m. Most coastal water and much fresh water is not blue, but green. One reason is the presence of chlorophyll-containing plankton, but probably of greater importance are the yellow-brown tea-coloured products of vegetable decay, that come both from decaying plankton and from waters flowing down rivers into the sea. The yellow substances absorb short-wave (blue) light and let the rest of the spectrum past. In deep water the yellow substances absorb the only wavelengths that the water itself lets past, and no light penetrates beneath, say, 150 m. But at lesser depths the water allows some green light to pass and green becomes the dominant water colour. In much fresh water, particularly where there is a lot of decaying wood or peat, the yellow products are relatively more concentrated, and here the water is relatively most transparent to red light. However, the presence of light-absorbing material can only reduce light penetration, although it does so more efficiently at some wavelengths than at others; and the absolute amount of red light in fresh water is still less at all wavelengths than in clear blue ocean water.

The physical reflectance of an object's surface does not change with depth, whether or not there is any light to be reflected from it. If light is provided by artificial means such as a torch or a photographic flash, then the innate spectral reflectance of the surface will be revealed. The use of artificial light 'brings out' colours that in nature are not there and there is good reason for thinking that the animals which live at these depths cannot see them either, because the problem lies not with the physiology of the eye but with the physical properties of the water itself.

**Image recording**

As with the eye, man-made image-collecting devices such as photographic emulsions and video tubes also have their own spectral sensitivity character-istics that effectively limit sensitivity to particular bands in the electro-magnetic spectrum, and, in addition, the lenses through which the light must pass are not equally transparent at all wavelengths. Nevertheless, it is technically feasible to photograph at wavelengths between about 200 nm and 1500 nm, and quite easy to photograph between 350 nm and 1000 nm. The broadening of the 'visible' spectrum from a band of, say, 150 nm that natural light might provide under water, to a band of about 350 nm that artificial light can provide, obviously has advantages in information-gather-ing because so much more can be seen of the nature and quality of under-water life, rocks, and artefacts than is possible if only natural light is used.

The extra information that can be obtained by extending the spectral range from that given by natural light to the band given by artificial light can

be used in the normal 'visible' wavelengths, because the lenses that are designed for use in air are made of glass which is transparent to these wavelengths. It is interesting to speculate what extra information might be forthcoming if the imaging devices were made sensitive to a broader spectral band. For example, proteins are constructed of amino acids, many of which absorb strongly in the UV around 280 nm. Specific sensitivity at these wavelengths might be useful in deciding if rocks or artefacts had a film of life growing on them. Short-wave light is much more strongly scattered than long-wave light, especially when the scattering particles are of molecular size. One of the greatest problems with underwater imaging is that scattered light interposes a veil of non-image-forming light between the eye or camera and the object so there is a corresponding loss in image contrast which is the main cause of reduced underwater visibility. By the use of powerful red-rich light sources and red-sensitive collectors, the problems of contrast reduction, at least in ocean and clear coastal water, might be reduced.

It is not enough to extend the spectral band to that at which the imaging device is sensitive. The UV honey guides in flowers are a good example, for most camera systems have some sensitivity in the UV wavelengths, but at the same time are much more sensitive to the 'visible' part of the spectrum, and so the image-gathering potential in the UV is swamped when trying to record the UV honey guides. Filters have to be used in front of the camera lens that specifically cut out visible light, allowing only the UV to pass. To extend the useful waveband for image-gathering, it is important to decide where in the spectrum, and how broad, the new wavebands should be.

The next thing to consider is the mechanism by which we capture the image in the eye and interpret it in the brain. This we cannot change. It goes without saying that the ability to detect light in the infra-red or ultraviolet does not bring with it some undreamed-of sensation of colour, and we are still left with the same three primary colours with which to interpret the visual scene. Our eyes are not equally good at distinguishing between colours. If we look at the spectrum, the colour changes fastest with wavelength in the blue-green and yellow-green to orange parts of the spectrum, and these are the regions where colour discrimination is best. If we take the whole gamut of colours which are represented in the trichromatic colour diagram, we are most sensitive to shades of yellow-green and reddish-purple. The use of false-colour photography should therefore involve the selection of wavebands where radiance differences between objects of interest are known to be greatest, and then to display them in colours for which our eyes are most efficient at detecting the differences. It helps, of course, if the colours on the video screen are not too bizarre, because these need experience to interpret and may not be accepted by all operators or by their employers.

The question of acceptability and the general aesthetic appearance of the picture is not to be dismissed out of hand on the grounds that the technical information is preserved in the picture and any other considerations are largely irrelevant. A scientific audience, in particular, will happily accept photographs that fall substantially short of the standards that prevail elsewhere. This is a pity, because good photographs can give information about questions that the investigator had not thought to ask in the first place, and this is particularly true in undersea exploration. Less easy to quantify are the 'political' benefits that come from high quality images. A strikingly good photograph compels attention in a way that a page of text never can. In the United States, for example, and increasingly elsewhere, there is evidence to suggest that photographs that are good enough to appear on television or in wide-circulation books and science magazines help in getting a research grant.

Often, poor results are due to the use of equipment that has been designed for too general a purpose, and it is necessary to decide exactly what photographic job is required and to budget for the specialist photographic equipment that is now usually available 'off the peg'. Video is a different story, and its potential is scarcely realized. Its great advantages over film are that others can share the cameraman's view at the time that he is shooting, and minute-by-minute, tape is far cheaper than film. At the moment video has the disadvantage that the equipment is very complex and bulky for use in the field and requires a substantial power supply. Even with all this equipment the resolution of even 'broadcast quality' video does not compare with 35 mm film. A further problem with video is that editing requires full studio facilities and is very much a job for the professional. However, there is nothing about these present problems with video that are likely to resist technical development, and in the long run there can be little doubt that video will become much more widely used, especially where continuous records or numerical analysis is needed.

# 2 Basic underwater photography for divers
## *M. Buehr and B. Picton*

### Introduction

Of all the activities available to the diver, the one that seems to be of most universal interest is underwater photography. Whether it is the scientist using photography as part of an underwater study, the amateur naturalist taking pictures with which to confirm an underwater observation, or simply a sports diver interested in recording his dives, more people than ever before are now using cameras under water, and the numbers will doubtless increase in the future. The beginner, however, can often find it difficult to make a successful start in the field of underwater photography. The equipment is generally expensive and there is an increasingly wide range of cameras, flashguns, and accessories available which can be confusing to a novice who may not understand fully the advantages and drawbacks of the various systems on the market. The techniques of underwater photography are often highly specialized, so that experience of land photography is no guarantee of success in the underwater environment. Finally, there are so many problems involved in taking pictures under water that a good deal of experience is often required of the photographer before he obtains any presentable pictures. This can have the effect of discouraging the beginner.

### Teaching underwater photography

In 1981 the Marine Conservation Society recognized the need for competent photographers to contribute work to its many projects and expeditions, and asked the authors to organize a course in beginning underwater photography. This was held at the Marine Biological Station at Millport, Cumbrae, and provided a week of theoretical and practical photographic instruction for fifteen students. The course gave an opportunity to put into practice some ideas on the best way for the novice to approach underwater photography, and to evaluate the practical results of these ideas. Operations were conducted on the premise that underwater photography is essentially a practical skill. Theory plays an important part, but is always secondary to practice. The most important skills of the underwater photographer are self-taught: the evaluation of a subject as suitable or not, the estimation of its reflectivity, the estimation of distance, the prediction of the effect of the flash, the decision on what exposure to use, the composition of the subject in the frame, and many more essential skills, are all learned by trial and error. The instructor can offer advice and criticism, but at the moment when the

picture is taken the photographer must guide himself. As practical trial and error is such an important part of learning to take pictures under water, an intensive diving programme was the most essential part of the course. Mistakes made on one film could be corrected on the next, when the circumstances in which they were made were still fresh in the mind. Occasional diving can lead to the repetition of mistakes and the forgetting of essential principles.

## Types of cameras and housings

The first matter which occupies the novice photographer must be that of equipment: what camera and flashgun to buy? A system suitable for beginners must be sturdy, reliable, and easy to use. It should ideally be fairly adaptable; that is, it should be possible to take several types of pictures with it (close-up, wide-angle, etc.). Finally, it should be capable of taking good pictures even when used by a novice, as the beginner must have some successes at an early stage if interest in photography is to be maintained.

There are at the moment of writing a number of purpose-built underwater or amphibious cameras on the market, as well as a range of waterproof housings which enable ordinary cameras to be used under water. Perhaps the most popular underwater camera is the Nikonos, but there are other, less expensive alternatives, such as the small 110 format cameras. The Minolta Weathermatic incorporates a flashgun, but is limited to a depth of about 5 m. The Sea & Sea 110 format camera can be taken down to 50 m, and has a small flashgun and a close-up lens available as accessories. Moving on to the 35-mm format, the Ricohmarine is a very useful system. This is a purpose built plastic housing, rated to 30 m, containing a small viewfinder camera that incorporates a clockwork motordrive facility. A small flashgun is available to complete the system.

Though these inexpensive cameras can produce very good pictures in some circumstances, they are essentially limited in scope, and the optical quality of their lenses may not always be of the best. They are ideal for divers who want a casual snapshot record of their underwater activities, but those seriously interested in underwater photography may find themselves somewhat frustrated by the limitations of these cameras. The camera recommended to beginners is the Nikonos, as it is easy to use, can accept a wide range of lenses and accessories, can be used with a wide variety of flashguns, and is capable of taking pictures of excellent quality even in inexperienced hands.

Occasionally, divers experienced in land photography want to house their single lens reflex (SLR) camera for underwater use. Ikelite have available a range of plastic housings to fit almost any camera on the market, and even if a diver's camera is an unusual make or model, do-it-yourself kits are

available with which made-to-order housings can be built. The Ikelite range also includes housings for cine cameras, flashguns, exposure meters, and other accessories. Housed cameras can have advantages over the Nikonos, and an experienced photographer will probably be able to cope with the difficulties of the system. However, for the diver with little previous photographic experience, the housed SLR can be difficult to use under water. He would be wiser to learn photographic basics with the Nikonos and move on later to a housed camera if he wishes.

### Lighting

Though photographers in clear, sunlit tropical waters may take good pictures using only that light which occurs naturally under water (ambient or available light), the British diver usually depends on a flash unit to illuminate his subject. Early underwater photographers used bulb flashes, but the cheapness and reliability of the electronic flash unit ('strobe' in American publications) have made it by far the most popular underwater lighting system. There are many good ones available, and it is not possible to recommend any unit in particular. Care must be taken to ensure that the flash chosen can be used with the camera for which it is intended: connection fittings on various models can be different. Some thought must also be given to the purpose for which the flash will be used. A small, compact unit with a relatively weak flash is ideal for close-up work (Fig. 2.1), but wide-angle photographs demand a powerful unit with a dome port (convex face) in front of the flash tube. Autoflashes are now becoming widely available. These are flash units with sensors that measure the light reflected from the subject and adjust the length of the flash to give (in theory, at any rate) a perfect exposure every time (Fig. 2.3, p. 14). These can be a good choice for the beginner, who will then be relieved of the task of estimating exposure at the early stages of training. Some flashes are equipped with a 'modelling light', which is a weak beam of light that can be switched on and off like a torch. This can be a useful indicator of the direction in which the flash is pointing, and is a great help to the photographer using a housed SLR, as it illuminates the subject and permits accurate focusing. It is not, however, essential for the Nikonos user who 'focuses' by estimating the distance between the camera and the subject.

### Film

The choice of film can be confusing to the beginner. Many novices assume that black and white film is appropriate for their first underwater efforts, as they think of it as 'simple' and basic. However, this film can be difficult for the beginner to use successfully. For one thing, contrast is an important

Fig. 2.1. A compact system for taking close-up photographs. The Nikonos is equipped with an extension tube and framer, and a small flash unit. (Photograph by K. Vaughan.)

element of a black and white print, and many underwater subjects are notably lacking in contrast. Much darkroom time and some experience in printing techniques are also necessary to produce a good picture. Though black and white can be an exciting medium for the experienced photographer, beginners usually get much better results with colour transparency film. The use of flash means that relatively slow film (low ASA ratings) can be used with consequent advantages of increased resolution and picture quality. Some types of film can be processed easily by the amateur, making it possible for the photographer to examine his pictures within a few hours of having taken them.

### Close-up systems

Once a novice has obtained a camera and flash, the first inclination is usually to start using the system as it is, without the complications of supplementary lenses or other attachments. However, the Nikonos equipped only with the standard 35-mm lens is comparatively difficult to use under water. Among other things, camera–subject distance and the correct exposure must be estimated, the position of the flash must be correctly adjusted, and some experience is needed to use the viewfinder successfully. The beginner must therefore make a great many decisions, estimations, and adjustments, and it is unlikely that he will be able to make them all correctly so early in his training. The result is likely to be a film so unsuccessful that it is difficult to assess just what has been done wrongly. This has the inevitable effect of discouraging the photographer.

Beginners do well if their first pictures are taken with a close-up attachment. The standard Nikonos 35-mm lens can focus no closer than 0.8 m, but with the use of supplementary lenses or extension tubes, camera–subject distance can be reduced to a matter of 7–10 cm. Supplementary lenses, which clip on to the front of the lens, can be removed and replaced during a dive, and so give the photographer a choice of systems on a single dive. They are made in different strengths and enable the camera to focus on objects down to about 20 cm away from the lens. Extension tubes fit between the camera body and the lens and cannot be removed under water. They are normally used for extreme close-up work as they enable pictures to be taken of objects from 15 to 5 cm in front of the lens (Plate 1a). An extension-tube system is optically superior to one using supplementary lenses, though the difference in quality of the pictures is probably not important in most circumstances.

For the beginner, a close-up system (whether with supplementary lenses or extension tubes) has several advantages. First, the amount of water between subject and camera is reduced, so reducing the effects of light absorption and scattering by water and the particles in it, and producing clear pictures with good colour saturation. Secondly, the close-up system is equipped with a frame attached to the front of the lens. This solves both focusing and viewfinding problems: any object in the plane of the frame will be in focus, and as the frame defines the boundaries of the photograph, objects will appear in the picture as they appear in the frame. Thirdly, the correct exposure to be used with the close-up system is very constant and predictable. At most, one test film will have to be taken to determine the best apertures (f-stops) to use. These exposures can then be used with confidence on future films. Finally, the correct position of the flash is easily determined. Once it is pointing directly at the frame it will need no further adjustment.

For their first dive with a close-up system divers must make a few preliminary adjustments to their camera but once under water can generally concentrate on looking for subjects. Beginners are advised to follow this checklist:

1. Set speed at $\frac{1}{60}$ s or $\frac{1}{30}$ s (if using mechanical Nikonos models). These are the only shutter speeds at which electronic flashes will synchronize properly with the camera shutter.

2. Set distance scale: usually at infinity ($\infty$) if using supplementary lenses; usually at 0.8 m if using extension tubes.

3. Determine exposure by checking information supplied with the flash-gun, by reference to a previous test film, or by asking advice from someone with a similar system. In the absence of all three, a test film will have to be shot in which all available apertures are used. This film will then provide a useful reference to help the diver decide on the optimum exposure. In any case, it is recommended that until they are totally familiar with their system beginners should always bracket their shots: that is, that they take three pictures of each subject; one at the aperture which is thought to be correct, one at the aperture above, and one below. For example, if a test film reveals that $f$11 is a good exposure, next time the photographer should take one picture at $f$8, one at $f$11 and one at $f$16.

4. Ensure that the flash is pointing directly at the close-up frame.

5. When under water look for small subjects, or small sections of large objects.

6. Make sure that the frame lies flat to the subject and as close to it as possible, not at an angle to it.

7. The subject should not extend much in front or behind the frame: flattish subjects are most suitable. Close up systems have a very shallow depth of field (that is, the area in front of the camera in which objects will appear in focus is very restricted).

Once the first film is exposed the photographer should have a good idea of which exposures produce the best pictures. These exposures should remain the correct ones as long as the same system is used. The first film also reveals any misjudgements in framing subjects, and usually the photographer will improve his performance on the second film. Close-up work can be extremely rewarding for the beginner, as he can produce good pictures after only one or two trials. It provides practical experience of the consequences of aperture changes, a demonstration of the concept of depth of field, and an introduction to the principles of photographic composition. However, the very simplicity of the technique means that, once it is mastered, the novice should move on to something more difficult in order to extend his skills. Though the standard 35-mm lens could be used at this stage, a useful next step is wide-angle work.

### Wide-angle systems

As a rule of thumb, a wide-angle lens can be thought of as including more in its field of view than an unaided human eye. The Nikonos 35-mm lens, though slightly wide-angle in air, encompasses less than a normal eye's field of view when used under water. Other lenses, or supplementary lenses, must therefore be used to give a wide angle of view. Lenses are described in terms of their focal length: when a 35-mm lens is focused on infinity, the distance between the optical centre of the lens and the plane on which it focuses is 35 mm (the focal length). Any lens with a short focal length is wide-angle in nature, and the shorter the focal length the wider the angle of view. There are two wide-angle lenses available from Nikon for use with the Nikonos: the 28-mm and the 15-mm. These replace the 35-mm lens on the camera body and so cannot be removed under water. Accessory push-on attachments (such as the Subawider or Viz-Master) can also be used for wide-angle work (Fig. 2.2). These can be removed under water and so provide a very flexible system. The optical quality of these accessory lenses is not as good as that provided by the 15- and 28-mm Nikon lenses, but again the difference in picture quality will probably not be of great importance to most photographers.

Whatever the system, a Nikonos used with a wide-angle lens or attachment will need a special viewfinder: the standard viewfinder in the camera will have quite a different field of view from that covered by the lens. Optical viewfinders (viewfinders fitted with lenses) can be obtained for all wide-angle systems, and are superior to the 'sportsfinders' or simple viewing frames that are sometimes used (Fig. 2.2).

One difficulty presented to the novice photographer by a wide-angle system is the need for a powerful flashgun fitted with a dome port (convex face over the flash tube) that will enable it to cover the same angle as the camera lens. The small flashes that are so useful for close-up work normally cannot cope with wide-angle photography: pictures with 'hot spots', or bright patches of light in the middle of large dark areas, can result if they are used. It may also be necessary to change the mounting of the flash. Good close-ups can be taken with the flash placed quite close to the camera, but successful wide-angle pictures demand that the flash be located some distance away (perhaps 50 cm or even further). The greater the camera–flash distance the less will be the problem of 'back-scatter' (the reflection of light from suspended particles back into the camera lens).

Once a suitable system has been set up, wide-angle photography, though more complicated than close-up work, is still fairly straightforward and can produce good results even for inexperienced photographers. Though the camera must be focused by setting the lens on the apparent camera–subject distance, the depth of field of wide-angle systems is so great that accurate

Fig. 2.2. A compact system for wide-angle photography. A supplementary lens has been added to the Nikonos, and a strong autoflash with a good angle of coverage provides the lighting. (Photograph by K. Vaughan.)

distance setting is not critical. Viewfinding and subject framing are also easy, especially if an optical viewfinder is used. The most difficult aspect of wide-angle photography is determination of the correct exposure. As with close-up photography, much time and trouble will be saved if the first film shot is a test film, taken of subjects at several distances and at all possible apertures. Careful examination of this film will then suggest the most suitable exposures to use in future. However, exposures for wide-angle pictures are not nearly as easily predicted as those for close-ups. Camera–subject distance, constant in close-up work, is widely variable in wide-angle photography. This distance, and the nature of the subject and its background

(whether they absorb or reflect light) will have profound effects on the exposure.

Autoflashguns can prove very useful when working with the unpredictable exposures involved with wide-angle photography, as they should provide the right amount of light on many different kinds of subjects and, within limits, at various subject–camera distances (autoflashes work reliably only when the subject is within about 1.5 m of the camera).

Apart from the problems presented by exposure, the beginner usually has few difficulties in taking good wide-angle pictures. If he selects large subjects (such as divers or underwater landscapes) and makes a point of taking pictures at very close distances, he usually finds his pictures well focused, with good clear colours (Fig. 2.3). Wide-angle work teaches the novice valuable lessons in evaluating a subject and determining the correct exposure for it. He will also have seen the effect of subject–camera distance on colour and contrast, and recognized some of the problems of using flash in murky waters.

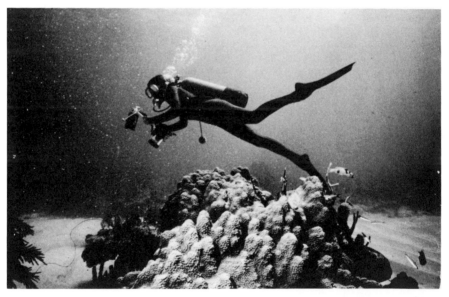

Fig. 2.3. Photograph of a diver in a seascape taken with a Nikonos wide-angle system. (Photograph by K. Vaughan.)

**Standard lens systems**

Once the novice is reasonably adept at wide-angle techniques, the only basic system he has not yet used is one involving the standard 35-mm lens. This

lens can be difficult to use successfully. In the first place, it focuses no closer than 0.8 m, and even at this distance the absorption and diffusion of light by water can make pictures hazy, lacking both in colour and contrast. The problem is even worse when there is suspended matter in the water, as there nearly always is in British waters. Secondly, the viewfinding system of the Nikonos can be difficult to use accurately. Thirdly, the subject–camera distance must be accurately estimated or pictures will not be sharp. Large apertures are often necessary when the 35-mm lens is used, and the depth of field with these apertures is relatively small. Accurate focusing (that is, accurate distance estimation) is therefore essential if pictures are to be in sharp focus. Finally, as is the case in wide-angle photography, the correct aperture is usually difficult to predict accurately. Even experienced photographers often need to bracket their shots to be certain of getting at least one satisfactory picture. In addition to the problems caused by distance estimation, viewfinder use, and the estimation of correct exposure, there is an additional difficulty in finding subjects of a suitable size for the 35-mm lens. Though in theory the camera will photograph subjects from 0.8 m away to infinity, in practice it is necessary to stay as close as possible to the subject in order to minimize the effects of water on the light produced by the flashgun. As one cannot get closer than 0.8 m to the subject, good subjects are really restricted to objects of roughly 30–50 cm across, such as a large fish or a diver's head and shoulders. Anything much smaller than this tends to get lost in the frame.

It takes much experience and hard work for a novice to become a really competent underwater photographer, and it cannot be expected that a week's course will turn a beginner into an expert. But the concentrated effort of one week's intensive diving and photography can do far more to teach the essentials of underwater photography than a year of occasional, casual attempts to use a camera on a dive. Lectures in photographic theory, though interesting and indeed essential for understanding and coping with some of the specialized problems involved, cannot actually teach anyone to take good pictures under water. That can only be done by practical experience and much trial and error.

### Guidelines

Not all those who are interested in taking underwater photographs will want to attend a course in the subject and, though an instructor can be useful in defining a problem and suggesting a solution to it, there is no real need for formal instruction. A beginner working on his own could easily follow the general outline given below:

1. Start with a system that is simple to use and that gives good results. Close-up lenses or extension tubes are ideal.

2. Wide-angle systems, though requiring some experience to use well, can be a useful second step.

3. Always keep a photo log in which you record full details of every film you take (subjects, lenses, exposures, distances, etc.) and the results obtained. This will keep you from repeating mistakes and provide a valuable 'photo manual' for your particular system.

4. Arrange to see your results as soon as possible after you take the film, and take your next roll as soon as possible after that, while the details of what you did are still fresh in your mind.

5. Learn to do E6 film processing so that you can see your results quickly.

6. Finally, don't get discouraged when things go badly, which they probably will at some stage. Nobody gets good results all the time, or even most of the time. Taking good underwater photographs is never an easy job, but there will always be the occasional brilliant picture that makes it worth while and will keep you going until the next one.

# 3 Diver-operated cameras and their marine biological uses

*A. Svoboda*

## Introduction

Although scientific diving and underwater photography were pioneered towards the end of the last century (Boutan 1893), it was only with the invention of self-contained underwater breathing apparatus (SCUBA) and its rapid development during the Second World War that a new impetus was given to diving. After the war, Hans Hass undertook scientific underwater expeditions to coral reefs, and his photographs and films introduced millions of people to the underwater world. Along with his friends and colleagues he started to use underwater photography for documentation and identification of flora and fauna, and for behavioural studies. Today a growing number of diving biologists use photography in a variety of ways to assist them in their ecological, taxonomic, and behavioural studies.

Refraction and selective absorption of light occur under water and light scattered by particles in the water leads to fogging. Housed land cameras with flat ports do not always give the best results, because the photographs tend to be low in contrast, have an overall colour cast, and also tend to be distorted at the margins. Wide-angle lenses with a shorter working distance improve the contrast and extend the range of colours that will be recorded. They also help to reduce back-scatter when artificial lighting is being used. Dome ports on underwater housings and the special underwater lenses of underwater cameras help to improve definition at the margins of the picture and reduce the edge distortion—even in the macro range.

## Application for biological research

### 1. In situ *species documentation*

Taxonomic descriptions of aquatic plants and animals are usually based on preserved specimens. Many non-diving biologists have considerable difficulty in identifying species from colour photographs or from living animals and find it easier after they have been preserved and have lost their colour. This procedure is, of course, still necessary for species where identification is based on microscopic details.

For the non-specialist, identification of animals and plants is easier from colour photographs than from preserved specimens or from scientific drawings of salient features. A scale-bar on the side of each photograph helps estimation of subject size. Most scleractinian corals, sea anemones,

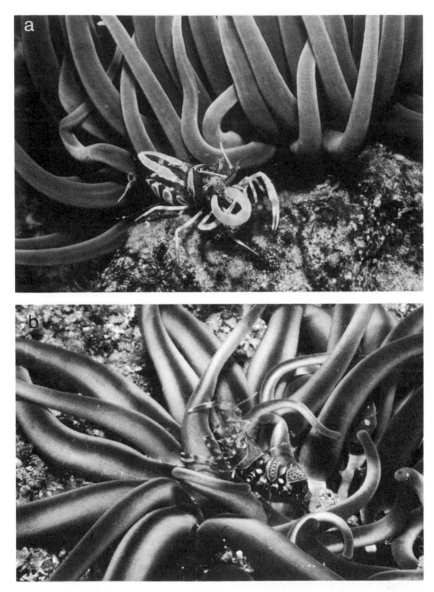

Fig. 3.1. (a). A symbiotic shrimp *Periclimenes sagittifer* feeding on an *Anemonia sulcata* tentacle tip. (b) *P. amethysteus* on *Condylactis aurantiaca*. Both Mediterranean species are easily distinguished by their pattern.

gorgonians, and sea pens are easy to identify from photographs when the polyps are extended and the body column is clearly visible. There are a few genera of scleractinian corals that have similar skeletons and the species can be distinguished only by the shape of the living tissue (e.g. *Euphyllia* and *Fimbriophyllia*).

The marine environment is very variable and a number of animals have adapted to it by having colours and patterns that camouflage them. This is true of many invertebrates such as turbellarians, molluscs, crustaceans, and also of shallow-water fish. Colours and patterns often change at night, though this 'night-dress' is usually uniform within the species. Needless to say, all this variability can make the identification of some species difficult from photographs. Species that do not show camouflaging colours or patterns often have their own specific coloration, and even the sexes can be separated in this way. An example is the symbiotic shrimp *Periclimenes* that lives on various hosts such as sea anemones (Fig. 3.1), corals, nudibranchs, and echinoderms (Svoboda and Svoboda 1975; Bruce and Svoboda 1983).

For over a hundred years, photographs of aquatic organisms have been taken in aquaria. Compared with underwater photography it is time-consuming; lighting is difficult because of the refraction of light at the air–water interface and the 'arranging' of active animals needs much patience. Tropical animals are difficult to keep alive in aquaria and it is easier to photograph them under water. Exceptions have to be made in the case of long-term behavioural experiments or species living within the substratum.

## 2. *Surveys of fauna and flora*

Several quantitative methods of underwater survey are used to study the composition, abundance, and distribution of species in epibiotic communities. Since the composition of communities is influenced mainly by environmental factors, changes in well-documented communities may reveal influence of external factors such as pollution.

For both rapid and detailed surveys photographic techniques are recommended to reduce time spent under water, especially where the normal quadrat/transect approach is used. First used for terrestrial plant studies, this approach has been extensively adapted for marine research (e.g. Molinier and Picard 1952; Laborel and Vacelet 1958; Scheer 1967). Quadrats of varying size and shape (400 cm² up to 25 m²) may be photographed depending on the extent and type of community involved (Fig. 3.2). If accurate black and white enlargements are made from negatives produced using a high-quality, fully corrected, lens it is possible to estimate the surface areas of benthic colonies by carefully cutting around the outline of the colony and weighing the pieces of photographic paper. Photography can also be used as an effective tool for recording species

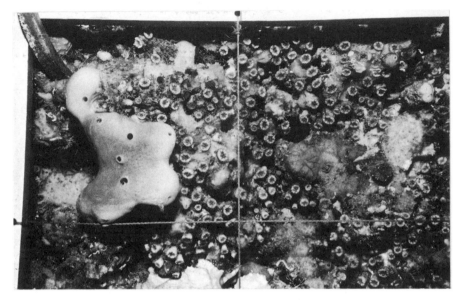

Fig. 3.2. A coral (*Polycyathus müllere*) colony on the roof of a Mediterranean cave. A test area of 200 cm² is shown in the upper left hand corner of a 1 m aluminium frame.

composition along a transect line. Such a method was used by Loya and Slobodkin (1971) during a survey of Red Sea reefs.

Photography of large areas should be carried out with wide-angle lenses to improve contrast and colour saturation, which are both poor with standard lenses. To assist in assembling photographic mosaics it is helpful to lay a network of ropes which can then be used as a guide when joining the photographs together.

### 3. Activity rhythm records

The daily and annual rhythms of many intertidal animals are well-known, but except in the case of animals of commercial value such behaviour has been little studied in the shallow sublittoral. By taking photographs at regular intervals of exactly the same area, information on the development, growth, and competition of species can be gained without destroying the communities (Lundälv 1971).

Daily activity rhythms are mainly dependent on light and tidal cycles. Such short-term rhythms can best be studied by using time-lapse photography spanning several days. The camera must be firmly mounted on a well-anchored tripod, must be motor-driven, and ideally should use electronic flash as a light source. To save the battery, the electronic flash should be switched on by an electronic timer and switched off at the required

capacitor voltage with simultaneous triggering of the shutter. Using large film cassettes, 200 exposures can be made on 60-mm film, 750 on 35-mm film, and about 4 000 on 30 m rolls of 16-mm cine film. Studies, even over one or two days, can be affected by detritus stirred up by changing currents (Fedra 1974; Olscher and Fedra 1977), while long-term experiments will require cleaning of the optical port in addition to re-charging of the batteries. When the development of the community is slow it is usually sufficient to take photographs on a daily, weekly, or even monthly basis.

Daily activity rhythms are found in many coelenterates such as corals, sea anemones, sea pens, and other soft corals. Most shallow water species feed only at night and withdraw their tentacles during the daytime, but in deeper water where there is less light, the animals also feed during the day. Occasionally, open polyps may be found in some species during the day when the water is rich in plankton or in dissolved amino acids that stimulate the polyps. A few species, like the coral *Plerogyra* and the sea anemone *Triactis producta* in the Red Sea, have two sets of tentacles, one for day, the other for night. The day tentacles are crowded with symbiotic algae that produce additional food for the host by photosynthesis. The slender night tentacles are spread out solely to catch plankton (Fricke and Vareschi 1982).

Both crustaceans and fish show colour changes that correlate with light and their activity rhythm. Many Mediterranean and tropical fish have special night colours that are completely different from their daytime colours. Shrimps often look pale at night because of a contraction of the pigment of the chromatophores. The Mediterranean species *Parapandalus narval* aggregates in caves at 10–50 m depth during the day, but can be found feeding in the open during the night. Similar behaviour patterns can be found in other invertebrates such as molluscs and echinoderms. Even sea urchins (e.g. *Diadema* ) prefer to emerge from crevices and feed at night, not trusting to the protection afforded by their spines.

The annual rhythms in temperate seas are mainly due to changes of water temperature and the seasonal light regime. These are both responsible for the seasonal growth and reproduction of algae and aquatic animals (Fig. 3.3). Field observations on the development and growth of benthic species is often difficult as their natural substratum is frequently crowded with other organisms. To make studies easier, artificial substrata (usually plates) composed of such material as limestone, cement-asbestos, or plastic can be used. Underwater, close-up photography of these plates can easily record the development and growth of species as well as the competition between them (e.g. overgrowing and grazing effects). In addition to plates used for photographic recording, plates should also be installed for productivity measurements and for collecting specimens for the purpose of checking identification. Work has been done using a 1 m$^2$ frame in combination with a 60-mm Hasselblad camera taking stereophotographs (Lundälv 1976), but

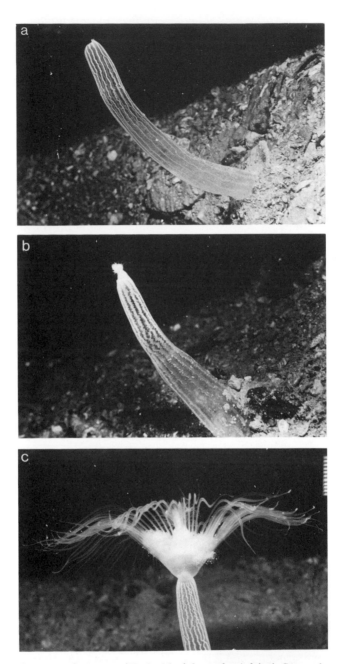

Fig. 3.3. In *Corymorpha nutans* (Hydroidea) from the Adriatic Sea, columns without tentacles (a), or with poorly developed tentacles (b), are common. Long-term studies (> 2 years) have shown that these represent regenerative stages leading to the fully-developed tentacle crown (c). The growth cycle takes place over the six winter months. A 10 mm scale is seen on the right of photograph (c).

for small areas, a 35-mm macro stereo system will produce the same results more economically.

## 4. Orientation to light and current

Light and water movement are key abiotic factors for sedentary animals living in the shallow sublittoral. Both these factors are themselves dependent on weather conditions, and they cannot always be measured at the same time as a particular community is mapped or collected. Since zonation of algae is strongly light-dependent, photographic transects of green, brown, and red algae can be used as indicators of the amount of light present. Because of the symbiotic relationship that corals have with zooanthellae, a similar zonation can be observed in hard and soft corals in the tropics.

Many sponges and tunicates that live at the entrance to caves have pigments distributed according to the amount of light they receive. Other sponges, like *Aximella*, direct their terminal oscular opening towards the light while the bushy Mediterranean gorgonian *Eunicella graminea* orientates the tips of its branches towards the light; broken individuals will re-orientate themselves if growth continues (Fig. 3.4). Several of the fan-shaped algae

Fig. 3.4. *Eunicella graminea*, which has symbiotic zooxanthellae, reorientates its branches towards the light when its position is changed.

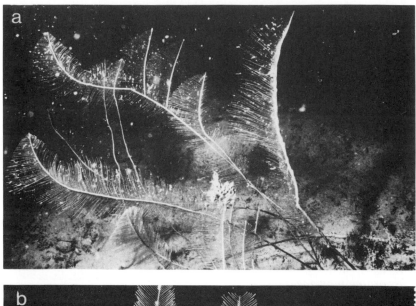
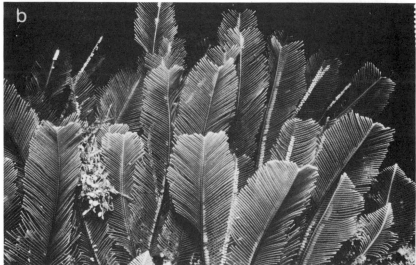

Fig. 3.5. (a). *Theocarpus myriophyllum* is bent over by strong tidal currents, nevertheless, the growing tips orientate themselves at right-angles to the prevailing current (from right to left of photograph). (b). In *Gymnangium montagui* the fans orientate so that the polyps face away from the current (from front to back of photograph).

such as *Halimeda*, *Udotea* and *Corallina* grow perpendicular to the prevailing direction of water movement irrespective of the direction of the light (Theodor and Denizot 1965). This phenomenon is apparently caused by the increase of torsion stability at high current forces. Most passive filter feeders show a similar growth orientation which is, of course, the optimal orientation of the filtering fans (Fig. 3.5a). The dense cover of small fan-shaped hydroids on hard bottoms makes the mapping of currents flowing close to the substratum easy by photographic methods. The hydroid *Gymnangium*, and related plumulariids, have polyps growing on one side of the fan only. Where there is a constant current in one direction, the polyps are on the side facing away from the current (Fig. 3.5b). When the current regularly reverses direction, the fans are orientated in a fashion statistically related to the current direction, allowing predictions to be made about the behaviour of the current on a long-term basis (Svoboda 1976). Current flow patterns well above the sea bottom can be mapped where larger gorgonians grow and have orientated themselves to a constant current direction (Wainright and Dillon 1969).

## 5. Recording movement

Cine or video techniques are useful for recording movement of marine animals. High-speed cine photography may be necessary for analysing rapid movement. Sixteen-millimetre cine film has the advantage over 35-mm film of a better depth of field, but definition is less good on each frame. Telephoto lenses are necessary for close-up studies of subjects that cannot be approached closely, while macro lenses up to 105-mm focal length are used with 35-mm cine cameras. Single or double reflex view-finders must be used for focusing with these lenses because of the reduced depth of field. Also, artificial lighting with telephoto lenses in turbid water often results in poor contrast. Many species show behavioural changes with continuous underwater lighting, especially the night-active filter feeders, though most do not react to electronic flash, with the exception of ophiuroids like the basket star *Astroboa nuda*.

## 6. Documentation of in situ experiments

Underwater photography can usefully provide a record of experiments set up both on the sea-bed (Fig. 3.6a–b) and in midwater. Photography is also invaluable for assessing the effectiveness of underwater sampling and fishing gear.

## Light conditions in the sea

Natural daylight plays a much more important role as a limiting factor in underwater photography than in land photography. A substantial propor-

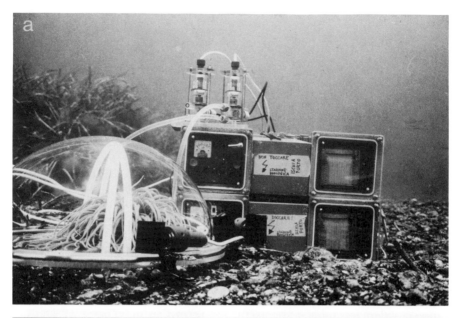

Fig. 3.6. (a). An *in situ* respiration and photosynthesis experiment using the sea anemone *Anemonia sulcata*. (b). An *in situ* behaviour experiment using a flume. The experiment showed that a host sea anemone (in cage) could be chemically traced by its symbiotic shrimp *Periclimenes sagittifer*.

tion is lost by reflection during transition through the air–water interface, especially in calm weather at low sun levels. Additional reduction of light intensity is caused by absorption by water molecules, suspended particles, and plankton. The combined effect of absorption and back-scatter from particles in suspension reduces underwater visibility from a maximum of 50 m in clear seawater down to less than 1 m in turbid water. As with fog on land back-scatter from particles causes a loss of contrast in the photographs, limiting photographic distance to about one-third of estimated visibility. As a result of refraction at the air–water interface, objects appear considerably larger to the eye and to the camera than they really are, and this leads to an under-estimation of distance. Lenses have to be focused on the apparent distance, which is 30 per cent nearer than the measured one, to be sharply in focus. Additional problems arise in colour rendition, due to the selective spectral absorption of the red part of sunlight by the water molecules. The increased amount of yellow humic acids in coastal waters and additional turbidity turns the blue, open ocean water, green. Colour correction filters in front of the lens can be used to a depth of approximately 5 m. Below 5 m artificial illumination is necessary to restore the colour of sunlight, for which daylight films are balanced.

## Underwater photographic systems

Thirty years ago cheap rangefinder cameras were the ones mainly housed for underwater photography, because of the danger of frequent flooding. The 24 × 24-mm Robot camera with automatic film transport was especially popular: its small format and the extended depth of field of the 38- or 40-mm lens enabled it to be used as a fixed-focus camera with just one of those untrustworthy stuffing boxes for the trigger. With the introduction of O-ring sealed control knobs and the improvement of 35-mm single lens reflex (SLR) cameras by incorporation of automatic diaphragms, many commercially-designed housings came on the market. Many of these are produced from seawater-resistant aluminium alloy to withstand the pressure at a depth of 100 m. Less expensive housings are moulded from lightweight transparent polycarbonate which enables the photographer to detect small leaks. All present-day SLR cameras have a range of interchangeable lenses. Special dome ports can be obtained for wide-angle lenses, but flat ports are better for close-ups or short telephoto lenses. The small eyepiece of prism reflex viewers gives some problems because the viewing distance is increased first by the housing itself and then by the face-mask. This means that only the central part of the viewfinder image can be seen. Scales and control lights for through-the-lens (TTL) light measurement are only visible in a few expensive camera bodies that are fitted with a sports prism finder, or with a small reducing lens.

The first professional underwater housing for 60-mm cameras was the Rolleimarin. It was designed by Hans Hass for the Rolleiflex twin-lens reflex camera and produced by Franke and Heidecke. The most recent model IV (no longer in production) was fitted with swivel mounted close-up lenses, a 30° viewing prism, and a large magnifying eyepiece for focusing. Housings for the SLR cameras Rolleiflex SL66 and various Hasselblad models are still in production. Both camera systems have interchangeable lenses, and dome ports are offered for the 40-mm and 50-mm wide-angle lenses. Zeiss computed a special glass dome port with a supplementary lens for the housing of the Hasselblad SWC to accommodate the 38-mm Biogon wide-angle lens.

Shortly before the Rolleimarin came on to the market, de Wouters from Belgium designed one of the first self-contained underwater cameras, which was produced as the 'Calypso-phot' by Spirotechnique, France. The poor definition of the 35-mm Som-Berthiot lens and the frequent malfunction of the bulb flash may have limited its wide acceptance at that time. Nevertheless, the Calypso-phot was used as a second camera by many Rolleimarin photographers, particularly for wide views because of its wide-angle lens and handy pocket size. Fifteen years ago Nikon obtained the licence to produce the Calypso-phot and have since systematically improved the mechanics of the housing. The last mechanical model, the Nikonos III, which is now out of production, is a coveted secondhand camera. The latest model, the Nikonos V, has a fully automatic TTL light and flash metering system with a manual override.

The 28- and 15-mm lenses made by Nikon have shown that underwater lenses can achieve the high definition that is now expected of quality lenses in air. Lenses of 35 and 80 mm focal length with flat ports are also available, and these can be used both in air and under water. The 28-mm lens is to be preferred to the standard 35-mm lens for use underwater because of its better definition. The 80-mm lens has a very narrow depth of field at distances of less than about 2 m, and accurate measurement of subject distance is therefore essential. Most marine biologists who use the Nikonos system use it to complement sampling and experimental work because it is so compact and robust, and offers a wide choice of lenses (George 1980).

The absence of a TTL viewfinder is a drawback. Optical viewfinders equipped with parallax compensation are now widely available , but there are still no rangefinders on the market. My experience has shown that split-image rangefinders give more accurate results in dim light or high turbidity than do systems that rely on the sharpness of an image focused on a ground-glass screen (Fig. 3.7).

Normal camera lenses are designed for use in air. When these lenses are used under water behind a flat port the picture angle is reduced to about three-quarters of the angle in air. This is because of refraction at the air–

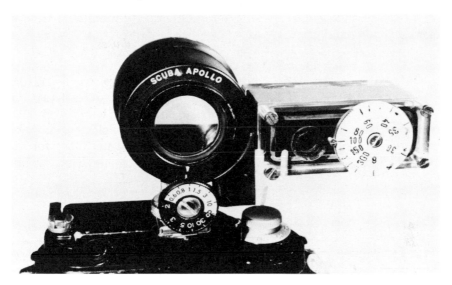

Fig. 3.7. A split-image rangefinder designed by the author for use with the Nikonos camera.

water interface. Flat ports are often preferred for close-up photography of small objects because the reduction of picture area can help with smaller subjects. With increasing lens angle and aperture, however, flat ports produce considerable chromatic aberration, astigmatism, and distortion which are most noticeable in the corners of the picture. With a correctly designed and mounted dome port the picture angle stays the same under water as it is in air and distortion and chromatic aberrations are reduced. The wider the lens angle the greater is the need for a dome port. The dome port itself also acts as a lens and produces a virtual image of the object a short distance in front of the dome. The camera lens has to be focused on this virtual image, either by short distance setting as with the Rolleiflex SL 66 in Wulf Koehler's Aquamarine housing, or by supplementary close-up lenses, as with the Hasselblad SWC with the Zeiss dome port. Dome ports considerably increase the image definition of wide-angle and fisheye lenses compared with flat ports, but many experienced underwater photographers claim that fully corrected systems still give better contrast and resolution. The resolving power (lines/mm) of various lenses at different apertures is given in Fig. 3.8.

For Nikonos lenses, not capable of close focusing, push-on close-up lenses fitted with distance probes are available from several manufacturers. Only the Hydrophoto close-up lens (12–28) and the Nikonos close-up kit can be used with the 28-mm UW-Nikkor without vignetting the image corners. With the close-up lens from Nikon the scale of reproduction is about 1:2 with

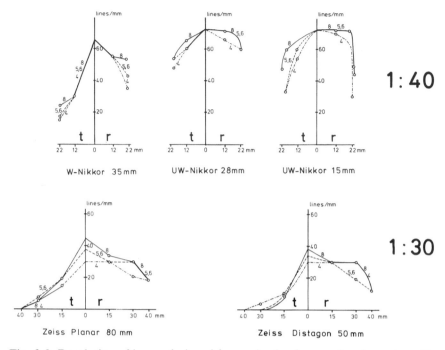

Fig. 3.8. Resolution of lenses designed for use in air when used under water with a flat port and at distances above the minimum specified (up to 3 m) (W-Nikkor 35-mm for Nikonos, Zeiss Planar 80-mm and Distagon 50-mm for Rolleiflex SL66) compared with lenses designed for underwater use (UW-Nikkor 28-mm and UW-Nikkor 15-mm for Nikonos) at various *f*-stops. A good tangential resolution (*t*) is more important for definition than the radial resolution (*r*). 64ASA film was used for the tests.

the 80-mm, 1:4 with the 35-mm, and 1:6 with the 28-mm Nikkor. Underwater tests show clearly that the Nikon close-up lens gives much better definition when used with the 28-mm lens (Fig. 3.9).

Extension tubes can be used for all lenses but have the disadvantage that they have to be mounted prior to the dive. For Nikonos the shortest possible tube yields an image scale of 1:3.8 with the 35-mm, and 1:3 with the 28-mm Nikkor. With longer tubes, image sizes greater than 1:1 can be obtained, but such pictures tend to suffer from uneven illumination caused by the oblique angle of the flash and from the small depth of field. Further stopping down increases the depth of field but reduces the definition (Fig. 3.9).

## Films and filters

Some scientific pictures are still shot on panchromatic black and white film. One reason for this is the relatively poor quality of black and white prints

made from colour slides, due mainly to lack of detail in shadow and highlights. Development of black and white film on expeditions is a much easier process than for colour film, and is useful for monitoring results or for making prints for use in the field. Last, but not least, costs are much lower for black and white film and for printing, and it is only exceptionally that scientific publishers will include colour plates.

Using a combination of underexposure, extended development time, and low-sensitivity films it is possible to increase image contrast to compensate for the low image contrast of many underwater scenes. Films of about 50ASA such as Ilford Pan F and Kodak Panatomic X have proved useful for this purpose. Medium- and high-speed films tend to become very 'grainy' when subjected to extended development. Underwater close-ups with a single flash may be too high in contrast. A useful technique here is to use medium-speed film and over-exposure, which is then compensated for by reduced development time which reduces grain size.

The use of filters may considerably increase the quality of black and white and colour pictures taken under water. When using black and white film, yellow filters help to improve the contrast between a subject and the background. Orange and red filters increase the photographic viewing distance but are limited to shallow depths because they strongly absorb light. Without filtering, the colour balance is distorted even at depths of 1 m. In clear water, CCR filters are used to restore the colour balance when the light path is less than 5 m. In greenish coastal water a combination of CCR and CCM filters yields better results. Below 5 m depth, colour balance can only be restored by using artificial light. Light measurements with filters are most easily made through the camera lens. When using supplementary light meters, such as the Sekonic Marine Meter II, measurements are made with the filter held in front of the meter. The light meter should be tilted downwards slightly to avoid under-exposure caused by the bright water background.

**Artificial light sources**

Photoflood lamps, with the disadvantages of long heavy cables and a low-light output, were first used for underwater photography between the First and Second World Wars (Mertens 1970). Early electronic flashguns (strobes) also provided a low light output, and the high voltages employed (up to 10 000 V) were dangerous. For these reasons flashbulbs were preferred by underwater photographers for many years. Flashbulbs have the disadvantages that the flash is of rather long duration, replacing the used bulb is awkward and time-consuming, and the used bulbs present a litter problem. Today, almost all artificially lighted shots are taken with electronic flash as the flash duration is shorter, recycling time is shorter, synchroniza-

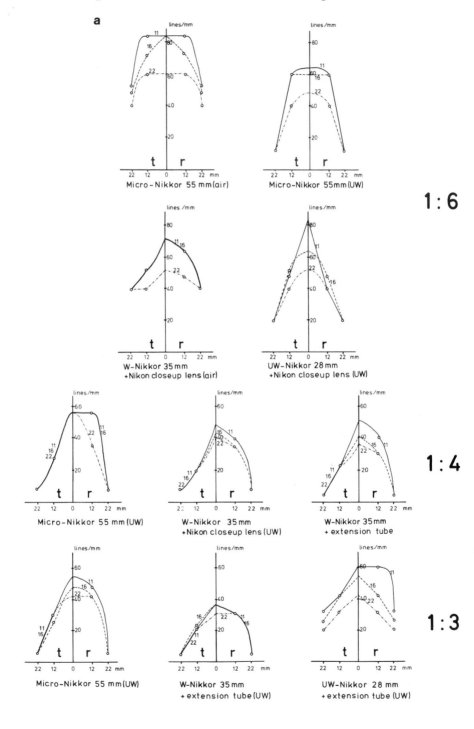

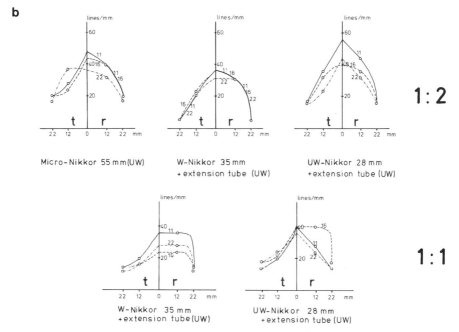

Fig. 3.9. Resolution of air-designed lenses and underwater-designed lenses in the macro range. The loss of definition when using air-designed lenses under water through flat ports is obvious if compared with the definition when used on land (Micro-Nikkor 55-mm, air). With increasing *f*-stop numbers centre resolution drops drastically. (a) 1:6, 1:4, 1:3; (b) 1:2, 1:1.

tion is perfect with diaphragm shutters, and there is no litter problem. Focal-plane shutters used in 35-mm cameras mostly synchronize at $\frac{1}{60}$ s. 60-mm cameras synchronize at $\frac{1}{30}$ s. Blurring due to image movement at the longer exposure time can be reduced by stopping down the aperture and increasing the flash intensity. The colour temperature of electronic flash is similar to daylight, and the same principles apply in the use of colour correcting filters as for daylight photography.

Small flashguns (used mainly for close-up photography) have disposable batteries and are particularly valuable in remote regions where battery-charging is difficult. The larger models needed for wide-angle lighting usually use rechargeable NiCd cells or, sometimes, disposable high-voltage batteries. Although many types of electronic flashgun are on the market, only a few cover a field of view wide enough for the 28- or 15-mm UW-Nikkor. However, it is possible to increase the angle of light output of some flashguns by using a specially designed dome port or by filling the reflector-lamp unit with silicone oil (Fig. 3.10). The results from tests using unmodi-

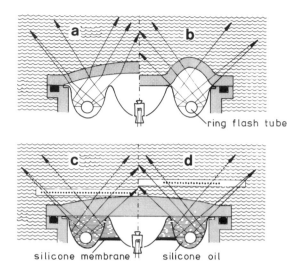

Fig. 3.10. Marlin I flashgun: (a) Unmodified; (b) With a specially designed dome port which helps to improve the evenness of illumination; (c, d) Good results are obtained by filling the air space between the reflector and the port with silicone oil which has only a slightly higher refractive index ($n$ = 1.47) than water ($n$ = 1.33). (c) With filter disc in position. (d) With ring filter in position.

fied and modified commercial flashguns are displayed graphically in Fig. 3.11.

The use of automatic flashguns for underwater photography is still in its infancy. The photocells are sensitive to particle backscatter, even when they are mounted close to the camera lens, and thus cause under-exposure in turbid water. However, the TTL automatic flash metering system of the Nikonos V when used in conjunction with the Nikon SB-102 and SB-103 flashguns seems to have largely overcome this problem. For distances of less than 0.8 m the SB-102 should be used with a neutral grey filter ($\times 4$ to $\times 10$) in front of the port to reduce the light intensity and enable the automatic TTL light output control to react on time. Only through experience will a photographer be able to deal with problems concerning the TTL flash metering system, such as photography of glossy, bright, or dark objects, or instances in which the object is not centered in the sensor field. In any event, automation is a valuable aid for improving photographic documentation, especially for those lacking experience.

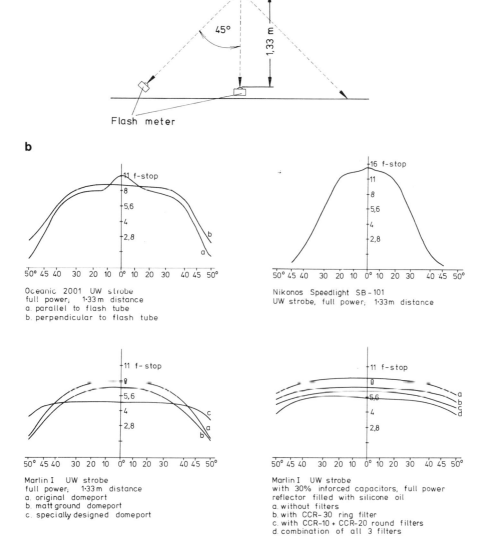

Fig. 3.11. (a). Layout of equipment for the flashgun illumination tests. (b) Results of illumination tests using three different flashguns, one of which was modified using either a specially designed dome port or by filling the reflector unit with silicone oil.

## References

Boutan, L. (1893). Memoire sur la photographie sous-marine. *Archs Zool. exp. gén.* **21**, 281–324.

Bruce, A. J. and Svoboda, A. (1983). Observations on some pontoniine shrimps from Aqaba, Jordan. *Zool. Verh. Leiden* **205**, 1–44.

Fedra, K. (1974). Filtrierverhalten und Aktivitätsrhythmik bei *Ophiothrix quinquemaculata* (Echinodermata). *Research Film* p. 1567 BHWK Wien.

Fricke, H. and Vareschi, E. (1982). A scleractinian coral (*Plerogyra sinuosa*) with 'photosynthetic organs'. *Mar. Ecol. Prog. Ser.* **7**, 173–8.

George, J. D. (1980). Photography as a marine biological research tool. In *Systematics Association Special Volume No. 17(a), 'The shore environment, Vol. 1:Methods'* (eds. J. H. Price, D. E. G. Irvine, and W. F. Farnham) pp. 45–115. Academic Press, London and New York.

Laborel, J. and Vacelet, J. (1958). Etude des peuplements d'un grotte sous-marine du golfe de Marseille. *Bull. Inst. océanogr. Monaco* 1120, 1–20.

Loya, Y. and Slobodkin, L. B. (1971). The coral reefs of Eilat (Gulf of Eilat, Red Sea). *Symp. Zool. Soc., Lond.* , No. 28, 117–39.

Lundälv, T. L. (1971). Quantitative studies on rocky-bottom biocoenoses by underwater photogrammetry. A methodological study. *Thalassia jugosl.* **7**, 201–8.

—— (1976). A stereophotographic method for quantitative studies on rocky-bottom biocoenoses. In *Underwater research* (eds. E. A. Drew, J. N. Lythgoe, and J. D. Woods) pp. 299–302. Academic Press, London.

Mertens, L. E. (1970). *In-water photography*. John Wiley, New York.

Molinier, R. and Picard, J. (1952). Recherches sur les herbiers de Phanérogames marines du littoral méditerranéen français. *Ann. Inst. Oceanogr.* **27**, 157–234.

Ölscher, E. M. and Fedra, K. (1977). On the ecology of a suspension feeding benthic community: filter efficiency and behaviour. In *Biology of benthic organisms* (eds. B. F. Keegan, P. O'Céidigh, and P. J. S. Boaden) pp. 483–92. Pergamon, Oxford.

Riedl, R. (1966). *Biologie der Meereshöhlen*. Verlag Paul Parey, Hamburg.

Scheer, G. (1967). Über die Methodik der Untersuchung von Korallenriffen. *Z. Morph. Ökol. Tiere* **60**, 105–14.

Svoboda, A. (1976). The orientation of *Aglaophenia* fans to current in laboratory conditions (Hydrozoa, Coelenterata). In *Coelenterate ecology and behaviour* (ed. G. O. Mackie) pp. 41–8. Plenum Press, New York.

—— and Svoboda, B. (1975). The Mediterranean anemone shrimps of the genus *Periclimenes*, Costa (Decapoda: Palaemonidae). *Pubbl. Staz. Zool. Napoli* **39**, 345–6.

Theodor, J. and Denizot, M. (1965). Contribution à l'étude des Gorgones. I. A propos de l'orientation d'organismes marins fixés végétaux et animaux en fonction du courang. *Vie Milieu* **16**, 237–41.

Wainwright, S. A. and Dillon, J. R. (1969). On the orientation of sea fans (Genus *Gorgonia*). *Biol. Bull.* **136**, 130–9.

# 4 Methods for *in situ* subtidal hard bottom studies

*H. Christie, R. A. Evans, and O. K. Sandnes*

## Introduction

Since 1978, the project 'Structural components of sub-littoral hard bottom plant and animal communities' has been run to work out a method for ecological monitoring. Parallel studies have been made in Oslo (southern Norway) and Tromsø (northern Norway) and the results compared.

The main sampling method chosen was stereophotographic recording at fixed sites. This non-destructive method allows both qualitative and quantitative studies of the macrofauna to be made. The technique is limited to even, rocky surfaces which should ideally be vertical to avoid sediment deposition and is thus well-suited for recording the epibenthos along the Norwegian coast where such rocky surfaces are quite common. Necessarily, other sampling methods and *in situ* experiments have been used in tandem with the photography, to aid interpretation of the photographs and to provide data additional to that which could be obtained from them. The information gained from settling experiments, substratum scrapings, and cage experiments, when added to that from stereophotography, gives a comprehensive picture of natural variation, the structuring of communities, and population dynamics (Christie 1980; Sandnes and Gulliksen 1980; Svane and Lundälv 1981; Christie and Green 1982).

Stereophotography of the subtidal epibenthos was first undertaken by Lundälv (1971). The stereophotogrammetric technique is described in some detail in Torlegård and Lundälv (1974). Modifications to the system were made by Kvalvågnes, Green, and Rørslett (1976) and these are described fully in Green (1980).

### Diving equipment

All sampling was carried out by SCUBA diving. Diving conditions in Norway are extreme, with air temperatures varying from $-30\,°C$ to $+20\,°C$ and water temperatures from $+20\,°C$ to $-2\,°C$. The Viking variable volume suit and the Unisuit provided the best protection against the lower temperatures, though both the Poseidon and Divex regulators tended to freeze, and even an anti-freeze cap did not always give adequate protection against the cold. It was found that very hot water poured over the first and second stages of the regulators just before diving was a help. Full face-masks were essential when working for an extended period, while the extreme conditions also meant that all diving equipment had to be very well fitting and conscientiously maintained.

## Mounting points for field equipment

The first step in establishing a recording station was to find a suitable rocky surface with the help of charts, echo-soundings, and divers. The site was then marked by fixing plug-in bolts into holes drilled in the rock surface. All permanent equipment was fastened to these bolts. An Atlas Copco Wasp pneumatic drill, coupled to a set of air cylinders, was found the most convenient way of drilling holes. The equipment was lowered to working depth on a rope, thereby reducing the amount of equipment handling by divers on descent and ascent. A drilling system which had the compressed air supply at the surface would have saved time.

An hydraulic drill was also tested, but was found less effective for underwater use than the pneumatic drill.

Both iron expansion bolts and F-shaped nylon bolts (Fig. 4.1) were used. A hammer, for pounding in the bolts, and a wrench for tightening the expansion bolts were necessary accessory equipment.

It should be noted that if the bolts and the equipment to be mounted on them are of different metals, a galvanic field may be set up which causes corrosion of the bolts. All permanently mounted equipment should be checked each month to see that it is not in danger of falling off.

Fig. 4.1. Sketch of a fixed stereophotographic site. b, F-shaped bolts; r, aluminium reference bar mounted with plastic end-pieces on to the bolts; c, one of the 12 photographed squares (50 × 50 cm); s, settling plate hung on rope (a).

## Reference bars

Stereophotographic recordings on fixed sites need a reference system. Mobile and permanent reference bars and a reference stereophotographic frame were both used (Fig. 4.1). The mobile bar was made of U-shaped aluminium with plastic end-pieces. The end-pieces were used to mount the bar on F-shaped bolts [a more detailed account of this mobile bar system is given in Green (1980)]. The permanent bar was made of iron with pins welded in place every 20 cm for attaching equipment (e.g. stereophotographic and collecting frames or cages). Both the mobile and permanent bars were 3 m long and marked at 50 cm intervals. The bars had floats

attached to them when they were being mounted or moved to lessen the weight for the divers. If the problems of corrosion can be overcome eventually, then permanently installed bars will save diving time.

### Stereophotographic recording methods

The underwater system introduced by Lundälv (1971) was based on a Hasselblad camera. One of the two systems employed here also used a single Hasselblad SWC with a Biogen 38-mm lens fitted with a Zeiss corrective lens. Two Rollei L40 RES flash units in underwater housings provided illumination and 6 × 6 cm 220 EDP roll film was used in the camera. As only a single camera was used it was necessary to move it from one position to another on the stereophotographic frame to obtain two photographs of the same subject for stereo analysis (Fig. 4.2).

Fig. 4.2. Stereophotographic frame used in conjunction with the Hasselblad camera; c, orifices for insertion of camera; m, frame mounting point.

The second system used two Nikonos III cameras, with 15 mm UW-Nikkor lenses, which were simultaneously triggered, the triggers being connected by a small rod (Fig. 4.3). The flash unit used was a Rollei E36RE in an Ikelite underwater housing, and, the flash was coupled to an exterior light sensor which automatically controlled the flash output. Kodak photomicrographic film (16 ASA) was used at an aperture of f5.6, and Kodachrome 25 at an aperture of f8, as indicated by the automatic flash. Exposure time was $\frac{1}{30}$ s, which allowed for the film in both cameras to be correctly exposed, even though there was a short time-lag in triggering both due to the mechanical synchronizing system.

The photographic frame/camera mount used for both systems ensured that a uniform sampling area, 50 × 50 cm, was photographed at a standard distance. As an aid to determining the exact position and size of individual

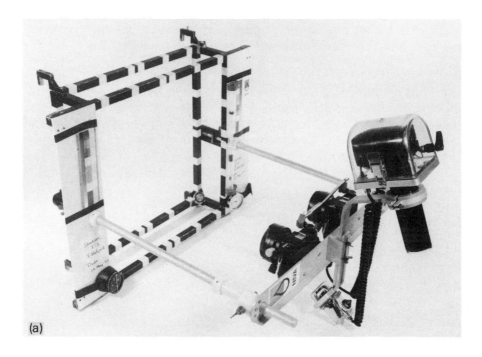

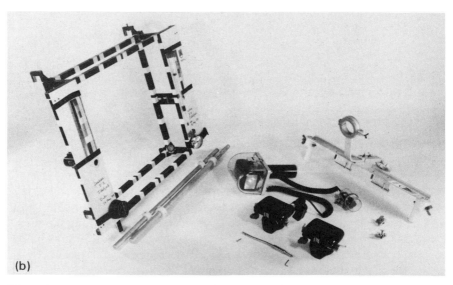

Fig. 4.3. The Nikonos III stereophotography system using two cameras, flash and sensor in underwater housings, and a photographic frame. (a) system ready for use; (b) equipment partially dismantled. (From Green 1980.)

organisms, the bottom edges of the frame were marked in centimetres. The cameras were positioned such that both the right and left cameras covered the whole sample surface, rather like two eyes. When the photographs are viewed through a stereocomparator the impression is three-dimensional. The frame could also have a variety of additional equipment attached to it, providing extra information; for example, colour scale, depth meter, thermometer, and tags made of plastic or slate with station name, depth, and date. Twelve stereophotographic recordings of 0.25 m² covering a community of 3 m² could be obtained by moving the photographic frame along the reference bar (see Fig. 4.1).

### Comparison of Hasselblad and Nikonos systems

In this project, the Hasselblad system has been in use for five years and the Nikonos for four years. The disadvantage of the Hasselblad system is that there is only one camera and the stereophotography takes longer, since the camera has to be moved from one stereo position to another and the flash needs time to recycle. It also means that vagile animals might move between the first and second exposures. Such stereophotographs are tiring to work with, and although a system with two Hasselblad cameras has been developed by Lundälv (personal communication) it is very unwieldy.

The major problem with the Nikonos system is the extra wear caused by the connecting bar between the two triggers. This sometimes leads to unexposed or half-exposed transparencies. An ideal system would include two cameras with motor drive and an electronic synchronized release in a single housing. The Nikonos system is both cheaper to build and lighter than the Hasselblad system and for these reasons alone can be recommended. Also, there are more types of film available for the Nikonos. However, the specific films already mentioned are to be recommended because of their fine grain, which is a distinct advantage when analysing slides at high magnification.

### Stereocomparator

The function of the stereocomparator is to project a pair of stereophotographs as a single three-dimensional image to aid the identification of individual organisms. The Wild micro-stereocomparator is no longer in production but it is relatively easy to produce a home-made system [for details see Green (1980)] which consists of two dissecting microscopes. The left side of the stereo-pair is viewed through the right ocular of the left microscope, and the right side is viewed through the left ocular of the right microscope (Fig. 4.4). The viewing stage of the microscopes is replaced with an elevated Plexiglas platform which allows the slides to be moved in any

Fig. 4.4. The 'homemade' stereocomparator. (From Green 1980.)

direction for accurate observation. The slides are illuminated from below. The usual magnification for analysing slides taken with the Nikonos system is ×15 – ×20 (possible up to ×40) and for Hasselblad slides ×12.

It is possible to identify organisms as small as 2–3 mm across and exact counts of individuals or estimates of abundance (per cent cover) can be made by point sampling (Bohnsack 1979; Christie 1980; Sandnes and Gulliksen 1980; Green 1980).

## Other sampling methods

### (a) *Settling plates*

Some settlement experiments were needed to provide qualitative information on the species likely to be settling on the photographed areas. Light spat settlements, for instance, were not always easy to detect on the photographs in the early stages of development. The plates comprised 10 × 10 cm ceramic tiles glued to a polyvinyl chloride (PVC) strip (Fig. 4.5). Each plate was hooked on to a rope tied to the reference bolts. The usual exposure time of the plates was two months, though this did vary according to the aim of the settling study. The plates were carried to and from the underwater recording stations in small plastic boxes.

A parallel study on recolonization was undertaken by scraping areas of

Fig. 4.5. Settling plate made from a ceramic tile (*a*), glued to a PVC strip (*b*). A hook (*c*) is used for hanging the plate on a rope.

rock clean and following up with regular stereophotographic recording of these areas.

### (b) *Collecting frames*

Initially, in order to ascertain the accuracy of the results obtained by analysis of the photographs, all the organisms living in the area photographed were collected. These were scraped off the surface (using chisels or scrapers) inside a 50 × 50 cm aluminium frame and either fell into a collecting bag hung beneath the frame (Fig. 4.6), or in some cases were removed by a suction sampler.

The frame, which was suspended from a permanent reference bar, had

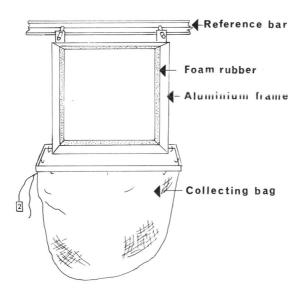

Fig. 4.6. The collecting frame with a sample bag attached to the lower edge. This bag hangs out from the frame much like an apron pocket. Note the numbering system, using pieces of plastic attached to the drawstring. The bags are drawn shut and tied before the next sample is taken.

foam rubber on its underside to provide a seal with the rock surface. The collecting bags used in conjunction with the collecting frame had a mesh size of 1.5 mm. The diver-operated suction sampler, which worked on the air-lift principle (Barnett and Hardy 1967; Hiscock and Hoare 1973), was connected to air cylinders and lowered to the working depth. The great advantage of the suction sampler over collecting bags was that it collected all the organisms, especially light ones, e.g. polychaetes or amphipods. However, when the sampler was used, large organisms or clumps of material had to be collected by hand to avoid clogging its 6 cm diameter collecting hose. The weight of the suction sampler made it difficult to handle on vertical faces and required the constant attention of an assistant diver. It was found preferable to use the suction sampler rather than collecting bags for quantitative sampling in areas where there was a strong current, and/or where the rock face was not vertical.

## Cage experiments

Predator-exclusion and controlled predator-inclusion experiments to study the effect of predators on community structure have already been used by Paine (1966), Menge (1976), and Reise (1978). Some mobile predators, for example the starfish *Asterias rubens* and the sea urchin *Strongylocentrotus* sp., were suspected of having an important effect on the benthic community structure along the Norwegian coast. Thus several different caging experiments were undertaken, and the results recorded using stereophotography.

Initial experiments used box-frame cages (covered with netting) of such a dimension ($\frac{1}{8}$ and $\frac{1}{16}$ m$^2$) that the stereophotographic recording frame could be placed over the whole cage. However, these small exclusion cages were found to be inadequate since they retained sediment that fell into them as well as the faeces of the caged predators. After much experimentation with different sizes of cage, a 65 × 65 cm cage fashioned from stainless steel netting with a 1 cm mesh was found to be the minimum size that would produce satisfactory results. A good seal was made with the uneven rock surface using foam rubber (Fig. 4.7). The dimensions of the cage were such that the photographic frame could be placed inside the cage once the lid had been removed.

An even larger box-frame cage (1 × 2 × 0.5 m) with a 1 cm mesh fishing net top was the most successful of all cages used for retaining or excluding starfish and sea urchin predators. The large dimensions of the cage meant that bolts had to be fixed at 50 cm intervals within the caged area to ensure that the photographic frame was exactly positioned for each exposure. The provision of fenced enclosures rather than cages would have made photography of the area somewhat easier. However, fencing, no matter how elaborate, did not prove an effective barrier to the passage of predators.

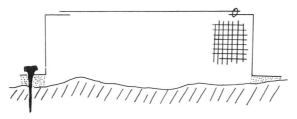

Fig. 4.7. Stainless steel (1-cm mesh) cage, 65 × 65 cm. This cage is large enough for the whole stereophotographic frame to fit inside once the cage lid is removed. One of the bolts is depicted passing through the stainless steel mesh, foam rubber, and into the rock surface.

## Dive duration

To establish a station with two photographic sites, at say 10 m and 20 m depth, normally takes two experienced divers about one day, providing there are no equipment failures. If cages or other equipment are to be set up, considerably more diving time is required. With experience, photographic recording on a station with two depths plus the setting up of a simple settling plate experiment can take as little as 15 min. If the distance between stations is not too great, three stations can be serviced in one day providing that diving operations have been carefully planned.

## Training in stereophotographic techniques

If a decision is made to use stereophotography as a sampling method, *in situ* training from an experienced operator is desirable. Approximately ten demonstration dives should be sufficient. Training in the analysis of stereo-slides requires considerable time. If photographic sites are already in use, comparison of the organisms pointed out and noted on a slate by the instructor with those seen on slides of the same area are very helpful. Five to ten dives of this nature should be included in the training. Special attention should be paid to those organisms which are camouflaged (Anomiacea), drab coloured (Bryozoa, polychaetes), or transparent (Ascidiacea). Comparing stereo-slides with material gathered by scraping also helps to sharpen observational powers. Comparison of the results obtained by the instructor and the novice when analysing the same pictures will give a good indication of progress. The training period will of course vary with the previous experience of the novice.

## Discussion

In order to use the methods described here effectively, it is necessary to ensure that the sites chosen are representative of the study area. Rocky

vertical walls are usually considered to be the most appropriate for the application of the photographic method. However, a rocky wall covered with algae is not suitable for photographic sampling when the weed canopy hides too much of the study area.

Carefully chosen sites can be used to determine the effect of a local pollutant (typical before and after study), but turbidity in polluted areas, and water depth often limit the test areas available for photographic sampling.

If an extended survey programme is intended, it is suggested that stereophotographic recording (and settling plate experiments) should be carried out monthly during the first year. Then, from the results obtained the most appropriate sampling intervals may be determined. In addition, two or three of the squares should be scraped (and the material collected) in the spring and in the autumn and recolonization of these areas followed photographically. These procedures when used in conjunction with settling plates and cages will give:

1. Information about seasonal and long-term variation of species in the photographed area.
2. A comparison of seasonal recruitment.
3. The time that a community requires to return to normal after a catastrophe (scraping).
4. Information on species interactions.

Stereophotography is a very suitable method for monitoring, since it gives the opportunity for nondestructive sampling at fixed sites, thereby providing data on temporal changes in individual species, populations, and communities.

### Acknowledgements

We would like to thank the skippers and crews of R/V Bjørn Føyn, Ottar, and Johan Ruud for their assistance in the field. Further we would like to thank cand.real. Norman Green, and diving chief Bjørnar Seim for help with the actual diving and equipment.

This project was financed by the Norwegian Marine Pollution Research and Monitoring Programme.

### References

Barnett, P. R. O. and Hardy, S. L. S. (1967). A diver-operated quantitative bottom sampler for sand macrofauna. *Helgoländer wiss. Meeresunters*. **15**, 390–8.
Bohnsack, J. A. (1979). Photographic quantitative sampling of hard-bottom benthic communities. *Bull mar. Sci*. **29**, 242–52.
Christie, H. (1980). Methods for ecological monitoring: biological interactions in a rocky subtidal community. *Helgoländer Meeresunters*. **33**, 473–83.

—— and Green, N. W. (1982). Changes in the sublittoral hard bottom benthos after a large reduction in pulp mill waste to Iddefjord, Norway/Sweden. *Neth. J. Sea Res.* **16**, 474–82.

Green, N. W. (1980). Underwater stereophotography applied in ecological monitoring. Report 1. Methods and preliminary evaluation. Norwegian Institute for Water Research. Report OF-80613, 99 pp.

Hiscock, K. and Hoare, R. (1973). A portable suction sampler for rock epibiota. *Helgoländer wiss. Meeresunters.* **25**, 35–8.

Kvalvågnes, K., Green, N., and Rørslett, B. (1976). Stereofotografering. Et hjelpemiddel i akvatisk biologi. Norwegian Institute for Water Research, NIVA, Oslo, 89–95.

Lundälv, T. (1971). Quantitative studies on rocky-bottom biocoenoses by underwater photogrammetry: A methodological study. *Thalassia jugosl.* **7**, 201–8.

Menge, B. A. (1976). Organisation of the New England rocky intertidal community: role of predation, competition, and environmental heterogeneity. *Ecol. Monogr.* **46**, 355–93.

Paine, R. T. (1966). Food web complexity and species diversity. *Am. Nat.* **100**, 65–75.

Reise, K. (1978). Experiments on epibenthic predation in the Wadden Sea. *Helgoländer wiss. Meeresunters.* **31**, 55–101.

Sandnes, O. K. and Gulliksen, B. (1980). Monitoring and manipulation of a sublittoral hard bottom biocoenosis in Balsfjord, northern Norway. *Helgoländer Meeresunters.* **33**, 467–72.

Torlegård, A. I. and Lundälv, T. L. (1974). Underwater analytical system. *Photogramm. Engng* **40**, 287–93.

# 5 A simple device for simultaneously focusing and determining field size in underwater photography

*G. W. N. M. van Moorsel*

## Introduction

Many underwater photographers, both amateur and professional, use cameras from the Nikonos series. One of the main reasons for the popularity of these compact cameras is the ease with which they can be handled. However, since they are not reflex cameras, field size and subject distance have to be estimated. A number of devices to overcome one, or both, of these problems are available. For determining field size, sportsfinders or accessory optical viewfinders, some with parallax correction, can be mounted on top of the camera. In close-up and macro-photography the depth of field is drastically reduced and special focusing devices such as focusing rods and chains are often used. A combination of focusing rod and framer eliminates both problems of determining field size and focusing but does introduce some new difficulties: (1) the small camera is turned into a more bulky apparatus; (2) moving animals such as fishes are easily scared away, and sessile organisms such as tube worms and tunicates often retract; (3) the framer itself may prevent certain photographs being taken because it does not fit into crevices and can be difficult to manipulate on soft substrata when taking photographs horizontally; (4) a flash unit that is being used in conjunction with the camera may cast shadows and/or reflections of the framer into the picture area.

If the photographer is using a housed SLR camera with a focusing screen the difficulties described above do not occur, but another problem arises. The low light levels encountered underwater can prevent the use of focusing screens and, as with non-SLR cameras, accessory sportsfinders or framers have to be used, or a 'pilot lamp' if it does not disturb the subject.

In order to overcome these problems a device is described here which allows simultaneous focusing and field-size determination at a short prefixed distance. The technique will be described for a Nikonos camera but can be adapted for other underwater cameras and housings. The device has proved reliable over the past five years when it has been used in combination with a Nikonos camera and a close-up lens. It is based on binocular viewing and is therefore not suitable for photographers without binocular vision. Two of the factors that dictate the size of the device are the inter-pupil distance ($P_D$) and the type of face-mask used. It is, therefore, constructed for an individual and cannot easily be used by other diver-photographers. If the device is mounted on top of an accessory close-up lens it is automatically removed if

the accessory lens is not used. The device is easy to construct and should be made from lightweight material such as PVC or aluminium.

## Operation of the device

When focusing on an object with both eyes, a second object placed in the same direction but at a different distance is seen as a double image. Usually one is not aware of this phenomenon, but a simple demonstration shows that the visual field contains many double images. If you hold a pencil vertically at a distance of 20 cm directly in front of your nose and look at infinity, you will see 'two pencils'. If you then focus at distances closer to the pencil you will notice that the two pencils approach each other until they overlap when your eyes are focused at a distance of 20 cm.

The device introduced here consists of a rectangular plate mounted above the camera lens/close-up lens combination. A rod is attached to the centre of the plate in a perpendicular position pointing backwards towards the photographer (Fig. 5.1(a)). The rod is aligned so that it touches the face-mask glass at a centre point between the photographer's eyes (Fig. 5.1b). An imagined extension of the rod would pass through the centre of the field of view when the camera is at the pre-determined distance. The size of the rod and plate are chosen in such a way that the two 'apparent' plates just touch when your eyes are focused on the object at the correct distance. At this distance, the outline of the two touching plates coincides with the picture area contour, though due to perspective distortion some deviation occurs at the corners (Fig. 5.2a). If one focuses on a point beyond the one dictated by the lens combination, a gap will be noticed between the 'two plates' (Fig. 5.2b). If one looks nearer than the dictated distance 'the plates' will overlap and the centre of the subject cannot be seen (Fig. 5.2c). This is due to the fact that at the correct distance the right half of the subject field is invisible to the left eye whilst the left part is invisible to the right eye. If one focuses too far away the centre part of the subject is seen by both eyes and if one focuses too closely it is invisible to both eyes.

Some practice is necessary in using the device in order that concentration is maintained on the subject. Rotating the device slightly during focusing will probably aid concentration.

### Determination of the dimensions of the device in close-up photography

The plate of the device is mounted above the close-up lens at the same distance $y$ from the centre $C$ of the subject field as the optical centre of the camera lens/close-up lens combination is from $C$ (Fig. 5.3). If one wishes, another distance between the plate of the device and $C$ may be chosen, but in that case some of the following equations become more complicated.

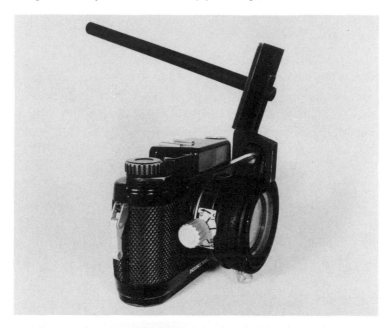

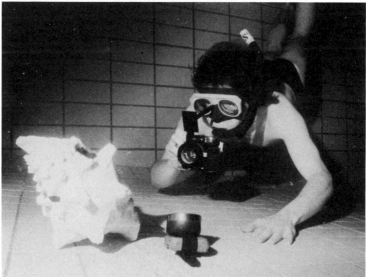

Fig. 5.1.(a) Device mentioned in text, consisting of a rod and rectangular plate mounted on a close-up lens. (b) Underwater photographer using device in order to determine the picture area and the distance prescribed by the camera lens/close-up lens combination.

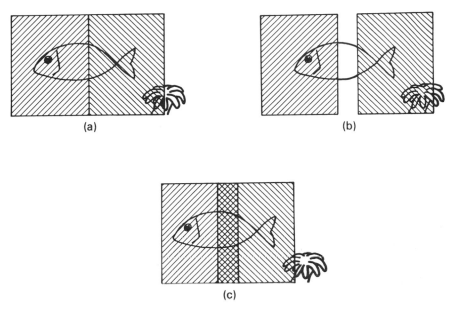

Fig. 5.2. View of subject 'through' device at correct distance (a), too far away (b), too close (c). Part of the subject field which is invisible to the right eye is hatched diagonally from bottom left to top right. Part of the subject field which is invisible to the left eye is hatched diagonally from bottom right to top left. In (b) the centre part of the subject field can be seen with both eyes. In (c) the centre part of the subject field (cross-hatched) is invisible to both eyes.

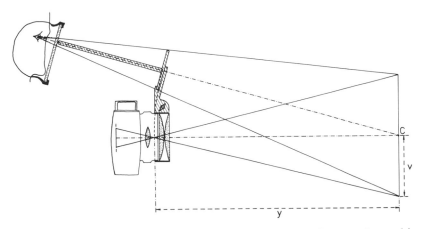

Fig. 5.3. Vertical section through optical axis of camera lens. Observer views subject field 'through' the device (hatched). C, centre of the subject field. For $v$ and $y$, see explanation in text.

If the camera lens is set at infinity and the close-up lens has a dioptre power in air of $D$,

$$y = 1.335 \, D^{-1} \tag{1}$$

in water, provided that the close-up lens does not lose dioptre power due to convex glass–water contacts.

Let us observe the light rays coming from the subject which refract at the water–glass–air surface and converge in the eyes of the photographer. In Fig. 5.4 these light rays are approximately straightened by positioning the eyes at a distance from the front of the face-mask glass of 1.335 times the real distance $e$ from the eyes to the inner side of the face-mask glass. Therefore, in Fig. 5.4 the distance $b$, between the front of the face-mask glass and the apparent eyes can be formulated as

$$b = 1.335e. \tag{2}$$

The remaining distance $a$ between the plate of the device and the face-mask glass, which is the length of the rod, can be determined if the pupil distance $P_D$ and the width of the field is known. This width depends on the horizontal lens angle ($_h$) used. Half of the horizontal field size ($w$) is given by

$$w = D^{-1} \, \text{tg} \, \tfrac{1}{2}\alpha_h. \tag{3}$$

  (tg = tangent)

The horizontal lens angle is the value in air and it is assumed that it is not changed by the use of the close-up lens.

From Fig. 5.4 it can be seen that $c$, which equals $a + b$, can be determined since

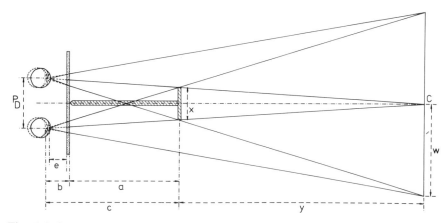

Fig. 5.4. Section perpendicular to section in Fig. 5.3, through eyes of the observer (left) and centre $C$ of the subject field. The device is hatched. For $w, y, a, b, c$, and $e$, see explanation in text.

$$\frac{c}{P_D} = \frac{y}{w}. \tag{4}$$

Substituting (1) and (3) eliminates $D$ and gives

$$c = 1.335 \ P_D \ \text{cotg} \ \tfrac{1}{2}\alpha_h. \tag{5}$$

(cotg = cotangent)

Therefore the length of the rod is

$$a = c - b = 1.335 \ (P_D \ \text{cotg} \ \tfrac{1}{2}\alpha_h. - e). \tag{6}$$

The width of the device's plate $x$ can also be determined from Fig. 5.4:

$$\frac{x}{c} = \frac{w}{y + c}. \tag{7}$$

Substituting (1), (3), and (5) in (7) leads to

$$x = P_D \ (1 + D \ P_D \ \text{cotg} \ \tfrac{1}{2}\alpha_h)^{-1} \tag{8}$$

If working with 35-mm film format, the horizontal side is 50 per cent wider than the height of the picture area. The height of the plate of the device can therefore be expected to be 2/3 times $2x = 4/3x$. Due to the inclination of the device, however, the upper part of the plate is somewhat closer to the corresponding part of the subject field in comparison with the lower part, depending on the distance $h$ between the centre of the plate of the device and the optical axis of the camera lens. Therefore a correction must be made.

In Fig. 5.5, the height of the upper part of the plate $(k_1)$ can be determined from

$$\frac{k_1}{k'_1} = \frac{c}{c + y - z_1}, \tag{9}$$

$k'_1 \ (= k'_2) = v \sin \beta - v \ y^{-1} \ (y^2 - h^2)^{\frac{1}{2}}$, $v$ is half of the vertical length of the subject field ($v = D^{-1} \ \text{tg} \ \tfrac{1}{2}\alpha_v$ or 2/3 $w$ if working with 35-mm film), $z_1 \ (= z_2) = v \cos \beta = v \ h \ y^{-1}$,

therefore

$$k_1 = c \ v \ (y^2 - h^2)^{\frac{1}{2}} \ (c \ y + y^2 - v \ h)^{-1}, \tag{10}$$

likewise

$$k_2 = c \ = c \ v \ (y^2 - h^2)^{\frac{1}{2}} \ (c \ y + y^2 + v \ h)^{-1}. \tag{11}$$

If one does not wish to use goniometric formulae it is also possible to determine the dimensions of the device from large-scale drawings only. It is recommended, however, that both methods are used.

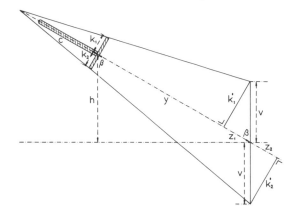

Fig. 5.5. Vertical section (as in Fig. 5.3) used to determine height of the plate of the device $(k_1 + k_2)$. $h$, distance between device (hatched) and optical axis of the camera lens. For $v$, $y$, $c$, $k_1$, $k_2$, $k'_1 k'_2$, $z_1$, $z_2$, and $\beta$, see explanation in text.

*Example 1.  Close-up photography* (all distances in millimetres).

My Nikonos camera has a 35-mm lens which has a horizontal angle of 53° in air (Roberts 1977). My $P_D$ is 68 mm and $e \approx 25$ mm; so the length of the rod must be

$$a = 1.335 \ (68 \ \text{cotg} \ 26.5° - 25) = 149 \ \text{mm}. \tag{6}$$

I work with a +4 (air) dioptre lens (m$^{-1}$), so the width of the plate is

$$x = 68 \ (1 + D \ 68 \ \text{cotg} \ 26.5°)^{-1} = 44 \ \text{mm}. \tag{8}$$

The height of the upper part of the plate $(k_1)$ can be determined if $v, h, y$, and $c$ are known.

$v = 2/3 \ w = 2/3 \ D^{-1} \ \text{tg} \ 26.5° = 83$ mm,
$h$ is chosen at 90 mm,
$y = 1.335 \ D^{-1} = 334$ mm,                                                           (1)
$c = 1.335 \ P_D \ \text{cotg} \ 26.5° = 182$ mm,                                          (5)
therefore $k_1 = 29.5$ and $k_2 = 27.0$ mm.                              (10) and (11)

Using the same set of formulae devices for other camera lenses, close-up lenses, or other film formats can be constructed.

*Example 2.  Macro photography*
A Nikonos camera is fitted with a 1:1 extension tube. The field size is $36 \times 24$ mm. Let us assume that the underwater distance between camera lens and subject is provided by the manufacturer or determined, for example,

by means of a Roberts Lens focuser (Roberts 1977). So we know the location of $C$ (cf. Fig. 5.3).

If we choose a distance $y$ of 70 mm between $C$ and the plate of the device, the length of the rod $a$ can be determined from

$$\frac{c}{P_D} = \frac{y}{w},\tag{4}$$

$$a = c - b \text{ and } b = 1.335e,\tag{2}$$

or $a = \dfrac{yP_D}{w} - 1.335\,e = \dfrac{70 \times 68}{\frac{1}{2} \times 36} - 1.335 \times 25 = 231\,\text{mm}$,   using   the

values of $P_D$ and $e$ from Example 1.

The width of the plate $x$ can be determined from

$$\frac{x}{c} = \frac{w}{y + c},\tag{7}$$

or $$x = \frac{c\ w}{y + c} = \frac{264 \times 18}{70 + 264} = 14.2\,\text{mm}.$$

where $c$ is calculated from (4).

If $h$ is chosen at 45 mm, $k_1$ and $k_2$ are determined from (10) and (11): $k_1 = 7.4\,\text{mm}$ and $k_2 = 7.1\,\text{mm}$.

## Conclusion

The device for focusing and determining field size is small, cheap, easy to construct, and especially useful if viewing through a focusing screen is not possible as with the Nikonos camera. It does not disturb living subjects because focusing rods and framers are omitted.

## Acknowledgement
The suggestions of F. T. G. van de Linde, Ir. R. Rozendaal, and Dr S. Weinberg, who critically read an earlier version of the manuscript, are gratefully acknowledged.

## Reference
Roberts, F. M. (1977). *Nikonos photography—the camera and system*. Aqua-craft Inc., San Diego, California.

# 6 Diving and underwater photographic techniques in the Antarctic

*D. Allan*

## Introduction

From its headquarters in Cambridge, England, the British Antarctic Survey maintains four research stations in British Antarctic Territory (that sector south of 60° S latitude, bounded by 20° W and 80° W longitude). Their principal station for biological studies is on Signy Island in the South Orkney Islands (60° 43' S, 45° 36' W), where for the past twenty years SCUBA diving has been an important technique used to conduct many programmes investigating aspects of the nearshore ecology and onshore limnology.

During 1976, 1979, and 1980, three winters were spent on Signy as the station diving officer. Much attention, particularly in the latter two years, was directed to underwater photography. The Survey were interested both in 'general interest' photographs of divers working, and in records of the underwater flora and fauna, which in many cases are unique to the south polar seas. This brief account describes the diving practices and the photographic techniques and problems encountered whilst carrying out the work.

## Diving practices

The diving year splits cleanly into two periods—operating in open water over summer, and under ice during the winter. From about November to April, when the sea is largely ice-free, diving is either from the shore or from small boats. A 5 m R.F.D. inflatable or 4 m Dell Quay Dory powered by 40 hp Evinrude outboards were used extensively. The station also has a diesel-engined 7 m launch which is taken as extra safety back-up if divers are venturing away from the immediate vicinity of the research station. The maximum summer water temperature of +0.5 °C is usually reached during January or February; air temperatures vary from −10 °C to +10 °C.

There may be some surprise at the selection of wetsuits rather than drysuits for thermal protection, but the former have proved to be much more suitable. Diving programmes at Signy are carried out using short immersion times, no regular diving exceeds 10 m. Dives are organized so that no decompression is required and because the scientists may not have extensive diving experience, the divers are closely supervised by the Diving Officer. To train field scientists to use drysuits and expect them to dive efficiently with them would be much more difficult and seems unnecessary.

The Survey have adapted the use of a wetsuit, evolved through previous years' experience.

The neoprene suits are basically 10-mm-thick unlined longjohns under a 10-mm zipless jacket with integral hood. Non-lined rubber has two advantages; it retains full stretch so made to measure suits can be very close fitting, and there is no 'capillary creep' of water up the inside of the material. Seams are not sewn, merely butt glued and taped both sides, again restricting ingress of water. For the feet, there are 10-mm boots with high ankle overlaps, for the hands, 6-mm mitts with all fingers enclosed and only the thumb stuck out on its own. Using these suits, comfortable dive durations of 45 min at approximately 8 m depth are easily possible.

Over April and May, autumn slips towards winter. The winds back to become predominantly southerly, bringing up icebergs and pack ice from

Fig. 6.1. Dive hole formed by cutting out two blocks of ice with a chain-saw.

the Weddell Sea. Air temperatures sink into the minus twenties, the water cools to $-1.8\,°C$, and on calm nights, the first trace of grease-ice forms over the cove. A succession of such nights in conjunction with windless days allows the grease to thicken through 'porridge' and pancake ice to consolidate into winter fast-ice. At this stage skidoos and sledges can be safely taken on to the ice and Signy's divers can start winter diving.

In the early winter, dive holes may be cut using an axe. However, once the ice attains a thickness of over about 30 cm a chain-saw is quicker. Two parallel cuts in one direction and three overlapping these at right angles produce two free floating blocks which can be easily pushed down and to one side, where they refreeze to the underside of the ice (Fig. 6.1).

With air temperatures as low as $-30\,°C$, or even effectively colder with the wind chill factor taken into account, it is the routine procedures on the surface, before and after the dive, which become crucial for the diver's comfort. At the research station, the sledge is loaded with any extra equipment before the divers don wetsuits and equipment. They step out warm, fully kitted up, virtually ready to enter the water. Afterwards, when the divers have completed their work, they are driven straight back for a hot bath. Although divers definitely did feel subjectively quite cold at times, especially in their hands and feet, core temperature measurements indicated that they never approached risk of hypothermia.

While under water, divers worked on a safety line, with a simplified set of signals to the attendant at the surface.

### Underwater camera systems

During three winters in the Antarctic, several different underwater camera systems were observed in operation. Self-contained Nikonos cameras were the most popular. There were also housed systems such as the Olympus OM 1 in a Perspex Aquasnap housing, and latterly a Nikon F2 in an Oceanics Hydro 235 alloy housing fitted with a dome port, behind which either the 24-mm or 55-mm macro lens was used (Fig. 6.2). As a source of illumination some divers used 'topside' Mecablitz or Sunpak electronic flashguns, in Perspex housings, while others preferred specialist equipment such as the Oceanics 2003 and Subsea Mark 150. Standard screw-in Nikonos connectors were used as well as some EO couplings. For cine photography, a Eumig Nautica Super 8 camera proved suitable even without accessory lights.

### Low-temperature effects

Hardly surprisingly, most photographic problems resulted simply from the cold. Perhaps less obviously, it was the very low air temperatures in which gear dramatically cooled which produced more difficulties than the $-1.8\,°C$

Fig. 6.2. Diver swimming alongside an iceberg and carrying a Nikon F2 camera in an Oceanics housing with a Subsea Mk 150 strobe (Photograph by P. Drummond.)

temperature of the water dived in. The inconveniences encountered once under water were more the minor irritations a photographer could expect to meet off British shores—for example, handling the focus and aperture controls of a Nikonos whilst wearing mitts.

At air temperatures down to −10 °C, there were few difficulties. Prolonged cooling of the camera, especially if it was also windy, could result in stiffening of the lens focus control between −10 °C and −20 °C. This was not too noticeable in the more sophisticated cameras such as the Nikon, Olympus, or Minolta, whose lenses come lubricated as a matter of course with comparatively low-temperature grease, but controls on older Praktica, Zenith, and Vivitar models would stiffen up appreciably. As the camera cooled, so also did the film and this increased the likelihood of it snapping or at least tearing at the perforations. Some Ektachrome 64 proved unusable, for if exposed at −25 °C or below, minute lines were visible after development, running vertically between each perforation hole, where the emulsion had cracked as it was wound on to the take-up spool. Further use of this type of film may show this fault to be due to the storage conditions or to batch inconsistencies rather than it being a normal characteristic of Ektachrome 64 at very low temperatures. Ektachrome 200 and 400, which have thinner emulsions, were not a problem.

Ektachrome 64 and 200 were by far the most popular for underwater photography. These could be processed at the research station without difficulty and so gave that all-important confirmation of results to the photographer. It was rather too long to wait up to a year for process-paid films to be returned from processors in Europe.

Once a camera was immersed, it had to stay under water until the end of the dive, or at least until no longer required. Exposing it to air at $-20\,°C$ or below would coat it with mushy ice, jamming the controls and giving the ultimate soft-focus to the lens port. Diving in fresh water presented more difficulties because the water coating the camera could freeze rock-hard in seconds, and with the lake or the sea at their respective freezing points under the ice, there was no means of melting ice so formed.

The cold also affected battery life in flashguns. A new set would last the duration of a dive, but their useful life was reduced markedly when compared with normal use in warmer waters. However, since most flash-guns were equipped with nickel-cadmium batteries which could be recharged before each dive, this problem was overcome. In the Eumig Nautica, two fully-charged AA batteries would power three minutes of cine film before recharging was necessary.

Cold dry gear, such as cameras or flashes inside the housings, would instantly become covered in condensation when brought back inside the base. To minimize this, and to avoid danger of cracking lens elements through too rapid heating, camera equipment was slowly warmed to room temperature.

Although it was feared that Perspex housings would become more brittle, and hence more likely to be damaged, under conditions of extreme cold, no evidence of this was forthcoming. One housing did suffer a crack, but this was probably the natural consequence of being dropped from a sledge at 25 mph on to hard ice. The risk of damage was not over once the dive site had been reached. On surfacing at a breathing hole being used by Crabeater seals on one occasion, divers watched 350 kg of aggressive seal lunge towards them straight over an Oceanics housing, squeezing it virtually half its depth into the slushy ice. It was pulled out of the ice undamaged—an impressive example of its durability.

**Fauna**

The diverse and extensive benthic communities found in the Antarctic offer considerable potential for underwater photography (Allan 1978). On the vertical faces and overhangs, where the effects of ice scour were minimal, the slower growing sessile and encrusting invertebrates had a chance to develop, and these niches were as colourful as on any coral reef (Fig. 6.3). Soft corals, anemones, bryozoans, brachiopods, and sponges grew in

Fig. 6.3. Diver investigating an overhang with sponges, soft corals, and anemones much in evidence.

Fig. 6.4. A giant isopod, *Glyptonotus antarcticus* (12 cm long), crawling along the sea-bed.

Fig. 6.5. A 30-cm-long inshore fish, *Notothenia gibberifrons* on the sea-bed.

Fig. 6.6. A pycnogonid sea spider with a span of 25 cm across the limbs.

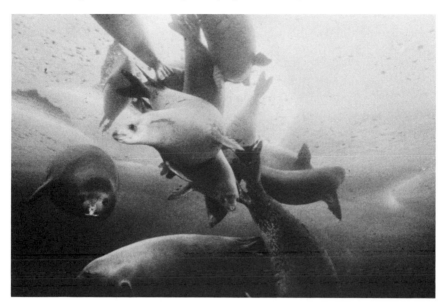

Fig. 6.7 Crabeater seals, *Lobodon carcinophagus*, under the ice.

Fig. 6.8. A Weddell seal, *Leptonychotes weddelli*, under the ice.

profusion, urchins, holothurians, and nudibranchs crawled in turn over them. On the weed curtains hanging down in front of the cliffs, tiny pinkish brown *Antarcturus* isopods clung in lines of a dozen or more (Plate 1b). Out on the open expanses of sea-bed, turning over the broad fronds of weed revealed many uniquely Antarctic animals: the giant isopod, *Glyptonotus antarcticus*, up to 17 cm long, crawling along head down, scavenging for food (Fig. 6.4); various species of *Notothenia* fish (Fig. 6.5) and, in deeper water, giant pycnogonids, with their spectacular 25-cm span, striding over the sea-floor (Fig. 6.6).

At different times of the year, encounters occurred with most of the Antarctic seal species. Crabeater seals (*Lobodon carcinophagus*) gathered in hundreds during July (Fig. 6.7), Weddell seals (*Leptonychotes weddelli*) appeared a little later when they returned to breed on the fast-ice of the coves and bays (Fig. 6.8). Elephant seals, Leopard seals and Fur seals were all encountered in the water during the summer after the sea-ice had broken out.

**Reference**

Allan, D. (1978). Beneath Antarctic waters. *Wildlife* **20**, 362–7.

# 7 *In situ* photography of gelatinous zooplankton
## L. P. Madin

## Introduction

During the last twelve years, the use of SCUBA diving has led to new approaches to the study of planktonic animals in the ocean (Hamner, Madin, Alldredge, Gilmer, and Hamner, P. 1975; Harbison and Madin 1979; Madin and Swanberg 1984). The ability to make direct visual observations and immediate manipulations of pelagic organisms in their environment has allowed biological oceanographers to study morphology and behaviour of animals that had previously been known mainly as the dead catch in plankton nets. An early discovery of this *in situ* approach was that the plankton includes a great many fragile, gelatinous animals that are greatly damaged or not caught at all by plankton nets, and were consequently rare or unknown to plankton scientists. Although visible to divers and usually collectable in jars, organisms like ctenophores, siphonophores, doliolids, and some medusae are often so delicate or so extended that they can never regain their natural shapes or postures in an aquarium. Only undisturbed *in situ* can the true functional morphology of these animals be appreciated, and only by *in situ* photography can this morphology be recorded for more detailed study. Thus, photographic methods are especially important to the study of systematics, morphology, and behaviour of a large and varied group of soft-bodied organisms whose importance in the world's oceans is becoming increasingly apparent.

Taxonomically, these gelatinous organisms include some radiolarians hydromedusae, scyphomedusae, siphonophores, ctenophores, some pteropods and heteropods, some polychaetes, pelagic tunicates, and many larval forms. Gelatinous zooplankton can also be defined as those animals whose bodies are made up of at least 95 per cent water. In consequence, the animals are generally fragile, large in volume for a given organic weight, neutrally buoyant or nearly so, and virtually transparent (Hamner *et al.* 1975). Fragility and large size make them difficult to collect or culture, while the transparency and large size can make them difficult to photograph. In coastal waters, transparent animals are difficult to see because of the turbidity of the water and even more difficult to photograph satisfactorily because of backscatter and obscuring by the suspended particulate matter. In clear oceanic waters, transparent animals are easier to see but still present very low contrast relative to the background because of the uniform intensity of the ambient downwelling light. In some instances, satisfactory photographs can be taken of an animal from below, back-lit from the

surface, but usually electronic flash is necessary to provide sufficient image contrast. The size of some gelatinous animals, especially medusae, ctenophores, siphonophores with extended tentacles or long colonial chains of pelagic tunicates can make their even illumination by artificial light difficult.

Diver-operated equipment for plankton photography is still fairly simple. Photographic systems for submersibles or remote operation have the same basic problems to overcome in imaging transparent animals, but are necessarily more complex in their design and operation. In this paper, I will consider the problems associated with *in situ* photography of gelatinous zooplankton both by divers and from submersibles, the kinds of equipment and techniques which are being applied, and the sorts of future improvements and developments which would be most valuable.

## Equipment and methods

### (a) *Diver-operated cameras*

Most gelatinous zooplankters fall into a size range from 1 to 20 cm, although colonies of radiolarians and doliolids may attain a length of a metre or more, and some siphonophores and salp chains may be tens of metres long. For most animals, then, a camera with a close-up lens or extension tubes providing a field size 10 to 20 cm in width is suitable. Organisms smaller than 1 cm are usually visible to divers, but require close-up accessories of higher magnification, yielding a field width of about 2–5 cm. The very large organisms can usually be photographed with a normal or wide-angle lens.

Almost any diver-operated underwater camera or housing is suitable for plankton photography if it can be equipped with the necessary close-up attachments. I have used the Nikonos II and IV-A fitted with extension tubes or close-up lenses, providing 1:3 magnification, and also a Nikon F2 fitted with the 55-mm Micro-Nikkor and housed in an Ikelite moulded plastic housing (Fig. 7.1). The advantage of the Nikonos is its compact size, an important consideration when photography is not the sole activity of the diver, and the camera must sometimes be left dangling while animals are collected or observations made. When equipped with an extension tube, the Nikonos can only be used for animals of a certain size. If a close-up lens is used instead, it can be removed underwater to accommodate larger subjects. As long as the close-up lens or extension tube has a framing device, there is no need to use an optical viewfinder with the Nikonos; it is easier to position the frame around the subject while watching from the side or above.

The single lens reflex with macro lens has the advantage of being able to focus on subjects within a larger range of sizes and distances. However, use of the reflex finder, even when fitted with a large aperture eyepiece such as

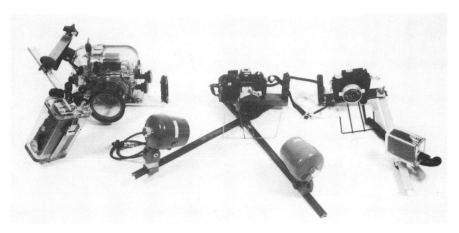

Fig. 7.1. Cameras used for plankton photography. From left: Nikon F-2 in Ikelite housing with Vivitar flash in Ikelite housing; Nikonos IV-A with two Oceanic 2000 flashes; Nikonos II with Vivitar flash in custom housing.

the Nikon Sportsfinder, is very difficult with planktonic animals. Keeping a small transparent object in view long enough to focus and photograph when subject, camera, and diver are all moving independently is totally impractical. It is usually necessary to use some kind of framing device even with SLR cameras. Disadvantages of the housed SLR include its greater bulk and more complicated operation, both of which make it difficult for a diver to do anything else but hold the camera.

On the whole, the most satisfactory camera for *in situ* photography of gelatinous plankton is probably a Nikonos equipped with a high-quality close-up lens and framer which can be removed under water. As with all equipment used in open water, the camera and all of its removable parts should have safety lines, to prevent their loss if dropped. It is also convenient to have a handle arrangement that allows the camera to be held and operated with one hand, leaving the other free to manipulate the subject.

Artificial lighting is essential to provide enough contrast for animals to be seen against the uniformly illuminated background. Since the animals are largely transparent, they must be illuminated from the side or slightly from the back, so that light is scattered from their body into the lens. This dark field illumination provides excellent contrast, edge definition and colour rendition of most subjects. The background becomes black, and back-scatter from particles between the lens and subject is eliminated. The simplest way to achieve this back-lighting is to mount one or two electronic flash units on arms long enough that they can be placed slightly behind the framer on one or both sides. An angle of about 60° between the axis of the flash and the optical axis is generally satisfactory. Two flash units will

provide more even illumination and allow use of smaller apertures; the second flash can be triggered by a photocell from the first flash. Depending on the size and reflector design of the flash units, it is sometimes desirable to fit them with hoods to minimize flare from stray light. A slight drawback to the hoods is that the subject animal is likely to get stuck in them during the course of manoeuvring it into the framer. For photography at night, an underwater torch can be mounted on a strobe and used as a modelling light.

Even small flash units provide enough light, when set up in this way, to allow the use of small f-stops with fairly slow film (e.g., *f*16 with Koda-chrome 25). The resulting depth of field and resolution usually produces a sharp image of the whole organism.

Once the camera is set up with close-up device, focusing framer and strobe(s) mounted for back-lighting, and apertures have been determined from test exposures, photography of animals that fit in the frame is a very simple procedure. A diver need only swim up to the subject, position it in the frame and release the shutter. If the animal is more or less optically dense than most, or of special importance, exposures should be bracketed. Larger subjects are more difficult, even if a removable close-up attachment allows them to be focused properly, because it is hard to provide even back-lighting for a subject several feet away from the camera. If the flash units can be removed and have sufficiently long cords, a second diver can position them beside or slightly behind the subject, while trying to stay out of the picture area. Small strobes may not have sufficient light output or a large enough angle of coverage to illuminate large animals. If the flash units cannot be separated from the camera mount, the only option for large subjects is to illuminate from the front, or use ambient light. The latter can be satisfactory for dense or partly pigmented animals, especially if they are photographed from below against the surface light or against a dark background (Fig. 7.2). If large animals are the specific subjects of investigation, the best approach would require two additional divers with high-powered, wide-angle flashes which can be positioned near the subject and triggered as slaves from a small flash mounted at the camera. An optical finder on the camera would be necessary for subjects at these distances.

The combination of back-lighting, close-up lenses, and small apertures goes a long way toward providing sharp, high-resolution photographs of transparent animals in the 1–20 cm size range. In some cases, visualization of a structure or an activity is enhanced by injecting coloured dyes or particulate suspensions into or around the subject. Currents of water produced by the swimming motions of medusae, siphonophores, salps, and larvaceans can be easily photographed by introducing a fluorescent dye into the water ahead of the animal so that it is entrained into the currents (Pl. 2a). Uranine dye is readily soluble in seawater and produces a brilliant yellow-

Fig. 7.2. Chain of the salp *Salpa maxima* about 10 m in length. Photographed by ambient light.

green colour which contrasts well with organisms and the dark seawater background. Suspensions of coloured particles, such as carmine, are effective in making visible filtering structures of animals such as salps and larvaceans. These organisms produce fine meshes of mucus to trap food particles from currents of water. The filter meshes are nearly invisible until the coloured particles are introduced, but can be photographed with striking contrast once stained. The combination of soluble and particulate dye in one injection can make water currents and filters visible simultaneously (Plate 2b).

Cinematography is a very useful tool for the study of locomotion of planktonic animals or processes like filtering, setting tentacles, responding to predators, etc. *In situ* motion pictures of gelatinous animals require a set-up similar to that for still photography, but with a movie camera and tungsten lights. The camera may be equipped with a close-up lens, although most 10-mm lenses used with 16-mm cameras under water will focus close enough to not require supplementary devices. I have used a Kodak K100 camera in a plastic housing and a Bolex Rex 5 in a Paillard housing, both equipped with a 10-mm Switar lens. Instead of strobes, tungsten reflector photofloods are used. These may be commercial underwater movie lights with self-contained batteries, or simply sealed-beam lamps with wires leading to a separate battery pack or to a power source on the surface. The available 6-V reflector lamps provide barely enough light for adequate subject contrast. Better results have been obtained with 120-V lamps supplied by a cable from a surface generator, although this arrangement is

logistically more difficult and can hamper the mobility of the diver. The movie lights are arranged to provide dark-field lighting just as the strobes would be.

## (b) *Submersible and remote cameras*

Photography of gelatinous zooplankton from submersibles or by remotely-operated cameras has the same requirements for optics and lighting as diver-operated cameras. Remote and submersible systems usually lack the capacity for precise manoeuvring and approach to the subject which a diver has, but of course can operate well below SCUBA range. Two submersibles, *Alvin* and *Johnson Sea-Link* have been used so far for the study of gelatinous plankton at midwater depths. The *Alvin* is equipped with a pair of externally mounted cameras above the pilot's window with a single large strobe adjacent to them. There are also strobes mounted above each of the two observers' ports on the sides which can be synchronized with hand-held cameras used for photography through the ports. The lights and cameras are primarily intended for photography of solid objects on the ocean floor, and are not well suited to midwater plankton work. During our use of the *Alvin* (Madin and Harbison 1978; unpublished observation), we altered the position of the strobe lights to approximate side-lighting. The main strobe at the front of the submarine was moved to the sample basket and aimed upwards so as to illuminate from below a volume of water in front of the external cameras. Strobes over the side port were moved further out on their mounts and rotated to illuminate from above a volume immediately outside each port. Sequential photographs from the outside-mounted cameras during descent provided data on the distribution of some of the animals seen (Madin and Harbison 1978), while photographing through the ports usually yielded the best portraits of individual animals (Fig. 7.3).

The *Johnson Sea-Link* incorporates an acrylic pressure sphere, permitting nearly 180° visibility, and is inherently better suited to the observation of midwater organisms. A suite of collecting devices and a camera system has been specifically designed for the study of midwater plankton with the *Sea-Link* (Youngbluth 1984). The camera used is a 70-mm Hasselblad with electric drive, mounted in a pressure housing. It is mounted on a semi-circular support with four electronic flashes surrounding the field of view. Side lighting for transparent animals is thus provided from all directions, and very even illumination of the field results. The large format of the film and the quality of the optics produce photographs with excellent sharpness and resolution. Organisms are brought into the field by manoeuvring the entire submersible, a relatively easy task because of the excellent visibility.

Remotely-operated cameras are far cheaper and more flexible to operate, but obviously are fairly unselective about what they photograph. Two systems have been described for photography of midwater animals (Breslau,

Fig. 7.3. A mesopelagic narcomedusa, *Solmissus incisa* photographed with a hand-held camera through the viewing port of DSRV *Alvin*. Diameter of the bell is about 15 cm.

Clarke, and Edgerton 1967). One is triggered by flashes of light from luminescent organisms. Termed the 'luminescence camera', it provides side-lighting and has produced good photographs of medusae and siphonophores. The other camera system is triggered when an animal swims through a small beam of light. This model incorporated frontal lighting. Neither of these systems has been much used recently.

A remotely operated camera which takes sequential silhouette photographs of plankton passing through a chamber has been developed to replace the cod end of a plankton net (Ortner, Hill, and Edgerton 1981). The device, which is now commercially available, records the presence of delicate organisms that would not survive preservation. It also provides a photographic record of patchiness of the plankton comparable to that obtained with the Longhurst–Hardy Plankton Recorder, but without the damage to specimens produced by that sampler.

Camera systems to record the presence and abundance of large and relatively sparse gelatinous animals must either concentrate the plankton first with a net, or properly illuminate and photograph a sufficiently large volume of water that sparse organisms will be recorded. A camera system using the latter approach has been developed at the Woods Hole Oceano-

graphic Institution for recording the vertical distribution of marine snow (detrital aggregations) (Honjo, Doherty, Agrawal, and Asper 1984). It can make a series of exposures of a large field which is illuminated from the side by collimated strobe lights, and produces excellent photographs of gelatinous animals as well as marine snow. A camera system similar to this could, in principle, be configured so as to be towed horizontally as a photographic trawl for recording the distribution of large and fragile organisms at various depth horizons. Such a device has not yet been put into operation.

### Applications of photography in *in situ* plankton research

The value of photography for recording *in situ* observations is especially great for gelatinous animals, some of which are so delicate that their normal appearance is never regained after collection. Photographs have served to document the description of new species of gelatinous plankters (e.g. Madin and Harbison 1978b) and in some instances provided the only record of the appearance of live specimens. Several oceanic ctenophores, which are so delicate that they dissolve in preservative, have been described (e.g. Madin and Harbison 1978a, b) or their presence recorded (Youngbluth, personal communication) only by *in situ* pictures.

Photography from submersibles is responsible for much of what we know about the gelatinous plankton at mesopelagic depths. Two good examples are the photographic evidence obtained by Barham (1966) for the importance of siphonophores in creating deep-scattering layers, and his subsequent report (1979) on the occurrence and distribution of the giant appendicularian *Bathochordeus charon* in midwater. This animal makes a filtering house 50 cm or more in diameter, compared to 1–2 cm for most surface-dwelling species. The huge houses are far too fragile for collection intact, but photographs have provided very clear evidence of their size, configuration, and abundance (Barham 1979; Youngbluth, personal communication).

In many other cases photographs can record the positions and orientations of organisms in their habitat. Medusae, siphonophores, and ctenophores usually rest in characteristic attitudes with their tentacles spread in fairly specific patterns (Mills 1981; Biggs 1977; Purcell 1980, 1981; Anderson 1974). Planktonic animals spend most of their time swimming, feeding or both, and a great deal can be learned about the mechanism of these activities by underwater observation and photography.

Biggs (1977) used *in situ* photographs of siphonophores as a basis for drawings of the characteristic attitude and tentacle spread of several oceanic species, and inferred differences in prey selection among the siphonophores based on differences in tentacle morphology (Fig. 7.4). Larson (1979) based some of his inferences on the feeding behaviour of deep-sea medusae on the

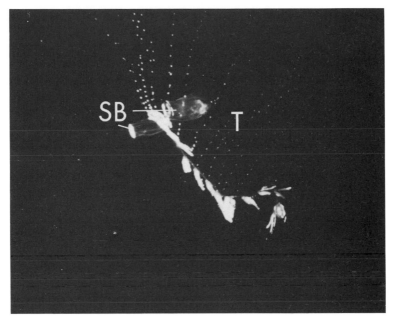

Fig. 7.4. *Diphyes dispar*, a siphonophore with only two swimming bells (SB) and tentacles arranged serially along a single stem. Dots along the tentacles (T) are clusters of nematocysts.

tentacle orientation recorded in photographs made from a submersible (see Fig. 7.3).

Examples of more detailed analysis of feeding behaviour might include description of prey-catching and handling by ctenophores (Harbison, Madin, and Swanberg 1978) as illustrated in Plate 3a. Interactions among large gelatinous predators and their prey can rarely be recreated in aquaria, but with luck and patience can be recorded under water (Fig. 7.5). Certain particle feeders also collect food with such large structures that they can only be seen *in situ*. The pseudothecosome pteropods produce mucus sheets up to 2 m in diameter to trap particulate food (Gilmer 1972), a mechanism known only through visual observation and underwater photographs (Fig. 7.6). Reproductive behaviour of the pseudothecosomes has also been recorded. A related group, the thecosome pteropods, have a similar feeding device, but on a smaller scale. This, and the special buoyancy regulating structures which are part of the feeding mechanism (Plate 3b) are also known from photographic evidence (Gilmer 1974). The behaviour exhibited by appendicularians in secreting and inflating a new filtering house has been described by Alldredge (1976) from *in situ* motion pictures of the animals. The complex internal structure of the larvacean houses, comprising channels,

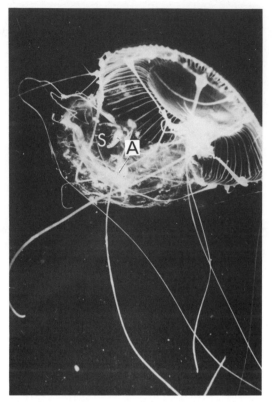

Fig. 7.5. The hydromedusa *Aequorea macrodactyla* catching a salp (S). Photographed in the Florida Current. Two symbiotic amphipods (A) can be seen in the salp; such amphipods are sometimes also eaten by the predator and sometimes escape.

screens, and filters has been described largely on the basis of *in situ* still photographs (Alldredge 1976, 1977), since the houses of many species are too delicate to manipulate, either for photography or microscopy, in the laboratory.

Non-living components of the plankton have also been the subjects of *in situ* photography. Large detrital aggregations, commonly known as 'marine snow', are extremely tenuous, and collapse upon collection by any means yet devised. *In situ* photographs (Fig. 7.7) have shown that there are several characteristic shapes of these aggregations (Trent, Shanks, and Silver 1978) which suggest particular sources for the aggregates. Some can be identified as the remains of appendicularian houses (Alldredge 1972, 1979) or pteropod mucus webs (Caron, Davis, Madin, and Sieburth 1982) on this basis.

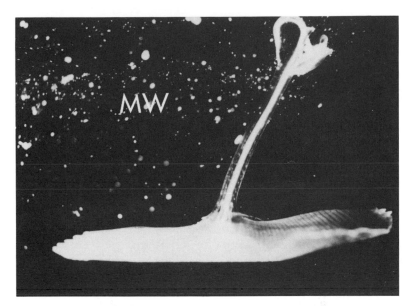

Fig. 7.6. *Gleba cordata*, a pseudothecosome pteropod which produces a mucous web (MW) up to 2 m in diameter with which to collect particulate food. The wingspan of this mollusc is about 10 cm. The mucous web has been seen only *in situ*.

Fig. 7.7. A mass of 'marine snow', or organic macroaggregate of the sort which originate from abandoned pteropod feeding webs, larvacean houses, etc. The aggregates may be 20 to 30 cm across, but can be photographed only *in situ* because they collapse into a fraction of their original size upon collection.

Associations and interactions between planktonic animals are almost always disrupted by conventional plankton sampling, and can usually only be seen *in situ*. Photography is an indispensable tool for recording the kinds of animals involved in interactions, and their position and behaviour relative to each other. Examples include the widespread associations between hyperiid amphipods and gelatinous animals. The amphipods behave as parasitoids, depositing larvae on or within a gelatinous host where they can feed and develop (Laval 1980). Often the adults, especially females, remain associated with their hosts for most of their lives, and the associations are usually with specific host species (Madin and Harbison 1977; Harbison, Biggs, and Madin 1977; Harbison *et al.* 1978). Photographic records of the arrangement of amphipods on their hosts are valuable clues to the feeding and reproductive behaviour of the parasitoids. Some species associated with salps congregate at the oesophagus or along the branchial bar of their hosts, where they eat part of the mucous food string of the salp. Juveniles of the family Oxycephalidae are left on ctenophores, where they roam over the body surface, grazing on the host's tissue (Fig. 7.8). In the family Pronoidae, juveniles are encysted within small excavations in the nectophores of their siphonophore hosts. Underwater photographs of these siphonophores clearly show the small amphipods, one in each nectophore.

Fig. 7.8. Juvenile amphipods on a ctenophore, *Ocyropsis* sp. Left there by their mother, these juveniles will consume the host as they grow.

Other, more tenuous associations are also documented by underwater photographs. The phyllosoma larva of the spiny lobster *Panulirus* is almost always found holding on to one or more small medusae (Hernnkind, Halusky, and Kanciruk 1976), which it appears to use as a source of locomotion and perhaps for defensive purposes, shielding itself behind the medusa and its tentacles when other organisms (or divers) approach. Juvenile fish of many genera cluster beneath large medusae (Mansueti 1963) and are sometimes seen singly with smaller jellyfish or siphonophores. The squaretails, *Tetragonurus* spp., are specialized predators of salps (Janssen and Harbison 1981) which, as juveniles, live inside the atrial cavity of the salps. Another, perhaps rarer, association between small squid and salps reported by Banas, Smith, and Biggs (1982) has also been documented by *in situ* pictures (Fig. 7.9).

An application of *in situ* photography which has not yet been used much is for the recording of spatial relationships and patterns of aggregation among organisms. Hamner and Carleton (1980) have demonstrated the value of a photographic method for small, densely aggregated animals. They took close-up photographs of copepod swarms on coral reefs, and, knowing the frame size and depth of field, could count the in-focus images on the film to arrive at the density of the swarm. Concentrations of copepods measured

Fig. 7.9. A juvenile ocotopod (O) clinging to the outside of a salp (*Salpa maxima*). The octopod is the same colour as the visceral mass of the salp.

in this way exceed three million copepods per cubic metre for one species; the photographic method consistently produced higher estimates than did sampling with nets, pumps, or large plastic bags, all of which may have caused some degree of avoidance by the copepods.

This approach has not been applied to larger organisms distributed in larger volumes, mainly because of the lighting problems discussed earlier, and because a photographic system that could cover a large enough volume to provide useful data (such as the remote plankton cameras described earlier), would be too cumbersome for diver operation. A camera and lighting array to photograph a field of about 1 m² would probably be the largest system practical for a diver. However, it is often easier, on this scale, to make visual observations of numbers of animals, their disposition with one another, etc., and record them on audio tape. Only where fairly fine details must be recorded and analysed might photographic records be worth the extra time and effort of processing and examining film. In cases like this, the use of stereophotography or video might significantly improve the quality of the data or the ease of its analysis. These techniques, as yet little used, are considered below.

### Future developments in plankton photography

*Diver-operated equipment*

Perhaps the principal difficulty in photographing plankton is the illumination and framing of large gelatinous animals. Long organisms like siphonophores, salp chains, radiolarian colonies and some ctenophores can rarely be photographed entire, providing a record of their normal orientation or arrangement in the water. It is hard to think of a technical solution to this problem, beyond the rather labour-intensive approach of independently held slave strobes which was discussed earlier.

Potential improvements to camera systems for animals at closer range might include lens systems with greater depth of field and/or resolution, close-up attachments with variable magnification, and automatic exposure control. Increased depth of field and resolution would obviously increase the chances of getting entire animals into sharp focus, and would enhance the value of the photographs as records of fine detail. If sufficient depth of field were available, the two dimensional focusing frame could be replaced by a three-dimensional frame indicating a volume within which everything would be in focus. This might be especially useful for animals with tentacles or appendages spread in three directions.

Close-up lenses with variable magnification are available for above-water cameras, but not as yet for underwater ones. It would provide greater flexibility in framing subjects of different sizes, provided that a variable

frame size indicator could be incorporated into the system. Single focus close-up lenses often lead to photographs containing only part of the subject, or in which a tiny animal is nearly lost in a large volume of water.

Automatic exposure is currently available for underwater photography via automatic strobes with separately housed sensors. The problem in using these for gelatinous plankton is ensuring that the sensor sees the same light that the lens does, that is, the light scattered and refracted into the lens by the transparent subject. Otherwise the sensor will see only dark background water, and the results will be over-exposed. Mounting the sensor directly over the camera lens and aiming it at the focusing framer can prove satisfactory. A more accurate system can be had with one of the cameras now available (e.g. Nikonos V, Olympus OM-2, Nikon F-3) which measure and control light from the strobe through the lens and during the exposure (automatic TTL metering).

Relatively little use has been made of stereophotography in plankton studies. I have experimented with a 35-mm Stereo Realist camera in a housing and obtained some satisfactory results with small animals. Diopter close-up lenses were used over the camera lenses. The distance between the two lenses was fixed, and too far for objects at close range to fall in the centre of the field of each lens. This resulted in excessive stereo separation of the two images and consequent difficulty in reconstructing a stereo image on viewing. None the less, the three-dimensional information, especially on spread of tentacles, orientation of organisms to one another, etc., can be very valuable scientifically as well as producing strikingly realistic images. What is needed for close-up stereophotography is a camera with an adjustable base-line distance between the lenses, perhaps an adjustment that is automatically coupled to the focusing mechanism. Stereophotography may also prove useful with larger field sizes, for recording the micro-scale spatial distribution of organisms. A difficulty would be adequate illumination of a field a few metres in width, but if this could be accomplished, stereophotographs could provide very detailed information on swarms or aggregations of small organisms as well as the spatial orientation of large ones.

Video cameras offer considerable potential for *in situ* study of zooplankton. The obvious advantage of video is that underwater images can be seen in real-time and also recorded on tape for subsequent review and analysis. There is no lag time due to film processing, and the data are in a form which is amenable to electronic image processing and analysis. Diver-operated video cameras and associated equipment are readily available commercial items, and offer optical characteristics and resolution almost comparable to 35-mm cameras. Most compact systems require a cable connection to the surface, but open water diving safety usually requires that divers be tethered in some way (Hamner 1975), so the cable would probably not be a great

hindrance. A few cableless systems, where both camera and recorder are taken underwater, are now available. Back-lighting for video would have to be arranged similarly to that for movie cameras, but smaller lights could be used owing to the greater sensitivity of video cameras. Indeed, special low-light level cameras are now used to record bioluminescence of organisms in the laboratory and presumably could be used similarly underwater by divers working at night. Continuous video records of organisms encountered by divers could be useful for the analysis of spatial pattern and the estimation of abundance for zooplankton which cannot be reliably sampled with nets.

Video cameras might prove even more useful in remotely operated survey systems. A camera mounted so as to record an illuminated field of fairly large size could be towed at depths beyond diving range to collect data on the distribution, abundance and diversity of large gelatinous plankton. The combination of a video and remotely-controlled film camera in such a device would provide both continuous real-time coverage and high-resolution photographs of organisms of particular interest. A towed device of this sort might be extremely valuable for locating and quantifying concentrations of gelatinous animals at meso- and bathypelagic depths, although the rather fleeting images of animals might make identification of species difficult, even from video tape or concurrent film records.

A technically more complex approach would be to use a remotely-piloted underwater vehicle equipped with an independent propulsion system, which would be able to conduct transect surveys but would also be able to stop, back up, and examine all sides of an organism. Vehicles of this kind are now available for servicing offshore oil installations, and possess nearly all the capabilities necessary for remote zooplankton observations. The capacity for continuous operation and data collection over long time periods and at a great range of depths would make these devices valuable tools for research on zooplankton throughout the water column. They are, of course, rather more expensive to use than is a diver equipped with a camera, but this may be more than offset by their greater endurance and depth capability.

A great deal of scientific progress in the field of underwater plankton research has depended on photographic methods as outlined earlier in this paper. Essentially, photography serves biologists in the pelagic environment in many of the ways that it serves them in other marine or terrestrial habitats. Since the water column is relatively inaccessible to man, photographic methods take on even greater importance, providing the first glimpse of many of the most characteristic animals of the plankton to both scientific and lay audiences (Hamner 1974; Anon 1981), and in some cases constitute the only record of the appearance, or even the existence of fragile or rare creatures.

We can expect to see continued use of photographic techniques and

application of new imaging technology in future efforts to investigate the varieties of life inhabiting the largest environment on our planet.

## References

Alldredge, A. L. (1972). Abandoned larvacean houses: a unique food source in the pelagic environment. *Science* **177**, 885–7.

—— (1976). Field behavior and adaptive strategies of appendicularians (Chordata: Tunicata). *Mar. Biol.* **38**, 29–39.

—— (1977). House morphology and mechanisms of feeding in the Oikopleuridae (Tunicata, Appendicularia). *J. Zool., Lond.* **181**, 175–88.

—— (1979). Chemical composition of macroscopic aggregates in two neritic seas. *Limnol. Oceanogr.* **24**, 855–66.

Anderson, E. (1974). Trophic interactions among ctenophores and copepods in St. Margaret's Bay, Nova Scotia. Ph.D. Dissertation. Dalhousie University.

Anonymous. (1981). Dance of the plankton. *Discover* (Aug.) 1981, 38–45.

Banas, P. T., Smith, D. E., and Biggs, D. C. (1982) An association between a pelagic octopod, *Argonauta* sp. and aggregate salps. *Fish. Bull.* **80**, 648–50.

Barham, E. G. (1966). Deep-scattering layer migration and composition: observations from a diving saucer. *Science* **151**, 1399–402.

—— (1979). Giant larvacean houses: observations from deep submersibles. *Science* **205**, 1129–31.

Biggs, D. C. (1977). Field studies of fishing, feeding, and digestion in siphonophores. *Mar. behav. Physiol.* **4**, 261–74.

Breslau, L. R., Clarke, G. L., and Edgerton, H. E. (1967). Optically triggered underwater cameras for marine biology. In *Deep-sea photography* (ed. J. B. Hersey), pp. 223–8. Johns Hopkins Press, Baltimore.

Caron, D. A., Davis, P. G., Madin, L. P., and Sieburth, J. McN. (1982). Enrichment of heterotrophic bacteria and bacteriovorous protozoa in oceanic macro-aggregates. *Science*, **218**, 795–7.

Gilmer, R. W. (1972). Free-floating mucus webs: a novel feeding adaptation for the open ocean. *Science* **176**, 1239–40.

—— (1974). Some aspects of feeding in thecosomatous pteropod molluscs. *J. exp. mar. Biol. Ecol.* **15**, 127–44.

Hamner, W. M. (1974). Blue-Water Plankton. *Natn. Geogr. Mag.* **146**, 530–45.

—— (1975). Underwater observations of blue-water plankton: Logistics, techniques and safety procedures for divers at sea. *Limnol. Oceanogr.* **20**, 1045–51.

—— and Carleton, J. H. (1979). Copepod swarms: attributes and role on coral reefs. *Limnol. Oceanogr.* **24**, 1–14.

——, Madin, L. P., Alldredge, A. L., Gilmer, R. W., and Hamner, P. P. (1975). Underwater observations of gelatinous zooplankton: Sampling problems, feeding biology, and behavior. *Limnol. Oceanogr.* **20**, 907–17.

Harbison, G. R., Biggs, D. C., and Madin, L. P. (1977). The associations of Amphipoda Hyperiidea with gelatinous zooplankton. II. Associations with Cnidaria, Ctenophora and Radiolaria. *Deep-Sea Res.* **24**, 465–88.

—— Madin, L. P., and Swanberg, N. R. (1978). On the natural history and distribution of oceanic ctenophores. *Deep-Sea Res.* **24**, 233–56.

—— (1979). Diving: A new view of plankton biology. *Oceanus* **22**, 18–27.

Hernnkind, W., Halusky, J., and Kanciruk, P. (1976). A further note on *Phyllosoma* larvae associated with medusae. *Bull. mar. Sci.* **26**, 110–12.

Honjo, S., Doherty, K. W., Agrawal, Y. C., and Asper, V. L. (1984) Direct optical assessment of large amorphous aggregates (marine snow) in the deep ocean. *Deep-Sea Res.* **31**, 67–76.

Janssen, J. A. and Harbison, G. R. (1981). Fish in salps: The association of squaretails (*Tetragonurus* spp.) with pelagic tunicates. *J. mar. biol. Ass. U.K.* **61**, 917–27.

Larson, R. J. (1979). Feeding in coronate medusae. (Class Scyphozoa, Order Coronatae). *Mar. behav. Physiol.* **6**, 123–9.

Laval, P. (1980). Hyperiid amphipods as crustacean parasitoids associated with gelatinous zooplankton. *Oceanogr. mar. Biol. A. Rev.* **18**, 11–56.

Madin, L. P. and Harbison, G. R. (1977). The associations of Amphipoda Hyperiidea with gelatinous zooplankton. I. Associations with Salpidae. *Deep-Sea Res.* **24**, 449–63.

—— —— (1978*a*). *Bathocyroe fosteri*, gen. nov. sp. nov.: a mesopelagic ctenophore observed and collected from a submersible. *J. mar. biol. Ass. U.K.* **58**, 559–64.

—— —— (1978*b*). *Thalassocalyce inconstans*, new genus and species, an enigmatic ctenophore representing a new family and order. *Bull. mar. Sci.* **28**, 680–87.

—— and Swanberg, N. R. (1984). *In-situ* methods for the study of planktonic organisms. In *Divers, Submersibles and Marine Science* (Ed. N. C. Flemming). Memorial University of Newfoundland, Occasional Papers in Biology **9**, 4–16.

Mansueti, R. (1963). Symbiotic behavior between small fish and jellyfishes, with new data on that between the stromateoid *Peprilus alepidotus*, and the scyphomedusa, *Chrysaora quinquecirrha. Copeia* 1963, 40–80.

Mills, C. E. (1981). Diversity of swimming behaviors in Hydromedusae as related to feeding and utilization of space. *Mar. Biol.* **64**, 185–189.

Ortner, P. B., Hill, L. C., and Edgerton, H. E. (1981). *In-situ* silhouette photography of Gulf Stream zooplankton. *Deep-Sea Res.* **28A**, 1569–76.

Purcell, J. E. (1980). Influence of siphonophore behavior upon their natural diets: evidence for aggressive mimicry. *Science* **209**, 1045–7.

—— (1981). Dietary composition and diet feeding patterns of epipelagic siphonophores. *Mar. Biol.* **62**, 83–90.

Trent, J. D., Shanks, A. L., and Silver, M. W. (1978). *In situ* and laboratory measurements on macroscopic aggregates in Monterey Bay, California. *Limnol. Oceanogr.* **23**, 625–35.

Youngbluth, M. J. (1984). Water column ecology: *in situ* observations of pelagic life from a research submersible. In *Divers, Submersibles and Marine Science* (ed. N. C. Flemming). Memorial University of Newfoundland, Occasional Papers in Biology **9**, 45–57.

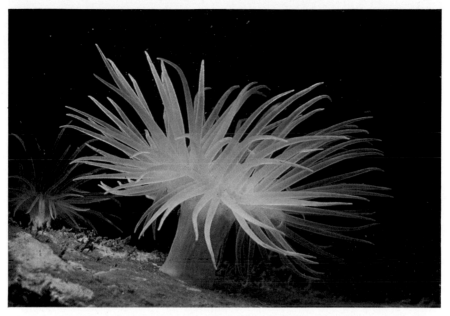

*Plate 1a. Close-up systems can produce detailed pictures of small objects such as this sea anemone.*

*Plate 1b. A 4-cm-long isopod,* **Antarcturus,** *on seaweed.*

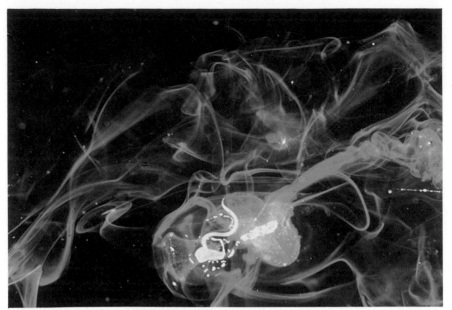

*Plate 2a. The larvacean* **Megalocercus huxleyi** *in its filtering house, about 3 cm across. Green uranine dye has been injected to illustrate the currents of water through the house generated by the vibrating tail of the animal. (Photograph used with permission of National Geographic Society.)*

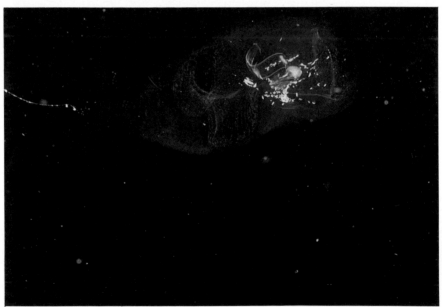

*Plate 2b. The larvacean* **Megalocercus huxleyi**, *injected with uranine dye and carmine suspension (red) to delineate both the house outline and the internal filtering structures.*

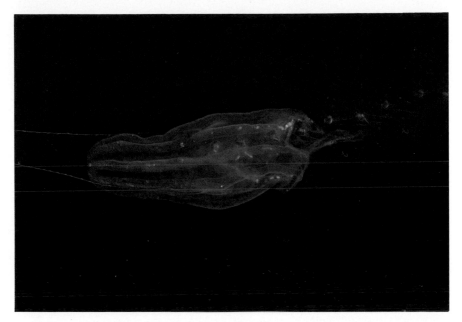

*Plate 3a. A ctenophore,* **Lampea pancerina**, *eating a chain of* **Salpa maxima**. *The ctenophore first contacts the salps with its tentacles, and then engulfs the prey with its broad mouth and stomach.*

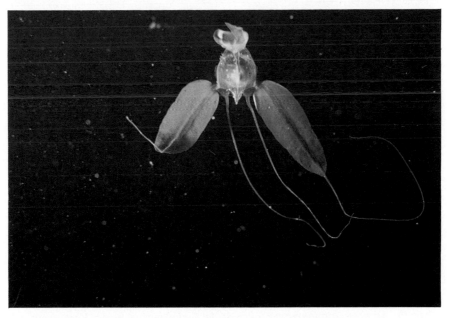

*Plate 3b. A thecosome pteropod* **Cavolinia** *sp. showing the green mantle extensions which aid the animal in maintaining buoyancy and stability while feeding.*

Plate 4a. The squat-lobster **Munida tenuimana** at the mouth of its burrow in Sognefjorden off Matsnaes at 1260 m depth. Pentax 55 mm lens and hemispherical port, field of view 1/25 m².

Plate 4b. Arm stereo photograph taken at the Galapagos vent site. Vestimentiferan tube worms **Riftia pachyptila**, the brachyuran crab **Bathograea thermydron**, and an undescribed mytilid mussel.

# 8 Designing underwater cameras

## P. J. Scoones

### Introduction

Of all the photographs that are taken each year, only a small proportion are under water. Yet subject-matter under water is almost as great as on land and the need for photography is often greater because it is inconvenient or impossible for most people to look for themselves.

### Single- or multiple-task cameras

In practice cameras fall into two classes, those that are designed for a single, defined task, and those that are intended to be as versatile as possible. The single-use camera is often designed in close consultation with the user, who specifies in some detail the special features required and what exactly he needs the camera for. Because the task is closely defined, the eventual unit may seem simple although it is really refined and sophisticated.

Where the final user cannot be consulted and there is no opportunity to assess his requirements and ability, a compromise has to be struck between the simple single-task camera and the 'all-singing, all-dancing, multi-mode

Fig. 8.1. A compact camera housing, with a miniumum of external controls and protruberances, designed for working divers.

reflex camera'. Such a camera may be much desired by the skilled under-water photographer whose purpose for diving is to take superb and artistic photographs of the most interesting subjects he encounters. The working diver who has to perform several different tasks besides photography needs a camera that is simple and reliable and produces results of an adequate technical standard (Fig. 8.1).

## Design constraints

### 1. *Depth*

The principles of pressure housing design are well known, but there are other less obvious problems. A camera that is overly bulky or heavy is likely to be difficult to transport and deploy, even under ideal conditions. In a small boat in a choppy sea it is likely to be damaged, or to damage other delicate pieces of equipment, as it is transferred in and out of the boat.

Under water, the high pressures that act on the body and lens-port can cause the focus to change, whilst controls can dislocate. Catches that appear secure on the surface may work loose if two parts of the body move closer together due to compression of an O-ring, and control spindles that pass through the wall of the housing may be forced inwards, causing the controls to bind up.

### 2. *Film capacity*

Sometimes there is a genuine need for a film magazine capacity that is greater than is normally available. However, this greatly increases the complexity of the unit with an increasing risk of malfunction. The cost also increases but it is sometimes argued that this is compensated for by the cheaper film when it is loaded in bulk, giving more exposures per mission, and less frequent film changes. In the author's experience few of these advantages are realized. Film is wasted 'because there is plenty', there are 'short ends' from 250 exposure lengths loaded into 250 exposure cassettes, and perfectly usable film in unmarked cassettes has to be dumped because no-one can remember who loaded it, when, and with what film.

### 3. *Optical requirements*

The optical requirements have to be decided early in the design process. The optical port is itself part of the lens system and tends to have a large effect on the overall shape, size and balance of the final product.

When light traverses the boundary between two media of differing refractive index such as air and water it changes in velocity. If it makes the traverse at any angle other than 90° to the boundary it suffers a change in direction (it is refracted), the effect being greatest at acute angles.

Unfortunately, the different wavelengths of light are refracted to differing extents with the result that coloured fringes are produced that are clearly visible at the boundary between light and dark areas of an image. They are still there although less visible where contrasts are less, and although not obvious, seriously degrade the definition of the image.

In the design of glass portholes the refractive index of glass and water are fairly similar, but the difference between glass and air is substantial. When there is a flat porthole light traversing the interface at right angles is substantially unaffected, but at greater angles of incidence the effects of refraction become progressively more serious. The practical effects are that pincushion distortion becomes evident, colour fringes and loss of definition occur at the edges of the picture, making wide-angle photography impossible, and lens angle is reduced by one-third, even at the centre.

To overcome these problems a hemispherical glass dome is used as the porthole, positioned so that its geometric centre coincides with the point inside the lens where the aperture appears to be with the lens stopped down (the front node of the camera lens). Using a dome port all the rays traverse the water/glass/air boundary at right angles and the problem appears to be solved! The dome is a curved surface and as such becomes a negative lens when used in water. In order to achieve a sharp image the camera lens needs to be focused on the virtual image produced by this new lens. This virtual image is located at $3\times$ the dome radius in front of the dome. The camera lens will produce a sharp image of objects at infinity when it is focused on this distance. For closer distances the camera needs to be focused even nearer.

Sometimes it is more convenient to fit supplementary, or close-up lenses in conjunction with the camera lens. The maximum benefit of the dome port is achieved if the close-up lens has a focal length such that the whole combination allows the camera lens to be set at infinity.

There is, however, one severe drawback to a dome port: the plane of sharp focus is a curve with the nearest point of focus in the centre. Even with wide-angle lenses on 35-mm cameras it is necessary to stop down the aperture and hence extend the depth of field to minimize this defect. The larger the radius of the dome the smaller is the effect, but there are prcactical limits to the size of dome that can be employed.

A third method is to use an assembly known as an Ivanoff port which corrects for defects at the interface whilst retaining the in-air performance of the camera lens. One practical advantage of the Ivanoff system is that the front element is substantially flat and is thus much less liable to damage than the dome. The disadvantages are that angles greater than 100° require a front element that is impractically large, and costly.

## 4. *Lighting*

Nowadays, lighting for still cameras is almost always by electronic flash. Yet

it is the item of equipment that gives more problems to the underwater photographer than any other. One might be forgiven for thinking that, with all the capability of modern electronics, reliable units would be available.

The fact is that it is not easy to design inverters with the required capacity whilst remaining reasonably compact. Perhaps significantly, the lower power units have a far greater reliability than their big brothers.

If the camera housing is designed on its own, it is logical to provide fittings that accommodate the commonly available flash units. At present a good compromise between reliability and price for the synchronization leads and plugs are the Electro-Oceanic water-mateable products. Increased reliability with triggering can also be achieved by adopting a pulsed-thyristor system. This does require additional circuitry and power supply within the main housing and modifications to the strobe unit, but the additional complexity is more than justified by the higher reliability it achieves.

## 5. *The photographer and the working diver*

Every underwater photographer who has reached a reasonable level of proficiency has developed his own requirements for equipment, but all share one overriding desire: the equipment should be as versatile as is practical. Whilst duly acknowledging that excellent work can result from skilled use of the ubiquitous Nikonos system, the remarks below are addressed to that other breed whose arms have grown long from travelling with hand baggage that weighs more than their total allowance for air travel.

The requirement is that the camera in its housing should retain as many of the control functions, and the use of as many of its lenses as it is reasonable to expect. The controls that are essential are focusing, aperture, shutter speed, and film transport. Reflex viewing is demanded by almost everybody as are interchangeable lens ports and easy film change. The controls should come conveniently to hand and the equipment should be as near neutral buoyancy in water as possible. Such equipment tends to be heavy, yet it should still be light enough to lift it off the ground without assistance! It is not a frivolous point to say that the equipment should be designed and finished with an eye to the aesthetic. Equipment that looks like a precision piece of engineering will be better respected and handled more gently.

A versatile 'photographers camera' of the kind just described may be complex in shape and need have a working depth not much greater than the air-diving limits. In contrast a piece of underwater photographic equipment designed for the offshore industry is more of a recording instrument, required for well-defined tasks. The equipment can therefore be set up prior to the mission with flash angle, aperture, and focus determined and locked off. Close-range work is usually involved and stout probes to establish camera distance and field of view are fitted. The present depth requirements are now about 600 m compared to one-tenth of that for SCUBA divers.

Deep diving is usually accomplished using helium breathing mixtures which leads to problems since helium is itself detrimental to some electronic components. In practice, cameras are usually attached to the exterior of the bell and this leads to some pounding on entering and leaving the water. For this reason a smooth compact design will lessen the risk of damage (Fig 8.1). External controls are also kept to the minimum. Underwater time for the working diver is precious and several other tasks may have to be performed during the dive, so photography must be efficiently and precisely undertaken.

# 9 Use of photographic and television cameras on the continental shelf

*N. A. Holme*

## Introduction

Over the past forty years photographic cameras have been increasingly used as a means of recording on the continental shelf, improvement in the quality of pictures being aided by developments in camera and lens design, improvement in the speed and quality of films, particularly for colour, and in the development of compact electronic flash units. Although underwater television systems were developed as long ago as the late 1940s (Barnes 1963) it has only been in the last ten years that, thanks to developments in solid state electronics, we have seen underwater television cameras becoming more compact and reliable, with development of low-light and colour cameras, matched by improvements in recording on reel-to-reel and cassette video-recorders.

The use of underwater cameras on the continental shelf involves a number of considerations, some of which are peculiar to the depth range, and some to the degree of turbidity and water movement encountered. The essential requirements are:

(1) provision of a suitable camera with watertight case and optical port;
(2) deployment of the camera to bring the subject into the field of view;
(3) remote operation of the camera—firing of the shutter in the case of photographic cameras, and a cable link to the ship for operation of video-cameras;
(4) provision of a suitable light source;
(5) solution of optical and mechanical problems caused by high energy conditions in shelf waters.

This chapter is solely concerned with remote operation of cameras from the surface. Situations where direct control can be exercised by a diver or from a submersible are only briefly considered here, since they are described elsewhere in this volume. It should be noted that the use of a television camera as a viewfinder enables a remotely-situated operator to have direct visual supervision over deployment of a photographic camera under water.

## Photographic cameras and their deployment

For continental-shelf photography it has been usual to employ a standard in-air camera, normally a motorized 35-mm model, fitted with a wide-angle lens. This is mounted within a purpose-made watertight case having a flat or

optically-corrected port, and with electrical connectors for firing the shutter and synchronizing flash. For use by divers there are underwater cases, often of plastic, manufactured for many of the popular makes of camera. However, these are not usually sufficiently robust or have insufficient depth capability for remote operation offshore; moreover the mechanical linkages provided for firing the shutter, focusing, etc. are unnecessary and a potential source of weakness. Acceptable results can only be obtained if a photographic camera is deployed to face a subject at a predetermined range, so that focus and stop can be preset. Although photographs have been taken of underwater gear, engineering structures, and of bait suspended within view of the camera, the vast majority of photographs have been of the sea-bed itself. The simplest means of taking a photograph of the sea-bed is by a camera lowered vertically from the ship. As the camera approaches the bottom a foot switch or counterweight operates a mercury switch to fire the camera, providing a series of photographs at a more or less constant distance off the bottom. An example of such a set-up was that used by Vevers (1951), over thirty years ago, who used a 35-mm Robot camera mounted in a watertight case with flat optical port, light being provided by a number of photoflood lamps. The camera was attached to a near-vertical pole with foot switch which operated the camera as it touched bottom. The assembly was 'bounced' along the bottom from a drifting ship, enabling surveys to be made of brittle-star beds and other grounds in the Plymouth area.

More often, a counterweight is used to trigger the camera, where it often forms a conspicuous object in the photograph (Fig. 9.1). In so doing it provides a scale, and the form of the plume of particles disturbed by its descent is an additional guide to the nature of the sediment (Athearn 1967). Because of the limited and relatively constant distance between camera and subject, such vertical photographs of the sea-bed lend themselves to the use of colour film, and to stereo photography (Southward and Nicholson, this volume) using a pair of cameras with overlapping fields of view. A magnetic compass may be incorporated into the frame to show orientation, which can be important in relation to current direction.

An alternative method of taking vertical sea-bed photographs was described by Eagle, Norton, Nunny, and Rolfe (1978). Here the camera was fired at regular intervals by an internal timing device, distance off bottom being regulated by reed-switches placed beside magnets suspended from two cables of unequal length hanging below the camera. Signals from the reed switches indicated when the camera was the correct distance above the bottom, and it was claimed that this method gave better control of camera positioning, and less bottom disturbance, than with the usual counterweight system.

For deep water use, more precise control over camera lowering can be obtained by attaching a pinger to the camera frame. In spite of all pre-

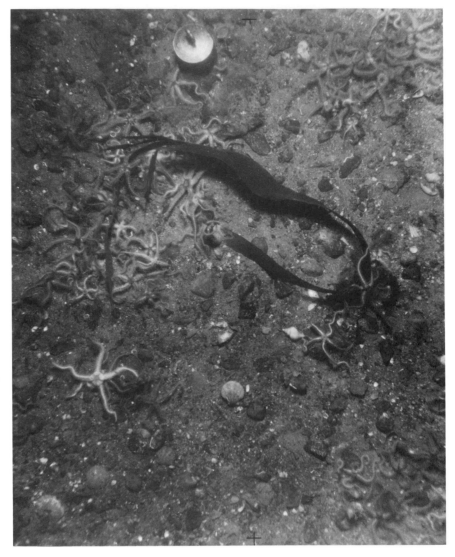

Fig. 9.1. Photograph of the sea-bed, with camera counterweight in field of view (copyright Marine Laboratory, Aberdeen).

cautions, the camera frame will from time to time hit the bottom or drift against an underwater obstruction, so the assembly should be well protected and of robust construction.

Photographic and television cameras have also been used on a tripod or other fixed base for time-lapse photographs or for continuous viewing of the bottom. Photographic cameras using 16 mm cine film are usually employed,

and by such means large numbers of single frames can be exposed over periods of days or weeks (e.g. Fedra and Machan 1979; Rumohr 1979; Jogansen and Propp 1980). A more or less permanently mounted television system is described by Kronengold and Loewenstein (1965), and other fixed television systems are described by Stevenson (1967) and Myrberg (1973). Where a camera is under water for more than a few days the likelihood of fouling organisms settling upon and obscuring the viewing port must be considered.

Photographs of the sea-bed have been taken from unmanned towed bodies, often carrying television cameras. For remote operation, the photographic camera is controlled by a timing device with initial delay, and some means of obtaining a constant distance above the bottom must be arranged. For example, Blacker and Woodhead (1965) fixed a camera within the body of a high-speed tow-net, by which means series of bottom photographs were taken at speeds up to 5 knots, distance off the bottom being measured by a transducer sounding to bottom, linked by cable to the ship's echo-sounder. A camera attached to the headline of a trawl has been used for benthos surveys in the North Sea (Dyer, Fry, Fry, and Cranmer 1982), the advantages of this system being that photography made no demands on ship's time additional to the trawling programme, and photographs and actual trawl catches could be compared.

**Interpretation of photographs**

Apart from questions of identification, which can be formidable, one of the main problems in interpretation of photographs is the question of distance and scale. Even when a vertically-lowered camera is fired by operation of a footswitch or counterweight, the precise position of the camera relative to the bottom at the moment of triggering is related to angle and speed of descent. From towed bodies and submersibles, distance may be even more difficult to estimate precisely and objects of known size (brittle-stars, urchins, beer cans) have been employed to give scale to photographs. Benthos Inc. have recently introduced a sonar device (Model 2110 Altimeter) which gives a readout of distance off bottom on each film frame, and this will no doubt remove some of the present uncertainties over distance estimation from cameras suspended above the sea-bed.

When the camera is attached to a towed sledge, distance and camera angle are thereby standardized so that problems of scale should no longer arise. However, with towed sledges there is a greater danger of damage or loss of gear through collision with objects on the sea-bed, and on rough bottoms this method may not be appropriate. The camera is normally positioned to point forward at an angle of 35° or less to the horizontal, photographs being taken at constant intervals by a timing device. For example, the 'troika', a

camera sledge designed for towing over rough grounds, has obtained many photographs from all depths (Laban, Pérès, and Picard 1963; Vaissière and Fredj, 1964). Wigley and Theroux (1970) used a forward-facing camera on a sledge for benthic surveys, but for red crab surveys in deeper water (Wigley, Theroux, and Murray 1975) a camera was mounted to point sideways, covering an area of 31.8 m² in each frame.

The oblique photographs obtained from a sledge-mounted camera are often scenically more attractive than vertical shots, but there may be problems of adequately illuminating the field, particularly for colour film, due to the range of subject to camera distances. The area covered by such oblique photographs can be calculated (Mertens 1970), but uncertainties in coverage relating to distortion at the edge of the field can be removed by taking a photograph under water of a squared grid, which can later be used as an overlay on photographic prints, or marked on a screen on to which the photograph is projected.

The majority of underwater photographs have been in monochrome, and for distances over about 2 m there seems little advantage in use of colour film. Due to the rapid extinction of red light, distant shots have a green or bluish cast which cannot be completely eliminated by a colour correcting filter. In any case, it may seem more natural that a distant view should have a similar appearance to that seen by a diver, while for close-up scenes, at a metre or less, good representation of colours is obtainable without recourse to a filter.

Electronic flash is almost universally employed as a light source, and this is best housed in a separate underwater case to allow lateral separation from the camera, so minimizing illumination of suspended particles in the field of view. The underwater housing will provide space for sufficient battery power for a large number of flashes, the only possible problem being to achieve complete and even illumination of the camera's field of view. This may require the flash to be positioned behind a domed port to widen the angle of coverage.

The main restriction to the use of photography and television under water is turbidity, which may make use of these media in estuarine and coastal waters difficult if not impossible (the use of image-intensifying systems for video is considered below). At all times, careful positioning and shading of the light source is important, and this may be critical under limiting conditions of turbidity. Offshore on the continental shelf, conditions are usually less difficult, although for best results use needs to be made of the clearer water associated with calm weather, neap tides, and slack water. Conditions are not necessarily best in summer, however, as at this time there may be much dead or moribund plankton close to the bottom. One suspects that pictures of the greatest clarity are only obtainable under the still conditions prevailing in the deep sea.

### Television cameras

For underwater television many of the same constraints apply as for photography. A variety of television cameras are available, the most commonly used having a vidicon tube which gives good results at daylight levels of illumination. The tube is capable of adapting to changing light levels, and in addition has an auto-iris to regulate light entry. For lower light-levels, Chalnicon and Silicon Intensified Target (SIT) tubes are available, the latter giving good pictures at moonlight levels of illumination (Harris 1980) (Table 9.1).

Low-light tubes are useful not only for studying behaviour of fish and invertebrates, but also in turbid conditions. They can often be used under ambient lighting conditions, when the absence of an artificial light beam reduces the back-scatter from suspended particles. It is not unknown for observers at a surface monitor to make out features which are not discernible to a diver below who is actually holding the camera!

The main advantage of television is that it provides instantaneous and continuous viewing and it is therefore particularly valuable for studies of the operation of nets and gear, for behaviour studies, and for wide-ranging surveys of bottom sediments and their fauna. Definition is necessarily poorer than for photographs, and at present the majority of cameras are monochrome. However, considerable advances have been made in development of colour cameras, which at present have a light sensitivity comparable to the vidicon tube.

For underwater lighting, mercury vapour or thallium iodide lighting is preferable to incandescent lamps, since the former more nearly approach the transmission characteristics of seawater and the sensitivity of the vidicon tube (Strickland, undated).

### Television and photographic camera packages

Television cameras may be deployed in much the same manner as photographic cameras, although the need for continuous viewing makes vertical lowering from a drifting ship less satisfactory. Under conditions of waves, currents, and swell it may prove difficult to maintain the camera at a constant distance from the bottom. For survey around coral reefs, where it would be unwise to use a bottom sledge, Goeden (1981) has developed a remote instrument package (TRIP 2) (Fig. 9.2) in a sturdy framework having video and film cameras, unwanted movement of the viewing system being stabilized by a gyro-controlled camera-head panning system.

The best use of a television camera is on a towed midwater body or bottom sledge, where it can be used in conjunction with, and as a viewfinder for, photographic cameras. Bascom (1976) describes an instrument package

Table 9.1. Comparison of performance of television cameras at different light levels (from Harris 1980)

| Camera type | Performance description (by light level) |
|---|---|
| (1) PLAIN VIDICON (sulphide type) | Fading into amplifier noise and vidicon defects → Good, very high definition pictures by target control, marred by excessive 'memory' at lower light levels → N.D.* filter or iris needed to prevent 'blooming' |
| (2) NEWVICON CHALNICON SILICON VIDICON | Fading into amplifier noise → Good, high definition pictures with low lag → Very good pictures can be maintained with N.D.* filter on lens |
| (3) SIT (16 mm) TUBE | Fading into photo-electron and amplifier noise → Good, very clear pictures → Good clear pictures with N.D.* filter on lens |
| (4) ISIT (16 mm) TUBE | Fading into photo-electron noise → Good clear pictures |

| SCENE ILLUM. LUX | $10^{-4}$ | $10^{-3}$ | $10^{-2}$ | $10^{-1}$ | $1$ | $10$ | $10^{2}$ | $10^{3}$ | $10^{4}$ | $10^{5}$ |
|---|---|---|---|---|---|---|---|---|---|---|
| VIEWING CONDITIONS | STARLIGHT | | MOONLIGHT | | | TWILIGHT | ROOM LIGHTING | | DAYLIGHT OVERCAST | FULL SUN |
| | OVERCAST CLEAR | | ½ MOON | FULL | | | | | | |

The above conditions are assumed in all cases   (i) Cameras are fitted with T2 lens   (ii) Scene reflectance of 50 per cent.

\* Neutral Density.

Fig. 9.2. TRIP 2 instrument package, with television and photographic cameras, which is towed above the sea-bed for surveys around coral reefs. (Photograph by G. B. Golden.)

which can be used either as a sledge or flown a few metres above the bottom. He remarks that 'we can think of no other single marine instrument that produces so much information'. The Department of Agriculture and Fisheries for Scotland laboratory at Aberdeen has developed a towed body, the positioning of which is controlled by electrically-powered motors, and there have been many applications in self-powered manned and unmanned submersibles.

Television cameras mounted on towed bottom sledges have been developed by Machan and Fedra (1975) and by Holme and Barrett (1977) (Fig. 9.3). In Holme and Barrett's sledge the television camera points forward at an angle of about 35° to the horizontal (Fig. 9.4), while a motorized 35-mm camera takes vertical photographs of the sea-bed at a range of 60 cm, the field being between the runners of the sledge. Progress over the bottom is monitored by an odometer wheel, revolutions of which are recorded on the video sound track. The wheel is now used to control firing of the still camera,

Fig. 9.3. View from front of Holme and Barrett's (1977) sledge with television and photographic equipment. The TV camera is at top, with transversely-mounted photographic camera, pointing vertically down, below it. The television light and electronic flash cases are also seen. The odometer wheel, which measures progress over the bottom, is at lower centre.

a frame being exposed at every tenth or other fixed number of rotations of the wheel. In this way photographs are equally spaced in distance over the bottom, and are therefore independent of speed of towing.

One of the main problems with towed television gear is correct deployment of the multicore television cable. Armoured cables are available, but are too expensive in lengths of several hundred metres for other than commercial use. Ordinary television cables are of low strength and must be supported, either by tying at intervals to the towing warp, or a separate rope must be used to take the strain off the television cable. In collaboration with the Institute of Oceanographic Sciences, a system using a cable clamped at intervals to a nylon rope has evolved. This has allowed Dr J. B. Wilson to operate a similar sledge at the outer limits of the shelf, with several hundred metres of cable outboard. Allowance must be made for the stretch of the supporting rope under strain, but if carefully supervised the system works well.

For video-recording, mains voltage at stabilized frequency and free from electrical interference is essential. On large research ships this should be no problem, but where a portable generator is used stability may not be sufficient for satisfactory recording. On occasions we have made what

Fig. 9.4. Photograph of television screen showing scallop (*Pecten maximus*) in the hollow which it has excavated in the sea-bed. Forward-pointing television camera is about 35° to the horizontal.

appeared at the time to be good recordings, only to find that they could not be replayed back on shore because they were recorded at an incorrect or fluctuating frequency. Machan and Fedra (1975) describe a system in which the output from a portable generator was rectified and fed into a 24-V battery. The 24-V d.c. supply was subsequently converted to 220-V a.c. by an inverter, the system incidentally providing a reserve of power if the generator should fail.

While the use of television under water requires considerably more trouble and expense than photography, the very considerable advances which have been made in television now make a combined television and photographic package a very worthwhile means of survey at shelf depths. For diver's use, Osprey Electronics have combined the two requirements into a single housing, containing a low-light television camera and photographic film camera, both operating through the same lens, rather in the manner of a single lens reflex camera (Fig. 9.5). The video display includes details of frame time and date, which are recorded also on to the photo frame at the time of exposure. In this way complete correlation of photo and video records is made possible, and the diver saves time normally spent in making separate photographic records.

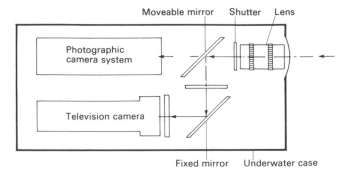

Fig. 9.5. Diagram of TVP camera developed by Osprey Electronics Ltd., Aberdeen. Both television and photographic pictures are taken through the same lens, by using a system similar to that in an SLR camera.

## References

Athearn, W. D. (1967). Estimation of relative grain size from sediment clouds. In *Deep-sea photography* (ed. J. B. Hersey), pp. 173–6. Johns Hopkins Press, Baltimore.

Barnes, H. (1963). Underwater television. *Oceanogr. mar. Biol.* **1**, 115–28.

Bascom, W. (1976). An underwater television system. *Southern California Coastal Water Research Project, Annual Report for the year ended 30 June 1976*, pp. 171–4.

Blacker, R. W. and Woodhead, P. M. J. (1965). A towed underwater camera. *J. mar. biol. Ass. U.K.* **45**, 593–7.

Dyer, M. F., Fry, W. G., Fry, P. D., and Cranmer, C. J. (1982). A series of North Sea benthos surveys with trawl and headline camera. *J. mar. biol. Ass. U.K.* **62**, 297–313.

Eagle, R. A., Norton, M. G., Nunny, R. S., and Rolfe, M. S. (1978). The field assessment of effects of dumping wastes at sea: 2. Methods. *Fish. Res. tech. Repts* 47, 24 pp.

Fedra, K. and Machan, R. (1979). A self-contained underwater time-lapse camera for *in situ* long-term observations. *Mar. Biol., Berlin* **55**, 239–46.

Goeden, G. B. (1981). A towed instrument package for fisheries research in Great Barrier Reef waters. *Fish. Res.* **1**, 35–44.

Harris, R. J. (1980). Improving the design of underwater TV cameras. *International Underwater Systems Design* **2**, 7–11.

Holme, N. A. and Barrett, R. L. (1977). A sledge with television and photographic cameras for quantitative investigation of the epifauna on the continental shelf. *J. mar. biol. Ass. U.K.* **57**, 391–403.

Jogansen, V. S. and Propp, M. V. (1980). Automatic underwater camera for registration of slow processes in marine environment. (In Russian; English summary.) *Biol. Morya Vladivostock* 1980 (1), 86–8.

Kronengold, M. and Loewenstein, J. M. (1965). Cinematography from an underwater television camera. *Research Film* **5**, 242–8.

Laban, A., Pérès, J.-M., and Picard, J. (1963). La photographie sous-marine profonde et son exploitation scientifique. *Bull. Inst. océanogr. Monaco.* **60**, No. 1258, 32 pp.

Machan, R. and Fedra, K. (1975). A new towed underwater camera system for wide-ranging benthic surveys. *Mar. Biol., Berlin* **33**, 75–84.

Mertens, L. E. (1970). *In-water photography. Theory and practice.* John Wiley-Interscience, New York, 391 pp.

Myrberg, A. (1973). Underwater television—a tool for the marine biologist. *Bull. mar. Sci.* **23**, 824–36.

Rumohr, H. (1979). Automatic camera observations on common demersal fish in the Western Baltic. *Meeresforsch.* **27**, 198–202.

Stevenson, R. A. (1967). Underwater television. *Oceanology International* **2** (7), 30–35.

Strickland, C. (undated). *Facts on underwater illumination.* Hydro Products guide, 37 pp.

Vaissière, R. and Fredj, J. (1964). Étude photographique préliminaire de l'étage bathyal dans la région de Saint-Tropez (ensemble A). *Bull. Inst. océanogr. Monaco* **64**, No. 1323, 70 pp.

Vevers, H. G. (1951). Photography of the sea floor, *J. mar. biol. Ass. U.K.* **30**, 101–11.

Wigley, R. L. and Theroux, R. B. (1970). Sea-bottom photographs and macrobenthos collections from the continental shelf off Massachusetts. *Spec. scient. Repts U.S. Fish. Wildl. Serv.* Fisheries Series 613, 12 pp.

—— —— and Murray, H. E. (1975). Deep-sea red crab, *Geryon quinquedens*, survey off northeastern United States. *Mar. fish. Rev.* **37**, 1–21.

# 10 Observing Norway Lobster, *Nephrops norvegicus* (L.) by towed sledge fitted with photographic and television cameras

*C. J. Chapman*

## Introduction

Previous work by Cole (1967), Chapman, Johnstone, and Rice (1975) and Chapman (1979) has emphasized the potential value of underwater television and photography in studies of the behaviour and ecology of *Nephrops norvegicus*. In the early work, the cameras were mounted on a simple frame suspended beneath a drifting or anchored ship. A logical development from this was to mount the cameras on a sledge which could be towed on a predetermined course. This paper describes such a sledge used to observe a population of *Nephrops* in the Lynn of Morvern (56° 30′ N, 05° 35′ W) on the west coast of Scotland. The main features of the sledge which distinguish it from other versions (see review by Holme in this volume) are the arrangement of the cameras to view the sea-bed in front of the sledge runners and the use of filtered lighting. These features are considered essential in studying species like *Nephrops* which are very sensitive to light and capable of moving away from the sledge path.

## Methods

### The sledge

The general form of the sledge and camera layout is illustrated in Figs 10.1 and 10.2. The basic framework was welded from 25 mm diameter aluminium alloy tubing (10 SWG). The 100 mm-wide runners were made from mild steel plate. These have since been replaced by 200 mm-wide runners to reduce the depth of sinking into mud. The sledge measured 1.96 m long, 1.68 m wide, and 1.7 m high.

The weight of the camera and lighting units carried at the front of the sledge was counterbalanced by weights added to each side of the runners, amounting to 48 kg. Plastic floats giving 26 kg of buoyancy were distributed along the top of sledge to give stability when lowering the sledge to the sea-bed. The fully rigged sledge, including weights, weighed 95 kg in water.

### Television system

The television camera (Hydro Products SDA 125) was mounted by adjustable brackets to view obliquely forward as shown diagrammatically in Fig.

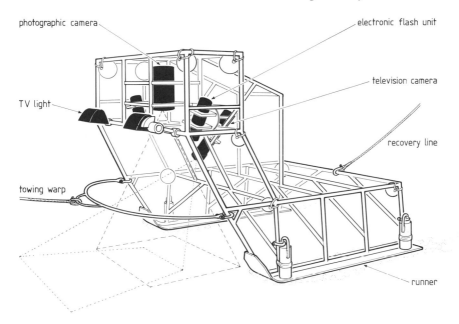

Fig. 10.1. Drawing of sledge showing arrangement of cameras and lighting units. Camera fields of view shown diagrammatically.

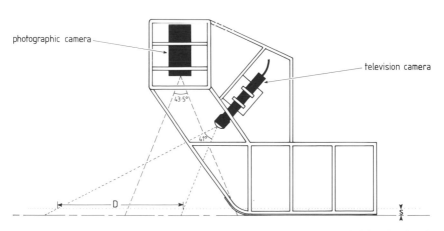

Fig. 10.2. Scale diagram of sledge from the side showing camera fields allowing for sinking of runners into the mud (S). The distance, D (= 1.03 m), corresponding to the height of the TV picture, was used to estimate towing speed and distance travelled. Further explanation in text.

10.1. The camera has an automatic iris and can be focused remotely. The camera housing has a domed window corrected for use in water.

Lighting for the television camera was provided by two 500-watt quartz-iodide lamps (Hydro Products HQ) mounted at the front of the sledge. The lamps were fitted with red Perspex filters to reduce their disturbance effect on *Nephrops*. The filters had a sharp cut-off at 600 nm so that most of the light was outside the visual range of the *Nephrops* eye, given by Loew (1976). On the other hand, the camera tube was most sensitive in the red portion of the spectrum (Fig. 10.3) so there was no discernible loss of picture quality using filtered light.

Power supplies to the camera and lights, focus controls and the video signal are carried through a multi-core cable connected to the towing vessel. The video signal was combined with a digital time signal (FOR-A type VTG 33F time generator) and then recorded on a video-cassette-recorder and monitor (Sony U-matic). Since video recording can be difficult on board ship because of unstable power supplies (see p. 96) the cassette-recorder was

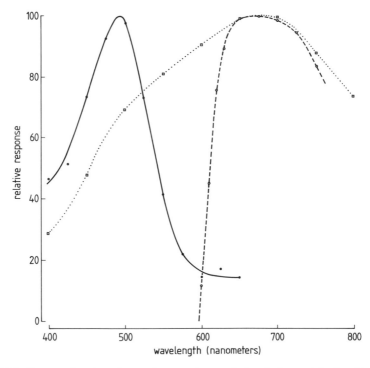

Fig. 10.3. Curves showing absorption spectrum of visual pigment in the *Nephrops* eye, after Loew (1976) (●———●), light transmission through red Perspex filters (○– – – – ○), and sensitivity of SDA television camera (□........□).

fitted with a motor drive amplifier in order to 'smooth' the mains voltage and frequency.

*Photographic system*

A large format camera (Hasselblad EM with 50-mm lens) in an aluminium housing was mounted vertically 1.22 m above the plane of the sledge runners (Fig. 10.2). The camera was used with a 70-exposure-capacity magazine loaded with 400 ASA colour negative film (Kodak SO/200). Lighting was provided by two electronic flash units (Osprey type OE 4000A) mounted either side of the camera. The camera was triggered from the ship through a twin core cable and switch, the number of photographs being logged on a digital counter.

As far as possible photographs of *Nephrops* and other organisms were taken at the centre of the camera field, to minimize the effect of distortion through the flat glass port of the camera housing. This was achieved by reference to the video monitor. The overlap of the two camera fields was such that the bottom edge of the television screen corresponded to the centre of the Hasselblad camera field (Fig. 10.2). This arrangement gave about three seconds warning of the subject before the photograph was taken.

*Initial trials with the sledge*

Trials with the sledge in the Lynn of Morvern were conducted during May 1980, on board the Fishery Research ship *Goldseeker*, a small stern trawler (length 15 m). The sledge was lowered from the stern of the vessel whilst underway and towed on a single trawl warp. The television and camera trigger cables were tied to the towing warp at approximately 10 m intervals during the launch.

An ultrasonic transmitter ('pinger') and a light synthetic rope with float were attached to the sledge to aid recovery in the event of the towing cables breaking.

The trials were conducted in water depths between 75 and 100 m at towing speeds from 0.3 to 0.45 m/s (0.6–0.9 knots). At these depths and speeds 200 m of warp was required to keep the sledge on the bottom.

*Analysis of results*

Estimation of the dimensions of the camera fields of view, essential for quantitative results, was complicated by the fact that the sledge runners tended to sink into the soft mud in the Lynn of Morvern. This was confirmed by towing the sledge back over the tracks made on previous runs. The tracks were then photographed to provide a reference scale from which the fields of view were calculated. These turned out to be less than the areas estimated from the lens angles given by the camera manufacturers and suggested that

the sledge runners were sinking about 100 mm into the mud (see Fig. 10.2).

To derive quantitative data using the obliquely-orientated TV camera two measurements were needed, the width of the field of view and the distance travelled by the sledge. From the lens angle the width of the field was estimated to be 0.73 m at the bottom of the screen. The distance travelled by the sledge in a given time was estimated by first calculating the average speed of tow. This was done when the video tapes were edited, by timing the passage of conspicuous objects on the sea-bed as they passed from the top to the bottom of the TV screen. This distance corresponded to 1.03 m on the sea-bed for 100 mm sinking of the sledge runners (Distance D in Fig. 10.2). The timing could be done to an accuracy of 10 ms using the digital time signals recorded with the picture. The speed was calculated in this way at intervals during the tow and averaged to give an estimate of the distance travelled by the sledge. This method had to be employed since the Decca navigator system carried by the ship was inaccurate in the enclosed waters of the Lynn of Morvern.

The video cassettes were analysed using an editing facility which enabled the tapes to be played back at $\frac{1}{20}$th of normal speed, and examination of single frames. Photographs were examined by projecting the negatives on to a screen, using photographs of the sledge track to provide scale. The total body lengths of *Nephrops* were measured from the negatives and later corrected to the standard carapace length (C.L.) measurement.

*Trawling*

One of the main aims of this work was to compare the size distribution of the *Nephrops* population obtained photographically with that obtained by trawl. After the television and photographic survey, four 30-min hauls were made on the same grounds using a Stuart 70-mm mesh *Nephrops* trawl with 37-m sweeps, 5.5-m spreading wires and 1.37 × 0.76 m metal 'V' otterboards.

**Results and discussion**

The results are based on the analysis of over 300 photographs of the sea-bed and seven hours of video-recording. Apart from *Nephrops*, eight other burrowing species were identified in the Lynn of Morvern. These were the false lobsters, *Calocaris macandreae* (Bell) and *Callianassa subterranea* (Montagu), the sea pen, *Virgularia mirabilis* (Müller), the squat lobster, *Munida rugosa* (Fabricius), the echiuran, *Maxmullaria lankesteri* (Herdman), the anemone *Cerianthus* sp. and the snake blenny, *Lumpenus lumpretaeformis* (Walbaum).

Identification of the first two species was based on recognition of their burrows since neither *Calocaris* nor *Callianassa* were seen. A few *Calocaris*

were caught in the trawl, presumably because they were close to the mud surface and were 'dug out' by the footrope. The openings into *Calocaris* burrows appear as funnel-like depressions leading to vertical shafts into the mud (Nash, Chapman, Atkinson, and Morgan, 1984). Those of *Callianassa* are small circular openings at the top of mounds of mud (Dr J. Atkinson, personal communication). 'Plumes' of muddy water were often seen emerging from these openings as the occupants ventilated their burrows. Subsequent settlement of mud particles around the openings probably accounts for the 'volcano' appearance of the burrow openings.

An echiuran believed to be *Maxmullaria lankesteri* was very common in the Lynn of Morvern. The proboscis of this animal was seen lying on the mud surface (Fig. 10.4). In colour photographs, the proboscis was pale green. They appeared to sense the approach of the sledge and usually withdrew into small circular openings in the mud (Fig. 10.4B). A few fragments of the proboscis were occasionally caught on the sledge runners.

There was a very high density of burrow openings, average density 70/m². The majority of these were attributed to *Calocaris*. The burrows of *Nephrops* were readily distinguished by their deep crater-like entrances leading to horizontal tunnels (Fig. 10.4A). Their density varied from 0.15/m² to 0.31/m² (i.e. roughly one *Nephrops* burrow every 3–6 m²).

Counts were also made of *Nephrops* seen in the entrances or outside their burrows (Table 10.1). This gave densities of *Nephrops* varying from 0.008/m² to 0.21/m². The wide variation reflects the periodicity of emergence of *Nephrops* from their burrows (Chapman *et al.* 1975) with greatest numbers appearing about an hour before and an hour after noon. The higher figure of 0.2/m² is likely to be closest to the true density and is in good agreement with the estimated burrow density. Counting burrows is likely to over-estimate the density of *Nephrops* because some burrows may be empty as a result of fishing. Despite the uncertainties, television surveys have potential value in allowing limits to be set to population density and other parameters used in mathematical modelling studies (Jones 1979).

The size distribution of *Nephrops* in the Lynn of Morvern, as determined from photographs, is compared to the composition of trawl catches in Fig. 10.5. This population consists mainly of small *Nephrops*, 87 per cent being below the marketable size of 30 mm C.L. At these sizes it was impossible to determine the sex of *Nephrops* from the photographs. Females accounted for 56 per cent of the *Nephrops* caught in the trawl. The smallest *Nephrops* in the photographs measured 10 mm C.L. and this may be taken as the size of first recruitment to the fishable stock. Little is known of the biology of pre-recruit *Nephrops*. They are known to occupy burrows in the same areas as the adults but it seems they do not emerge during their first year of life (Chapman 1980). Obviously, the pre-recruits are excluded from the estimates of density given above.

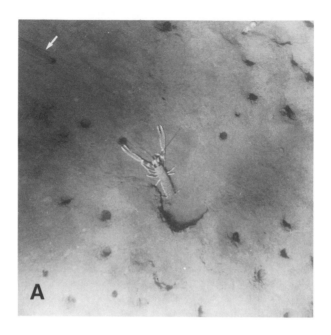

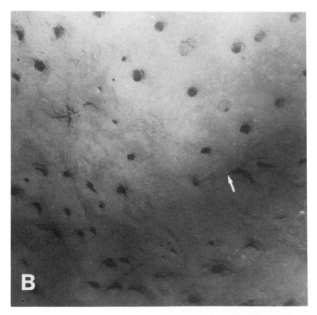

Fig. 10.4. Flash photographs of the sea-bed in Lynn of Morvern from original colour negative film. A, showing *Nephrops* at the entrance to its burrow, and the proboscis of *Maxmullaria* (marked by arrow). B, the proboscis of a *Maxmullaria* is shown withdrawing into its burrow. Area of sea-bed represented by each photograph, 0.48 m².

ıble 10.1. Summary of TV sledge runs in Lynn of Morvern, with counts and ınsities of *Nephrops*.

| ıte | Time BST[1] | Duration (min) | Average towing speed (m/s) | Area surveyed (m²) | Counts of *Nephrops* in burrow entrance | away from burrow | total | Density of *Nephrops* (No./m²) away from burrow | total |
|---|---|---|---|---|---|---|---|---|---|
| /5 | 0849 | 61.5 | 0.321 | 1066 | 9 | 46 | 55 | 0.043 | 0.052 |
| /5 | 0936 | 31 | 0.314 | 525 | 3 | 4 | 7 | 0.008 | 0.013 |
| /5 | 0945 | 57.5 | 0.352 | 1093 | 9 | 24 | 33 | 0.022 | 0.030 |
| /5 | 1028 | 20 | 0.350 | 378 | 1 | 2 | 3 | 0.005 | 0.008 |
| /5 | 1051 | 29.5 | 0.304 | 485 | 19 | 70 | 89 | 0.144 | 0.184 |
| /5 | 1126 | 38 | 0.384 | 788 | 12 | 38 | 50 | 0.048 | 0.064 |
| /5 | 1230 | 15 | 0.308 | 249 | 1 | 19 | 20 | 0.076 | 0.080 |
| /5 | 1244 | 34 | 0.419 | 769 | 9 | 14 | 23 | 0.018 | 0.030 |
| /5 | 1338 | 33 | 0.427 | 762 | 35 | 123 | 158 | 0.161 | 0.207 |
| /5 | 1421 | 48 | 0.443 | 1149 | 10 | 12 | 22 | 0.010 | 0.019 |
| ıtals eans | | 367.5 | 0.366 | 7264 | 108 | 352 | 460 | 0.048 | 0.063 |

ïme given is the half-way point on each run.

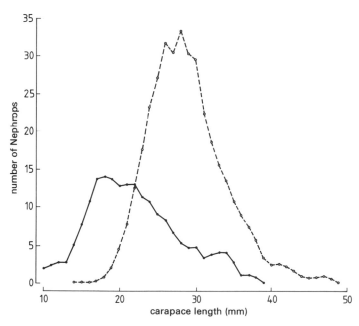

Fig. 10.5. Graphs showing the size distribution of *Nephrops* (males and females combined) in the Lynn of Morvern determined from photographs (●———●, 196 individuals) and by 15 min tow of 70-mm mesh trawl (○– – – – ○, 369 individuals). Data smoothed by taking three-point moving averages.

It is evident from Fig. 10.5 that small *Nephrops* (below 25 mm C.L.) are poorly represented in the trawl catch, presumably because they escape through the meshes of the net. The question of mesh selection is important since the control of mesh size of nets is virtually the only form of management employed in the *Nephrops* fisheries. Yet, our knowledge of the selection properties of *Nephrops* trawls is scanty. It is widely believed that *Nephrops* escape from many parts of the net in addition to the codend. Therefore, there is a need for methods which measure the selectivity of the whole net. Comparison between size distributions of *Nephrops* from photographs and the trawl (Fig. 10.5) is clearly one possibility. Ideally, the camera and trawl would need to be towed at the same time and place. This was not possible in the present work.

For future work, improvements to the sledge are planned, the most important being provision of a device to monitor the amount the runners sink into the sediment and hence a complete calibration of the camera field throughout each tow.

### Acknowledgements

I thank my colleagues R. Priestley, P. Barkel, and C. Shand for the development and field operation of the camera equipment, and B. Ritchie for design work on the sledge frame.

### References

Chapman, C. J. (1979). Some observations on populations of Norway lobster, *Nephrops norvegicus* (L.) using diving, television and photography. *Rapp. P.-v. Réun. Cons. int. Explor. Mer* **175**, 127–33.

—— (1980). Ecology of juvenile and adult *Nephrops*. In *The biology and management of lobsters, Vol. 2* (ed. J. S. Cobb and B. F. Phillips), pp. 143–78. Academic Press, New York.

—— Johnstone, A. D. F., and Rice, A. L. (1975). The behaviour and ecology of the Norway lobster, *Nephrops norvegicus* (L.). In *Proc. 9th Eur. mar. Biol. Symp.* (ed. H. Barnes), pp. 59–74. Aberdeen University Press.

Cole, H. A. (1967). Observations of *Nephrops* with underwater television. *Repts Challenger Soc.* **3**, 58–9.

Jones, R. (1979). An analysis of a *Nephrops* stock using length composition data. *Rapp. P.-v. Réun. Cons. int. Explor. Mer* **175**, 259–69.

Loew, E. R. (1976). Light and photoreceptor degeneration in the Norway lobster, *Nephrops norvegicus* (L.). *Proc. R. Soc.* B **193**, 31–44.

Nash, R. D. M., Chapman, C. J., Atkinson, R. J. A., and Morgan, P. J. (1984). Observations on the burrows and burrowing behaviour of *Calocaris macandreae* Bell. *J. Zool., Lond.* **202**, 425–39.

# 11   Photogrammetry in sediment transport studies
## *R. H. Wilkinson, E. J. Moore, and A. P. Salkield*

### Introduction

The *in situ* characteristics of sea-floor sediments such as grain size or microtopography can be studied by a range of techniques. The majority of present-day studies are usually based on either acoustic or optical methods, the choice between the two normally being made by the physical scale of the problem under investigation.

In order to conduct surveys of major sea-floor bedforms such as sand and gravel waves (which are of the order of metres high and tens to hundreds of metres long, covering areas of several square kilometres), the techniques employed would normally be based on ship-mounted acoustics; for example, side-scan sonar and echo-sounders. Owing to ship motion and lack of acoustic resolution these systems are not suitable for the observation of ripple bedforms (which are of the order of centimetres high and tens of centimetres long), or of individual particles of gravel. The resolution of acoustic instrumentation may be improved by operating at higher frequencies, but this introduces problems caused by increased attenuation and scattering within the water column which limits the operational range.

In areas where water clarity allows, optical techniques can be used as an alternative to acoustics to study the small size scale end of the spectrum. Two examples of the use of photographic and television cameras are described in this presentation. The information obtained covers a range varying from the qualitative observational type (i.e. big, small, or is it moving?) to the more quantitative (i.e. the piece of gravel that moved was approximately 25 mm in diameter).

### Gravel movement studies

It has become apparent that understanding of the physical processes governing gravel movement on the sea-bed is inadequate for efficient management of coastal resources. As a result, it was necessary to study the threshold of motion and transport rate in relation to the near bed flow under field conditions. Investigation of the threshold entailed characterizing the flow by using several propellor current meters (as in the next section) and identifying the size of the gravel particles and instant of initiation of motion.

Following preliminary surveys of gravel areas, a site in the West Solent was selected for long-term studies. Characterization of the water flow which provides the force to move the sea-bed material was performed by using

conventional rotor flowmeters mounted as shown in Fig. 11.1. The technique of flow characterization is described in the section on sand ripple movement, and Fig. 11.1 also shows additional equipment used for ripple measurement.

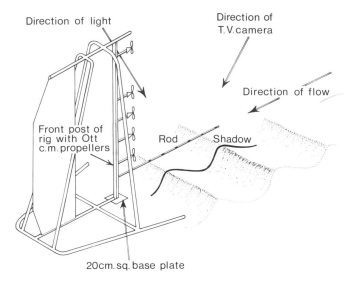

Fig. 11.1. Diagram of rotor flowmeters and ripple measurement rod in position on the sea-bed.

Optical systems, both still photography and television, were used to observe any movement that occurred and, in the case of gravel, to provide an estimate of the size of the material undergoing transport. For gravel, the movement of particles can be monitored, since individual particles can be unambiguously recognized for long periods until they move. The same cannot be said for sand particles where one relies on visible bulk movement in the form of ripples. Previous experience of working in areas of high sea-bed mobility had shown that optical systems can be used successfully but the standard of the results obviously depended entirely on the water clarity prevailing at the time. Visibility at the Solent site did not usually exceed 1 m!

## Still photography

The ideal system to provide both qualitative and quantitative analysis of the sea-bed would be a pair of calibrated stereocameras capable of producing highly accurate photogrammetric measurements. It was felt, however, that the environmental conditions would prohibit still photography of the quality required for proper stereo analysis. Also, the expense of analysis is rather

high for extended use. As a first trial it was decided to use a single camera fitted with a time-lapse facility, to enable single shots to be taken at predetermined intervals starting at a fixed time.

The camera used was a 35-mm purpose-built unit manufactured by the Underwater Marine Equipment Laboratory (UMEL). This camera was fitted with a built-in timer which enabled the start-time and time-interval between frames to be fully programmed to requirements. The optics consisted of a 35-mm Promura f3.5 lens fitted behind a domed corrector port and the camera would accept either standard 35 mm cassettes or up to 200 exposures on dark-loaded perforated film.

With foreknowledge of the site conditions it was decided to mount the camera within 0.5 m of the sea-bed and at an angle of 50° from the vertical. A trial run with the camera in this position was carried out in clear water. For this trial divers were used, and they placed a scale directly in front of the camera and pointing away from the lens as an aid to establishing a close-range focusing scale, and to provide a basis for later measurements if required.

At the survey site in the Solent the camera was used over four experimental periods during which 36 exposures were taken with an interval of 8 min between exposures for each individual period. These were developed on board immediately on retrieval and examined. Owing to the turbid conditions, the negatives were not perfect but did show evidence of gravel movement having occurred between frames. On return to the laboratory, prints made from the negatives confirmed that movement had been recorded, but generally the photography was of an unacceptably low quality. This did not allow estimates of the size of the mobile material to be made.

**Underwater television**

An underwater television system was also mounted on the measurement rig. This proved to be an exceptionally useful instrument when operating under conditions of high turbidity when photographic techniques were unsatisfactory. Good images were obtained because a SIT (Silicon Intensified Target) camera was deployed, which allowed operation without lights and so avoiding the inevitable back-scatter from suspended solids. The option to use a light was available, but on most occasions results were better without it.

The television camera was fitted on a pan and tilt head, which enabled the operator to periodically scan the rig to check for weed fouling the current meters, which was a frequent problem, particularly during spring tides.

Continuous monitoring of the television picture gave a good indication of gravel movement. Video recording was carried out during any periods when

Fig. 11.2. Photograph of image of sea-bed on television monitor taken whilst using the pause facility during playback.

Fig. 11.3. Photograph of image on television monitor with an overlay to display optical distortion in the system.

significant movement was anticipated, and some success has been achieved in taking still photographs of the monitor during playback by making use of the pause facility on the VTR. An example of such a photograph is shown in Fig. 11.2, which was taken on a Minolta SRT101 using FP4 film with an exposure of $\frac{1}{15}$s at f4.

Some thought has been given to the future use of television in other circumstances, but as a survey tool in its own right, and as a means of calibration for other remote sensing instruments, it is desirable to have the ability to carry out scale measurements of gravel particles on the television image. In order to carry out measurements on the image, the following variables would need to be recoverable to exactly the same settings as used for calibration purposes: angle of view, lens to subject distance, monitor vertical hold, and horizontal hold. The first two settings changed whenever the pan and tilt unit was used to move the camera for current meter rotor inspection. In order to recover the original camera position, a control is required which is visible on the image. This control was provided by the 20 cm square base plate of the rotor current meter front support post. The camera was positioned on the rig so that the base plate was visible in a suitable part of the image when the camera was angled for an optimum view of the gravel bed. This base plate is seen on Fig. 11.3; also shown on this photograph of the video monitor is an overlay produced to allow for optical distortions in the system. This overlay was made by placing an accurately drawn test grid on the floor of a water-filled tank, then with the camera in its operational position the overlay was drawn on to a transparent sheet attached to the monitor screen to correspond with the image of the test grid. As may be seen, considerable pincushion distortion is present within this particular system, which could have led to errors of between 25 to 50 per cent in estimating particle size as displayed on the monitor.

The distortion may be introduced both by the camera and the monitor, which does not have a flat screen. In general, when using a television system for photogrammetric-type measurements, a calibrated scale must be included in the field of view and some method of allowing for distortion included in image analysis.

A further use of television in gravel studies has been carried out in the development of a trap designed to catch mobile gravel on the sea-bed (see Fig. 11.4). The heavily-ballasted trap is fitted with a fin to ensure that it lines up into the prevailing tidal flow, and it is allowed to rest on the sea-bed for a pre-determined time. Gravel particles moving downstream are caught in the trap and can be analysed on return to the surface. The trap is fitted with four current meters, an inclinometer and normally the SIT camera. The camera records information on the effectiveness of the trap, and also shows whether or not gravel is caught by ploughing when the trap is dropped or lifted from the bed. This can occur because the rig, which is ballasted to be tail-heavy,

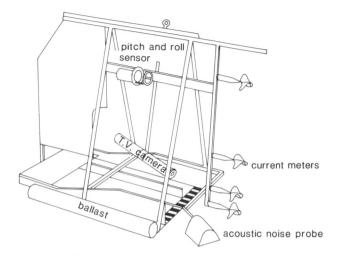

Fig. 11.4. Diagram of gravel trap fitted with current meters, an inclinometer, television camera, and an acoustic noise meter.

may spin on lowering or lifting and scoop up particles in addition to those caught by flow-induced movement.

The acoustic noise meter, also shown on Fig. 11.4, is a hydrophone used to measure the noise produced by the moving particles. In order to calibrate this instrument visual data on the initiation of gravel movement as observed on the television is used.

### Sand ripple profile measurements

Velocity measurements have been made in the tidal boundary layer adjacent to the sea-bed in order to evaluate the frictional shear stress that the flow exerts on the bed. This is of interest to physical oceanographers for various reasons such as the study of tidal dynamics and, as in this case, study of the sediment-carrying capacity of the flow. If the bed is composed of sandy material it will probably be rippled, with the crestlines of the ripples tending to be perpendicular to the flow direction.

The velocity measurements were taken at several heights in the bottom couple of metres and averaged over ten minutes. The general layout of the frame used to hold the propeller velocity sensors is shown in Fig. 11.1. This was lowered from a three-point anchored ship, and having aligned itself with the flow by means of the rear fin, was left in one place as long as circumstances would allow whilst the data was recorded on board the ship.

In the near-bed region, as long as the flow can be approximated to a steady, uniform flow, the vertical mean velocity profile can be written as (e.g. Soulsby 1983):

$$\frac{u(z)}{u_*} = \frac{1}{\varkappa} \ln\left(\frac{z}{z_0}\right) \tag{1}$$

where $u(z)$ is the mean velocity measured at a height $z$ above the bed. The term $u_*$, which is equal to $\sqrt{(\tau/\varrho)}$ (where $\tau$ is the bed shear stress and $\varrho$ is the fluid density), is called the 'shear' or 'friction' velocity because it has the dimensions of velocity. The bed roughness length $z_0$ is a measure of how the roughness or texture of the bed influences the flow. The constant $\varkappa$, known as von Karman's constant, can be taken as 0.4 in most circumstances. If the flow is vigorous enough to disturb and transport the sand of which the bed is composed, the shape of the ripples will change. This will be reflected in changes in $z_0$ and hence bed shear stress, as can be seen from eqn (1). It was the study of this interaction between the bed and the flow that was the motivation for the development of this technique.

A single oblique-angle photograph was taken of the shadow of a straight graduated rod cast onto the undulating sea-bed. If the light/rod/camera geometry is known, together with the optical characteristics of the camera, the shape of the sea-bed in relation to the rod can be calculated.

The light was arranged to cast a shadow of the straight rod onto the sea-bed as in Fig. 11.5. It can be seen that the distance of the local bed level beneath the rod (h) can be deduced from the distance from the rod to its shadow.

$$h = RS. \frac{z_L}{\sqrt{(z_L^2 + y_L^2)}} . \tag{2}$$

If this is done at several points along the rod, a profile of the sea-bed along the length of the rod is obtained. In order for this to be interpreted as a profile along a straight line, the height of the bed at 'S' has to be (substantially) the same as that vertically below the rod, i.e. the local bed

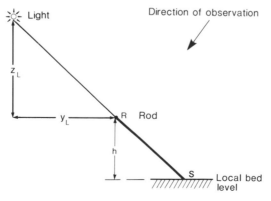

Fig. 11.5. Geometry of arrangement of light source, graduated rod, and its shadow on the sea-bed for use with eqn (2).

slope perpendicular to the rod must be small. This effect can be minimized by not positioning the rod too high above the mean bed level, and the approximation can be checked by using two parallel rods casting two shadows.

The shape of the 'shadow plane' (i.e. that containing the rod and the curve where the shadow cuts the bed) was recorded photogrammetrically, either using an underwater closed-circuit television system or a photographic camera. These alternatives are discussed later. The geometry is simplest if the optical axis of the camera is normal to the shadow plane. In this case, there is a constant scale factor relating the true length of the shadow (RS) to that on the photograph (or television screen), which is equal to the ratio of the camera–object distance to the 'equivalent principle distance'. This latter can be thought of as a focal length of the complete image-producing system and is a function of camera–object distance. When the camera is focused at infinity, it is equal to the focal length of the lens multiplied by the magnification between negative and print. When using a television system, the negative is 'replaced by' the image on the videcon tube, and the magnification is produced electronically between this and the screen of the monitor.

The lighting used a single 500 watt thalium iodide bulb. It was put inside a metal shroud with a blackened interior and a slit of only a few degrees width around the light-rod direction (Fig. 11.5) in order to reduce back-scatter from suspended particulate matter.

As can be seen from the general arrangement in Fig. 11.1, the rod was mounted on the front of the instrumentation frame projecting into the flow, and the camera was mounted on the frame itself, tilted forward looking along the rod. Again, it is simpler if the optical axis of the camera is kept perpendicular to that normal to the rod which is contained in the shadow plane. The scale factor then varies along the rod, but is constant perpendicular to it, as the rod is parallel to the principle line (see Glossary) of the photograph. From the geometry of Fig. 11.6 it can be shown that

$$\frac{x_r}{x_i} = \frac{L_c}{f - x_i \sin\theta} \tag{3a}$$

Hence the local scale factor in the direction of the principle line is

$$\frac{dx_r}{dx_i} = \frac{fL_c}{(f - x_i \sin\theta)^2} \tag{3b}$$

where $x_r$ = distance along rod measured from isocentre;
$x_i$ = distance measured along image of rod from isocentre;
$\theta$ = angle of forward tilt;
$L_c$ = perpendicular distance from camera to rod;
$f$ = equivalent principle distance.

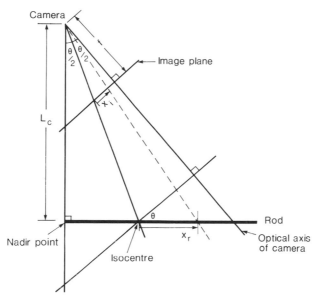

Fig. 11.6. Geometry of arrangement of camera and rod for use with eqns (3) and (4).

It can also be shown that the scale in the direction at right-angles to the principle line is

$$\frac{S_r}{S_i} = \frac{L_c}{(f - x_i \sin\theta)},$$ (4)

where   $S_r$   = distance measured at right angles to rod in shadow plane;
       $S_i$   = distance measured at right angles to rod in image plane.

Note that the scale is constant in this direction, so the origin of S is unimportant in this case.

If the optical axis of the camera is normal to the rod (i.e. $\theta = 0°$) but not normal to the light-rod direction, the arrangement appears as in Fig. 11.7. The principle line is now in the direction of the shadow, and so the relevant scale factor for measurements of the length of the shadow is [similar to eqn (3b)] given by:

$$\frac{dS_r}{dS_i} = \frac{f \, L_c}{(f - S_i \sin\alpha)^2},$$ (5a)

where   $S_r$   = distance in shadow plane from isocentre;
       $S_i$   = distance in image plane from isocentre;
       $\alpha$   = angle of lateral tilt.

Note that the scale factor is now a function of the distance from the

isocentre. The actual length of the shadow can be derived from eqn (3), and is:

$$RS = \frac{fL_c\,(S_{i,1} - S_{i,2})}{(f - S_{i,\,1}\sin\alpha)\,(f - S_{i,2}\sin\alpha)}\,, \tag{5b}$$

where $S_{i,1}$ and $S_{i,2}$ are the measured distance between the isocentre and the points corresponding to R and S on the image. It can be seen that it is wise to keep $\alpha = 0°$ for the sake of simplicity.

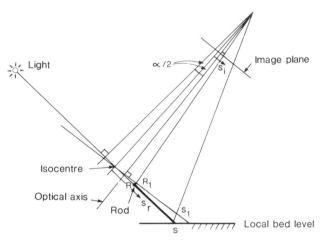

Fig. 11.7. Geometry of arrangement of camera, rod, and light source for use with eqn (5).

It is helpful to sketch on the image plane contours of constant scale factor in the three cases considered. In the most simple case of zero tilt, the scale factor is constant over the whole image. The appearance of the shadow of the rod falling onto a flat bed that is a constant distance beneath the rod can be seen in Fig. 11.8(a). With forward tilt, the image appears as in Fig. 11.8(b), and with lateral tilt as in Fig. 11.8(c).

The completely general case is when the camera is positioned so that there is both forward and lateral tilt. This is easier thought of as 'tilt' and 'swing' , where 'tilt' is the angle between the optical axis and the perpendicular from the camera to the shadow plane and 'swing' is the angle between the principle axis and a reference direction. As the measurement that is required is the perpendicular distance from the rod to the shadow on the sea-bed (RS in Fig. 11.5), the reference direction is that parallel to the rod in the shadow plane. This is not parallel to the rod in the image plane, and more control is required in the field of view to resolve the problem. Thus the general case is best avoided because of this much increased complexity.

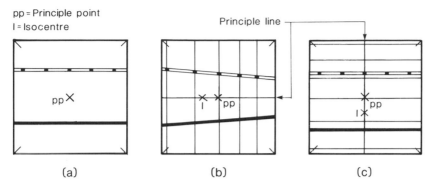

pp = Principle point
l = Isocentre

Principle line

pp✕

✕ ✕pp
l

✕pp
l✕

(a)                    (b)                    (c)

Fig. 11.8. Appearance of the rod shadow on a flat sea-bed with (a) a constant distance beneath the rod, (b) a forward tilt, and (c) a lateral tilt.

## Practical experiences

As an underwater television camera was already available on the experimental rig in order to monitor the velocity sensor preformance and observe the sea-bed, this was initially used to record the shape of the shadow. However, when the system was tested in the laboratory, by using it to measure the known shape of a 'plywood ripple', it was found to be unsatisfactory, as indicated by Fig. 11.9.

It can be seen that the distortion takes the form of putting a spurious curved trend in the data, together with making the amplitude too great at the right-hand end. The source of the distortion was not investigated.

Consequently, it was decided to use a photographic camera. A Hasselblad 500 EL/M camera with an 80-mm lens was used. This camera has an electric

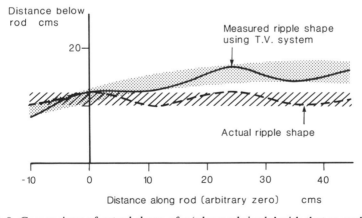

Fig. 11.9. Comparison of actual shape of a 'plywood ripple' with that recorded by a TV camera.

drive, gives 55×55 mm negatives and can be fitted with a magazine that contains 70 exposures. It was installed in an Ikelite polycarbonate underwater housing with a plane port. The remote trigger consisted of a timer box that was wired to close the contacts of a relay in the underwater housing. The camera was set on 'Bulb' so that the shutter speed could be varied between 4s and $\frac{1}{16}$s. A laboratory test of this technique proved satisfactory. An example of a photograph obtained in the field using this system is shown in Fig. 11.10. The bands on the rods are 10 cm apart, and were used to give an *in situ* calibration to find the equivalent principle distance on the photograph using eqn (3*a*) (care was taken to ensure that there was only forward tilt).

Fig. 11.10. Typical photograph obtained by using a Hasselblad 500 EL/M to photograph rods and ripples on the sea-bed.

The distance between the rod and the corresponding shadow perpendicular to the principle line was then read off the photograph at many positions on the photograph. These values were converted to the true length of the shadow using eqn (4) (this scale factor being constant in a direction perpendicular to the principle line) and hence to distances of the bed beneath the rod using eqn (2). Programmes have been written to perform all the calculations on a digital computer.

**Conclusion**

There is a dearth of instrumentation in the difficult field of sedimentation research and as a result a wide range of techniques find application. In this presentation, two uses of optics have been described, together with some of the inevitable problems and limitations that were encountered. The authors feel that it must be stressed that full cognizance is given to the distortions that can occur in the images obtained. This has been shown to be particularly

important when using underwater television as a photogrammetric instrument.

## Acknowledgements

This work was supported on a contract from the Department of the Environment.

## Glossary

### Principle point

The centre of the photograph—the point where the optical axis of the camera intersects the image plane. A photogrammetric camera of high accuracy will have a 'fiducial plate' which is a system for putting marks on the edges of the negative; the principle point is at the intersection of the lines joining these marks. Where accuracy of a very small percentage of the camera–object distance ('flying height') is required, as in aerial photogrammetry, the positions of these marks have to be determined with great precision. The camera–object distance used underwater is inevitably small because of limited visibility and so the relative accuracy required is not so great, and it is sufficient to locate the principle point at the intersection of the diagonals of the negative. If prints are being used, care must be taken in case their edges are cropped.

### Principle line or axis

This is the line drawn through the nadir point* and the principle point.

### Isocentre

The bisector of the angle of tilt (that between the optical axis and the perpendicular to the image plane) intersects the image plane at the isocentre. It is of necessity on the principal line, between the principle point and the nadir point.* It is the place on the image where the scale is the same as on the untilted photograph.

### *Nadir point

This is the point where the perpendicular from the camera to the plane of interest (e.g. the horizontal, or in this case, the plane of the shadow) cuts the image.

## Reference

Soulsby, R. L. (1984). The bottom boundary layer of shelf seas. In *Physical oceanography of coastal and shelf seas* (ed. B. Johns). Elsevier, Amsterdam.

## 12 Photography of the deep-sea bottom fauna with remotely operated cameras

*A. J. Southward and D. Nicholson*

### Introduction

There was a gap of forty years between the first experiments in underwater biological photography (Boutan 1900) and the first successful photographs of deep-water bottom life. Up to 1939 there are few recorded instances of attempts in the deep sea, and even these did not obtain any photographs of life on the bottom (e.g. Johnson 1939; Harvey 1939). It needed the motivation and practical expertise of the Lamont/Woods Hole group (Ewing, Vine, and Worzel 1946, 1967) to show that remotely-operated cameras could be a worthwhile scientific tool. Between 1939 and 1946, this group introduced many of the features of present-day cameras, including: bottom contact exposure triggering (Fig. 12.1); free-fall pop-up cameras; flash lighting; towed vehicles; and time-lapse automatic exposure. Later progress, as reported by Edgerton (1967), Hersey (1967), Mertens (1970), Blacker (1973), Buchanan (1975), Isaacs and Schwartzlose (1975*a*), Patterson (1975), and Hayward (1978), is all based on the concepts developed in those years. However, deep-sea bottom biological photography is still far

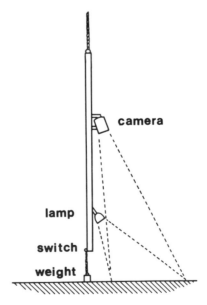

Fig. 12.1. Principle of the pole-mounted camera (Ewing *et al.* 1946).

from being a routine operation. The problems are reviewed here in the context of low-budget investigations of the small to medium-sized animals of the continental slope. Illustrations are taken from surveys in the Bay of Biscay, the Atlantic to the west of Britain and the Norwegian fjords.

## Optics and camera mechanisms

The optical and mechanical problems of underwater cameras are similar, whether they are used in deep or shallow water, but the methods of solution are often different. It is probably still true for the general run of deep-sea work that optical distortions are less important than the difficulties of placing the camera system in the right position and focus to photograph bottom life (Ewing *et al.* 1946).

For deep-sea work, the optical problems have been met in several ways. Some cameras have an ordinary lens of moderately wide angle (e.g. 35-mm focal length or more) behind a flat window ('plane port'), and the distortion and aberration at the edges of the field are ignored. This works better with simple lenses of the 'Tessar' type than with modern multi-element constructions. An early type of correction employed a large external auxiliary lens in the water, some distance in front of the port (Laughton 1957), but such correctors are now expensive to make and maintain. Today most deep-water cameras are fitted with a lens corrected for use under water, either specifically manufactured (e.g. Hopkins, Wray, Dallmeyer (Fig. 12.2) or made for shallow water commercial systems (e.g. 'Nikonos'). A smaller number of deep-sea cameras (e.g. the UMEL camera) employ a standard lens in conjunction with a spherical port or dome. A spherical port should correct most of the errors of refraction, and is simpler to make than special lenses (see Knapp 1947; Hopkins and Edgerton 1961; Mertens 1970; Coffman and Laikin 1979). In practice, there is little distortion at the edges of the field if the lens is correctly set with its principal node at the centre of curvature of the port.

There is little difference in optical performance between a corrected lens of 35 mm focal length behind a plane port and a standard lens behind a spherical port. The latter system is preferable if close-up work is being combined with more general surveys of the bottom, since a wider choice of focal lengths is available. However, a spherical port with surfaces in parallel forms a negative lens, and it is therefore difficult to use a long focal length lens on the camera without undue lengthening of the pressure housing.

The ports for deep-sea cameras, whether plane or spherical, can be made of glass or methacrylate plastic ('Perspex', 'Plexiglas'). Glass is stronger under compression and resistant to scratching, but is weak under tension, and is liable to spalling. Plastic is easier to shape and polish (see Glover, Harwood, and Lythgoe 1977), but also easy to scratch. Its main defect is a

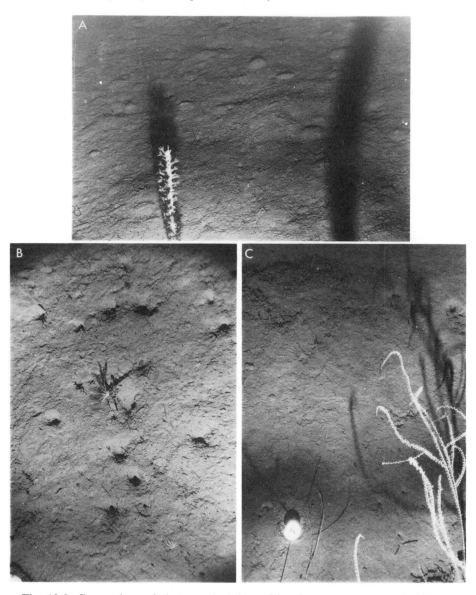

Fig. 12.2. Comparison of photographs taken with a deep-sea camera and different optical arrangements. (A) Oblique view at 1540 m, Santander submarine canyon, uncorrected Dallmeyer 50-mm lens and external in-water correcting lens. (B) Vertical view off Santander, 600 m, field covered approximately 0.7 m², uncorrected 55-mm Pentax lens: note unsharpness at edges of field and vignetting or coma at the corners. (C) Vertical view off Santander, 750 m, lens corrected for use in water (35-mm Wray), approximately 1.2 m² field of view: note better overall edge definition compared with B, and trigger weight in view.

tendency to deform and creep under pressure (Edgerton 1967), which may cause distortion or focus change, though it recovers afterwards; there are camera ports designed to resist pressure-induced distortion (Patterson 1975).

Early deep-sea cameras were similar to shallow-water models, in that an existing camera body was placed inside a specially-shaped underwater case. A frequent choice was the 35-mm 'Robot' (Ewing, Worzel, and Vine 1967; Owen 1967; Wigley and Emery 1967), which has a useful spring-driven motor that allows a picture to be taken, the film wound-on, and the shutter re-tensioned, by a single electromechanical impulse. However, the inferior pressure resistance of tailor-made cases soon led to the use of tubular housings of steel or aluminium alloy; in most of these the camera mechanism is spread out along a chassis, with the lens looking out of a port in one end-cap, and the cable connectors mounted in the other (e.g. Edgerton 1967). Most commercial models follow this pattern, varying only in whether the case is of steel or alloy, and whether the end-cap O-ring seals are compressed axially or radially. Some designs have simple push-fit end-caps, held in place by clamps, others use a coarse continuous thread, and others (the most convenient) have breech-block type end-caps which need only a partial turn to lock. All end-caps, of course, are held in place by the external pressure after the first few metres of lowering below the surface.

The tubular layout of deep-sea cameras has several advantages in addition to pressure resistance. Batteries for operation of the film-wind mechanism and shutter can be placed where convenient, and the electronics are easy to reach. Large film spools can be spread out along the chassis to permit long lengths of film to be used—5, 15, or 30 m according to design—and consequently a long series of pictures can be taken on each lowering. Many models therefore have a device for recording on each frame the date, time and a serial number (e.g. Edgerton 1967) to give easy identification after processing. A robust electric drive is needed for the heavy-duty cycle of such long-series pictures, and the gearbox must be strong enough to resist stripping should the film jam in the gate or the drive sprocket. It is useful to have a microswitch in the film gate to cut off the power supply to the wind motor if the film jams.

Photographs are usually taken by closure of an electrical contact, either by a bottom switch or from a timer; this closes a relay which then fires the flash unit, or operates the shutter if one is fitted, and starts the film-wind motor. When a frame has been wound on the motor switches off and a signal is given that the camera system is ready for another picture. Shutters are an endless source of trouble in deep-sea cameras. Even a trace of dampness caused by condensation can cause jamming or failure to trigger the flash unit. It is much simpler to do without shutters, and to carry out shallow-water testing at night.

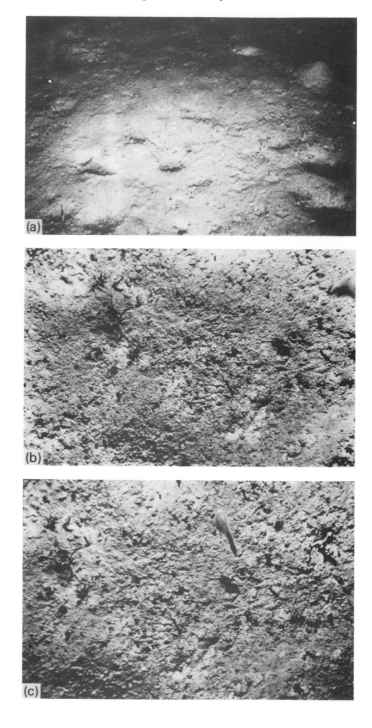

Standard film cassettes are also a nuisance, since the leader has to be excessively long to follow the chassis layout; another cassette is needed for take-up, and jamming can easily occur. The best arrangement is to have the film chamber of the camera enclosed in a light-tight sleeve (e.g. Laughton 1957; UMEL). The chassis carrying the lens can then be removed from the pressure housing in daylight for adjustment of focus, aperture, and electronics. Short lengths of film for testing purposes can be cut off inside an ordinary changing bag and loaded into the usual small 35-mm developing tank without fogging the rest of the roll.

Most deep-sea cameras, other than the time-lapse cine models, use 35-mm film, and the only restriction on choice of sensitive material is the availability of bulk lengths. In Europe this tends to limit choice of colour reversal materials to E6 Ektachrome or its equivalent by other makers (Gehret 1981). The most usual choice is 200 ASA Ektachrome, or its previous equivalent for E4 processing, 160 ASA High-speed Ektachrome. These films are easy to uprate or downrate in speed during processing, there is a wide availability of processing kits, and substitute formulae have been published (Gehret 1981). Both E4 and E6 can be processed at sea in the conventional small tanks for 36-exposure lengths, but this is not recommended as standard practice. There can be slight variation in colour between lengths, and there is much greater risk at sea that the emulsion surface will be scratched or marked by particles from the solutions or dust from the ventilators while drying. Continuous-run automatic colour processing machines are beyond the financial limits of most expeditions, and it is best to store the exposed rolls carefully and have them all processed together by a commercial laboratory specializing in 35-mm cine work.

There has been much debate about the merits of colour film for deep-sea bottom photographs and also of colour television systems used underwater (Robinson 1978). It is true that colour contrasts in the deep sea are subdued compared with the continental shelf and that public expectation is greater than reality (Glover *et al.* 1977). Colour is useful at intermediate depths along the continental slope, and can help pick out small animals with low monochrome contrast (Fig. 12.3). It has less advantage for photographs of the sea-floor sediments, though geophysical surveys have used colour in cameras towed at up to 10 m off the bottom (Lonsdale and Spiess 1977).

Fig. 12.3. Comparison of oblique and close-up vertical stereoscopic views of the same station, Hebridean Slope, 1200 m. (a) Oblique view from colour transparency, showing modelling of relief, and a small prawn in a hollow, field of view approximately 1 m²; (b) Left-hand side of stereo-pair, from black and white negative; (c) Right-hand side of stereo-pair, from colour transparency, field of view approximately $\frac{1}{30}^2$. The close-up stereo-pair were taken about 2 min after the oblique view, and show a similar prawn very close to the camera, giving an escape response.

Results from the continental slope and the fjords show reduced colour contrast and back-scatter effects at more than 2 m off the bottom: red pigments become diluted in a blue haze which does not appear to affect black and white photography so much.

The best compromise is a pair of cameras in stereoscopic mode, one loaded with colour, the other with fine-grain black and white film (cf. Owen 1967). One camera of the pair, usually the right-hand side, loaded with colour film, is arranged as the master, and controls the flash unit and the pinger. The acoustic signals received at the surface show if this camera is functioning. The other camera is loaded with black and white film: our own preference is for Ilford Pan F, but others prefer the slightly better acutance, with slightly coarser grain, of FP4 processed in a special developer. After recovery from the bottom, the black and white film is processed in a compensating developer (e.g. 'Acutol' or diluted 'Microphen') to check that this camera, and also the flash unit, were operating correctly (see Fig. 12.3). Adjustment can then be made to the lighting arrangement, lens aperture, and focus if required.

For stereoscopic viewing the black and white negative is printed onto positive stock, which is developed in a warm-tone developer or is later processed in a sulphide toner. The resulting mud-coloured slide forms the left half of the stereo pair and is viewed alongside the colour transparency from the right-hand camera, by means of two projectors or in two small hand viewers. There is surprisingly little dilution of colour in this way, though operators with left eye dominance are advised to reverse the arrangement of colour and black and white film in the cameras.

There are many types of plug and socket for making up the wiring harness of deep-sea cameras. The best are those with a self-wiping capacity, made of synthetic rubber, and capable of being connected while wet (e.g. Electro-Oceanics). This type is not as robust mechanically as the rigid plastic pattern with steel or brass pins (e.g. Marsh and Marine) but seldom suffers from salt creep and electrolytic blackening of pins. All electrical connections should be isolated from the water (i.e. double insulated). Failure to do so results in electrolytic corrosion of alloy pressure cases if an error is made in polarity on one unit, or if there is a fault to earth.

### Lighting

The deep sea is virtually without light, apart from flashes produced by luminescent organisms, and pictures must be taken by artificial light. Some early cameras had tungsten lights powered from batteries, and a few time-lapse cameras still do (Isaacs 1969). Otherwise flashbulbs were preferred, and these gave way to electronic flash when the latter became small and powerful enough.

As with film-winding arrangements, the duty-cycle of deep-sea flash photography is more severe than on shore, and it is worthwhile using robust flash units, or else having on hand replacement units that fit the pressure housing. The tubular pressure housings for electronic flash take the same form as those for the cameras, with the components spread out on a chassis, the flash tube or flash head in a glass dome fitted to one end cap, and the synchronizing leads in the other. There are a number of special requirements apart from reliability. Certainly the flash must be powerful enough to illuminate dark surfaced muds. At up to 2 m off the bottom almost any flash unit with a power output of 40 watt-seconds or more will give enough light to expose 50 to 200 ASA rated film at medium f-stops. For surveys of larger areas it may be necessary to increase the power to 400 watt-seconds or use faster film, or both.

Filling the field of view of the camera can be a bigger problem. Many operators tolerate a central hot-spot, and this is least displeasing when the camera and flash are set to take oblique photographs, when the distant part of the frame is always under-exposed. For vertical photographs, and for close-ups, it can be more important to light the whole field evenly. When a standard lens and a standard flash head are used without correction for refraction change they will both cover a smaller area than they would in air. However, if the lens is corrected, or is used with a spherical port, then the flash may not fill the field. Sometimes this can be adjusted by arranging the flash head at a different angle, but better results may be obtained if the tube only is placed inside the glass dome, and the reflector mounted in the water outside. Maximum evenness of lighting, at the expense of modelling, can be obtained with unfocused simple bowl reflectors placed outside the flash dome, but this usually requires opening the lens aperture by one or two stops.

There is some choice of power supply for flash units, although high-tension dry batteries are now obsolete. Some low-power units will operate well on throw-away nickel alkaline cells, and if a double pack is fitted these may last long enough to expose 15 m of film (400 flashes) in one lowering. High-power units are cheaper to run on re-chargeable nickel-cadmium cells, but will not generally expose a 30-m roll at full power without re-charging.

Electronic flash does not necessarily freeze all movement of subject or camera. Some low power units and some 'computer' units at low-power settings have very short flashes, less than a millisecond, as may special repetitive (stroboscopic) units which operate at high voltages and low capacity. However, most of the flash units used with deep-sea cameras have a flash duration of several milliseconds (Fig. 12.4). The light output takes the form of a peak followed by a 'tail' of declining intensity, and for a given charge voltage the higher the output power (capacity) the longer the tail. If the camera system is hanging on the end of a wire from a drifting ship, or

Fig. 12.4. Tracings of the intensity and duration of electronic flash recorded by means of a silicon photovoltaic cell and storage oscilloscope: the X-axis is calibrated in milliseconds; the Y-axis is believed to be linear but has not been calibrated. (a and b) Multiblitz Press Universal at 80J and 160J (b) power settings, as used in certain UMEL underwater flash units. (c) Mecablitz 184 as used in certain Institute of Oceanographic Sciences (IOS) underwater flash units. (d) example of small flash intended for amateur use, Metz 303. (e, f, g) Multiblitz at 160 J power setting, drawn with faster sweep of the oscilloscope: (e) with 0.5 ms cut-off; (f) with 1.0 ms cut-off; (g) no cut-off.

being towed in a vehicle, blurring will be visible when close-up photographs are enlarged, and also when the animals show an escape reaction to the bottoming of the camera. This blurring is more obvious in black and white pictures, since the negative emulsion is sensitive to the flash down to one-third peak intensity, when the effective exposure time can be several milliseconds. It is less troublesome with fast colour film, where the effective sensitivity is to two-thirds peak intensity, but may still result in exposures longer than 2 ms. Selection of flash units with short straight flash tubes may help, though such units tend to give less power than hairpin or coiled tubes. The best remedy is an electronic switch to cut off the flash at a pre-set time after triggering, and thus reduce the tailing effect (Southward, Robinson, Nicholson, and Perry 1976) (Fig. 12.4). Such a device can be combined with automatic control of exposure.

   In theory, it should be useful to have automatic control of exposure when the amount of light reflected from the bottom is expected to vary, for example, along the continental slope where there are rapid changes in the proportion of white foraminiferal particles to dark terrestrial particles in the

mud. In practice, exposure control by varying the flash output can be disappointing. Often the whole power of the flash unit is needed, or else the detector will respond to light reflected from suspended particles near the camera (cf. George 1980). When the flash is used at an oblique angle the illumination is uneven anyway, and some variation can be accepted in the density of the part of the field nearer the lens. For vertical close-up photographs automatic control of exposure is more useful, otherwise it will be necessary to make repeat runs at different flash output settings or lens apertures.

Synchronization of flash is simplified if the camera is without a shutter, and this is the only way to ensure reliable stereoscopic pictures. However, it is important not to rely on the existing synchronizing circuit of amateur flash units. These may have 180 V across the contacts, which can give the operator a shock under marine conditions, as well as cause blackening of the pins on underwater connectors. It is best to fire the flash unit through a low voltage signal and internal thyristor.

### Arrangement and triggering of cameras

Remotely-operated deep-sea cameras fall into four major groups: mounted on a pole; enclosed in a cage; towed on sled or an off-bottom vehicle; and free-fall, including time-lapse systems.

*Pole-mounted cameras*

The earliest successful deep-sea cameras (Ewing *et al.* 1946) had the camera and light fastened to a long pole, which carried a bottom contact switch close to the lower end. A typical arrangement of this type takes a picture when a weight suspended from a cord touches the bottom, allowing a spring-loaded switch to close, thus setting off a flash and then winding the film on for one frame (see Fig. 12.1). The pole is then hauled up some distance from the bottom and relowered for the next picture. Some early models had to be brought right up to the surface to be reset manually. The lens is focused for the distance between the camera and the sea-bed at the moment when the flash fires, ensuring a reasonable degree of constancy of area photographed, and sharpness. Several designs follow this arrangement, including that by Laughton (1957), which has two parallel poles (Fig. 12.5A), and certain commercial models which give the camera and flash some protection from knocks (e.g. Alpine Geophysical). Most of the pole arrangements place the light low down below the camera, to give modelling of relief and help reduce some of the back-scatter.

Since 1948, the pole-mounted camera has been greatly improved by incorporation of a pinger. In essentials a pinger is a small self-contained echo-sounder (sonar), which is programmed to emit one pulse of sound

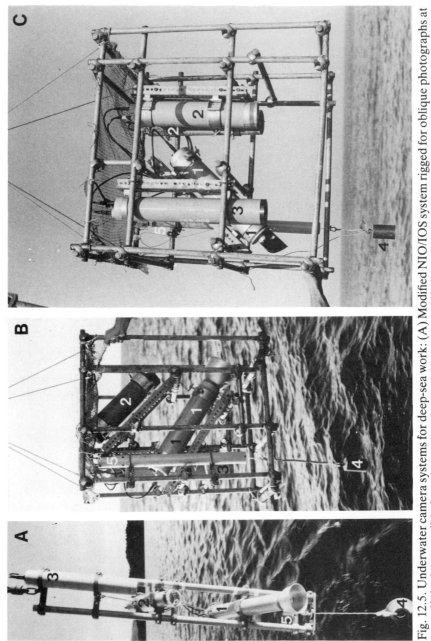

Fig. 12.5. Underwater camera systems for deep-sea work: (A) Modified NIO/IOS system rigged for oblique photographs at 2 m off the bottom. (B) Cage frame for closer oblique views. (C) Cage frame rigged for close-up vertical stereoscopy. (1) flash unit; (2) camera; (3) pinger; (4) trigger weight for bottom contact; (5) switch.

every one or two seconds during lowering of the instrument. When the bottom contact switch closes, the pinger is turned to a faster mode (1 or 2 pulses per sec), or in earlier versions is switched off, signalling to the surface that a photograph has been taken. In the most convenient designs the camera switching circuit is arranged to hold the pinger at the faster rate until the film has been wound on and the flash unit has had time to charge up, so that reversion to slow pinging signals that the apparatus is ready to take another photograph. In the early days of pingers the signal was detected at the surface through a small hydrophone and hand-held amplifier feeding into headphones. It was therefore a great improvement in the 1960s when precision-timed pingers became available and the signal could be displayed on a precision graphic recorder. In this way, the camera can be seen to be approaching the bottom as the direct ping signal gradually approaches the ping reflected from the sea-bed (Hersey 1967). However, for really close photography of the bottom it is essential to control the last moments of descent by the sound signal and await the change in ping rate, as the direct and reflected pings merge on the graphic recorder before the bottom switch makes contact (Southward *et al.* 1976). On receipt of the bottom contact signal, the camera array is quickly raised off the bottom for 10 or 20 m, and held thus until the ping rate reverts to normal, indicating that the camera is ready for use again.

The pole-type camera array has been easy to convert to free-fall operation by addition of a pressure-resistant float at the top of the pole and a weight near the bottom. At a preset interval after bottoming, e.g. by solution of crystals, by corrosion of a light alloy link, or by means of an explosive bolt-cutter operated from a clock, the weight is released and the rest of the gear returns to the surface (Ewing *et al.* 1946, 1967; James 1976).

## Cage-type frames

The simplicity of pole-mounted cameras can be a great advantage, especially for geophysical work where pictures are taken several metres off the bottom. However, it is often desirable to protect the camera and flash units from knocks against the ship and the sea-bed. Also, in biological work it is often necessary to bring the camera closer than 2 m, often less than 1 m, from the sea-bed. In close approach, the pole array tends to drag along the bottom and may fall over completely. This happens because the acoustic signal showing bottom contact takes one second to traverse every 1500 m of water, and thus in great depths it may be several seconds before the signal reaches the operator, and more than one ping period may be needed to elicit reaction. In this time interval, the wire is still being lowered from the winch, and enough will be paid out to put the whole array on the bottom. For these reasons cameras mounted inside a cage-type frame are preferred for close-up biological work (e.g. Owen 1967). The cage should be designed to sit flat

on the bottom each time it is lowered, though of course, the actual photograph is taken by means of a bottoming switch and weight, in the same way as a pole-type array, just before the cage itself reaches the sea-bed.

Remotely operated cameras in a cage-type frame are available commercially (e.g. UMEL) and have been described by several workers (Owen 1967; Shipek 1967; Singleton and Cole 1972; Southward *et al.* 1976; Gooden 1981). The camera can be mounted to give vertical or oblique views, and it is easy to install two cameras for stereophotography (Fig. 12.5). Combined vertical and oblique photography is possible, by addition of a third inclined camera and an additional flash unit (cf. Fig. 12.3).

### Sled-mounted cameras

The next stage in the evolution of deep-sea cameras was to place them in a vehicle towed on or just off the bottom. The camera-sled resting on the bottom is the simplest to operate. The Cousteau 'Troika' has been used with great success (Laban, Pérès, and Picard 1963; Hersey 1967; Laubier and Sibuet 1977; Chardy, Guennegan, and Brannelec 1980), and several other deep-water modes have been described (Thiel 1970; Wigley and Theroux 1970; Machan and Fedra 1975; Holme and Barrett 1977; Uzmann, Cooper, Theroux, and Wigley 1977; Gooden 1981; see Holme, this volume). The final development of this gear is to mount the camera in the mouth of a beam trawl, or, to put it another way, to tow a net behind a camera sled, thus obtaining photographs and samples from the same ground (Rice, Aldred, Billett, and Thurston 1979; Kidd and Huggett 1981; Rice and Collins, this volume). For deep-water use it is usual to mount the camera pointing ahead of the sled, so that the picture is not spoiled by the cloud of mud stirred up by the runners. A considerable advantage of a sled-mounted camera system is that, provided the runners are on the bottom, the pictures remain in perfect focus. This contrasts with the variability of close-up pictures taken with suspended camera systems. Suspended systems are set to take a picture at a given moment while being lowered slowly towards the sea-bed. Out of focus pictures can easily be obtained if the ship is rolling or pitching, when the camera may descend much faster than is allowed for in the series of relays that intervene between bottoming of the weight and firing of the flash.

There are problems in controlling the direction of tow of a sled at slow speed, and determining the exact position at which the photographs were taken, but on smooth bottoms where the relief is gentle and the fauna well-dispersed these are small disadvantages compared with the advantage of well-focused pictures of known area of view. For rougher grounds and steep-sided canyons sleds are unsuitable and suspended cameras preferable (Golden 1981).

*Other types of camera vehicle*

Deep-sea cameras have been mounted on a variety of vehicles for towing several metres above the bottom: hydrofoil planes, platforms, elongated cages and partly streamlined 'fish' have all been described (Ewing *et al.* 1967; Patterson and Brundage 1965; Rebikoff 1976; Spiess 1974; Spiess, Lowenstein, Boegeman, and Mude 1976; Grandvau, Michel, and Duranton 1979; Vadus and Busby 1979). Typically, the arrangement includes a pair of cameras for stereophotography, side-scan sonar, and television; and the height off the bottom is usually monitored through a sonar signal and/or television pictures carried to the towing ship through a conductor-cored cable. It is most usual to control the depth of tow by adjusting the length of the cable (Spiess *et al.* 1976), though Wingham (1977) has shown that water brakes may be more effective. The television system most commonly fitted is of the still picture type, requiring a narrow bandwidth (50 kHz), though real-time transmissions are apparently possible (Siapno 1975). With the exception of the shallow-water towed vehicle described by Blacker and Wood-head (1965), towed vehicles tend to be beyond the financial means of purely biological surveys, though of undoubted value for geophysical investigations (Lonsdale and Spiess 1977; Luyendyk and Macdonald 1977; Lonsdale and Hollister 1979).

Cameras have been attached in or on other types of bottom sampling gear in addition to beam trawls. Wigley and Emery (1967) have described a system with a camera body in one half, and the flash unit in the other half, of a Campbell grab. This arrangement takes a picture by bottom contact just before the grab itself hits the bottom, and allows direct comparison of quantitative benthos samples with the photographs. A similar system has been described for use with a spade-box corer (Felix 1980), and free-fall cameras have been combined with coring tubes (Ewing *et al.* 1967; James 1976).

*Time-lapse cameras*

Another early idea (Ewing *et al.* 1946), to employ a pop-up camera system to take a sequence of bottom photographs, has proved a useful method for assessing the migratory nature of deep-sea animals, their response to food, and the time-scale of re-working of sediments by the infauna. The arrangement is similar to the pole-type camera, but with a tripod base, and camera and light mounted on different legs (Isaacs 1969; Isaacs and Schwartzlose 1975*b*; Dayton and Hessler 1972; Rowe, Keller, Edgerton, Staresinic, and MacIlvaine 1974; Hessler, Ingram, Yayanos, and Burnett 1978). Some systems use 35 mm cameras and electronic flash; others have 16-mm cine cameras and tungsten lights which are switched on at intervals for short periods by a timer; and some use bait to attract mobile animals into the field

of view of the camera. An alternative is to place cameras inside a baited rectangular trap (e.g. Guennegan and Rannou 1979).

*Stereophotography*

The use of two cameras to give overlapping stereo pairs was introduced in deep-sea work by Ewing *et al.* (1967). Such pairs of cameras have been mounted on poles, in cage-type frames, or on vehicles. For geophysical photogrammetry they are usually arranged in parallel, pointing vertically down, with an overlap of about 50 per cent. Given the length of the base-line between the cameras it is comparatively simple to contour the bottom topography and calculate the size of objects (Owen 1967; Mertens 1970; see also Atkinson and Newton 1968). When a stereophotograph is taken close to a subject it is usual to arrange the base-line between the cameras to correspond with the inter-pupillary distance in man (approximately 60 to 70 mm), so as to avoid distortion of perspective. It is not easy to mount two separate deep-sea pressure housings this close, or even two cameras in one pressure case. The system described by Owen (1967) used two uncorrected lenses of 30 mm focal length set 11 cm apart. Southward *et al.* (1976) used 35 mm or 55 mm focal length lenses behind spherical ports set 11 cm apart, but the camera cases were designed to tilt at an angle up to 15° from one another so that substantial overlap could be obtained at less than 50 cm off the bottom. The stereoscope pairs from these systems exaggerate vertical height slightly, but the pairs are not difficult to bring into common focus, and the effect is not displeasing. The method is very useful for showing small details of bottom topography, how close animals are to the bottom and to what extent they are partly buried in the mud, and the orientation of tubes projecting from the surface. It also shows if the camera frame was tilted, or the bottom sloping, at the moment of exposure.

**Environmental and biological results of deep-sea bottom photography**

From the earliest days, photographs of the bottom shattered many long-held views about environmental conditions and life in the deep sea, e.g. lack of currents and scarcity of life. There were ripple-markings and other signs of water currents (Ewing *et al.* 1946, 1967); even pictures without animals showed tracks or burrowing activity (Ewing and Davis 1967). Sponges and delicate foraminferans (Tendal and Hessler 1977) are shown in natural extension (Figs. 12.6 and 12.19a). In some places the cameras can see a long distance (Fig. 12.7), in others there is much back-scatter from particles in suspension (Fig. 12.8), and often when ripple markings are present there are signs of flocculent material in the hollows (Figs. 12.9 and 12.10). Evidence of sediment transport (Fig. 12.11), slumping and biological re-working is easy to find (Figs. 12.12, 12.13, 12.14, and 12.15). Finally, time-lapse cameras

Fig. 12.6. The siliceous sponge *Hyalonema* at 1705 m depth in the Santander canyon. Schneider Curtagon 35-mm lens with hemispherical port, trigger set for 0.7 m off bottom, field of view $\frac{1}{7}$m².

show the existence of a wide-ranging migratory fauna, including amphipods, brittle stars and fish, which are attracted to bait (see p. 135). Hence the old concept of the ocean depths as a dismal, unchanging near-desert, populated by a few living fossils, could be discarded well before the discoveries at the hydrothermal vents showed that lack of light and high hydrostatic pressures in themselves are no handicap to development and evolution of rich and varied deep-sea communities (Smithey and Hessler, this volume).

With regard to the results of photographic studies of deep-sea sediment transport and currents there is an extensive literature. Those interested should consult the references in Hersey (1967), Lonsdale and Spiess (1977), Heezen and Hollister (1964), Stanley and Taylor (1977) , and Lonsdale and

Fig. 12.7. Oblique photographs taken with sled-mounted camera at 2280 m in north Rockall Trough (Scottish Marine Biological Association (SMBA) station M), showing clarity of water close to the bottom. Wray 35-mm lens, field of view approximately 1 m². (a) close view of holothurian; (b) more distant view of holothurian, showing also an asteroid making tracks and star-shaped excavations.

Fig. 12.8. Oblique photograph at 2900 m in the Rockall Trough, at the SMBA permanent station. The eel is close to the camera, and over-exposed; more distant detail is obscured by a cloud of particles in suspension, which were present in every picture on this occasion at this station. Lens and field of view as Fig. 12.7.

Fig. 12.9. Close-up vertical view of flocculent material accumulated in hollows, N. Rockall Trough, 2200 m. Pentax 55-mm lens and hemispherical port, field of view $\frac{1}{30}$m².

Fig. 12.10. Close-up vertical photograph in the Shamrock Canyon at 1837 m, showing abundant small holothurians (U-shaped gut visible) obscured by haze of fine particles close to the bottom. Lens and field of views as Fig. 12.9.

Fig. 12.11. Close-up of another part of the Shamrock Canyon at 1440 m, showing coarse deposit left by turbidity current: tubes of polychaete worms protruding. Lens and field of view as Fig. 12.9.

Fig. 12.12. Close-up of another part of the Shamrock Canyon at 1473 m, showing burrow with three exits, and protruding arms of a brittle-star. Lens and field of view as Fig. 12.9.

Fig. 12.13. Close-up of bottom of Bjørnafjorden, near Bergen, at 540 m, showing holothurian (*Mesothuria*) responsible for faecal pellet, and many animal tracks. The holothurian covers itself with spines and tubes from other animals. Lens and field of view as Fig. 12.9.

Fig. 12.14. Close-up of relatively barren bottom of Sognefjorden at Arnefjorden, 1200 m depth. Most of the deposit is re-worked faecal pellets. There are four white amphipods with long legs. Lens and field of view as Fig. 12.9.

Fig. 12.15. Close up in the Torrelavega Canyon at 1345 m, showing tubes of Pogonophora. Wray 35-mm lens, field of view $\frac{1}{10}$m².

Hollister (1979). There is also a fairly extensive literature on biological re-working of deep-sea sediments and its stratigraphic significance (for references, see Rowe *et al.* 1974; Kitchell 1978; Kidd and Huggett 1981). It is interesting to note that in contrast to earthworms, which gradually cause stones to sink into the soil (Darwin 1881), bioturbation of deep-sea sediments may actually help to retain manganese-coated nodules at the surface of the sediment (Paul 1976; Piper and Fowler 1980; but cf. Felix 1980). In some regions, for example in the rather oligotrophic conditions of the deepest part of the Norwegian fjords (1200 m), photographs confirm that much of the surface layer of the sediment is made up of re-worked faecal matter in various stages of decay (Fig. 12.14).

Deep-sea photography has many benefits for biological studies, but so far only a small part of the results of photographic surveys has been published. This delay is in part due to costs of printing colour photographs, but problems in identification and analysis of the fauna depicted can be con-tributing factors. There is great advantage in being able to compare photographs with simultaneously-collected bottom samples (Uzmann *et al.* 1977; Rice *et al.* 1979). The study of the hadal fauna by Lemche, Hansen, Madsen, Tendal, and Wolff (1976) shows what can be achieved from photographs when a group of experts are brought together. However, the more general photographic reviews of deep-sea life by Heezen and Hollister (1971) and by Menzies, George, and Rowe (1973) are worth consulting.

Equally interesting results can be achieved by analysis of communities or individual species shown on photographs. For example, deductions about the walking-type locomotion of some holothurians (Hansen 1972); the arrangement and feeding methods of the stalked crinoids that are found aggregated on the harder substrata of the slope (Conan, Roux, and Sibuet 1981); and the role of large amphipods as scavengers in the Philippine Trench (Hessler *et al.* 1978). Photography is capable of showing animals that are not always taken in sampling gear; it can show how much of the fauna is on the surface of the sediment (Figs. 12.16 and 12.17, Plate 4a) compared with the permanent burrowers. The animals are displayed in their true state of body expansion (Fig. 12.18) and orientation to water movements (see Fig. 12.7). Stereophotography can show the exact relationship of an animal to the sediment surface, whether it is resting upon it or slightly within it, and can show the angle from the bottom taken up by tubes and extended siphons (Figs. 12.15 and 12.19). When a long sequence of photographs is available, it is easy to draw deductions about how patchy the epifauna is, and if the species are aggregated or dispersed. Examples of some of these aspects of deep-sea bottom photography are shown in the accompanying illustrations.

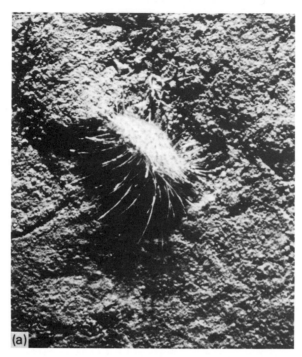

Fig. 12.16a. Enlargement from part of close-up vertical photograph in the Santander Canyon at 2017 m, showing the irregular sea urchin *Pourtalesia* on the surface. About natural size. Lens as Fig. 12.9.

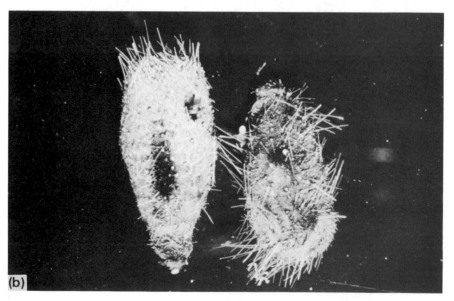

Fig. 12.16b. *Pourtalesia* specimens photographed after sieving and preservation ×1½.

## Present problems and future prospects

Many of the technological problems of deep-sea photography may be said to be solved, but there are quite a few difficulties that remain in handling camera systems at sea, including communication with the camera, winches and location of pictures.

The present system of acoustic links requires several seconds for the signal to travel from the camera to the ship, and much can go wrong in this time. The information is sent sequentially and it takes an even longer time to interpret. In many cases, the signal from the pinger is so attenuated when it is displayed on the graphic recorder that interpretation takes on the form of inspired forecasting rather than deduction. The solution here appears to be an optic fibre link in the towing cable. This would give almost instantaneous communication with much better signal-to-noise ratio than is possible with low-frequency acoustics, and the virtually unlimited bandwidth available could be used for simultaneous transmission of several parameters. Addition of a digitized real-time television system would allow much better control of the subjects to be photographed. The technology for this type of development is available today.

Suspended camera systems suffer from a fault present in all intermittently-used oceanographic winches—the wire tends to 'set' in tension round the drum. When the wire is paid out under load all is well, but the moment

Fig. 12.17. *Munida* from Sognefjorden, alive after dredging and sieving, about half natural size; compare Plate 4a.

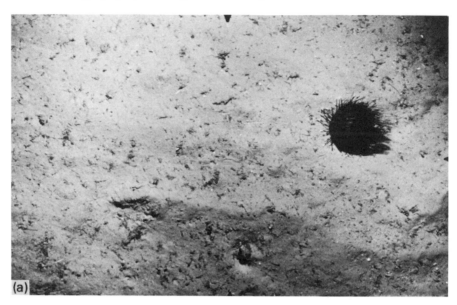

Fig. 12.18a. The 'pancake' sea urchin *Areosoma hystrix* at 1620 m in the S. Bay of Biscay, north of the Fosse Cap Breton. Note rounded form and large spines tipped with white on the left side. Pentax 35-mm lens and hemispherical port, field of view $\frac{1}{3}$ m².

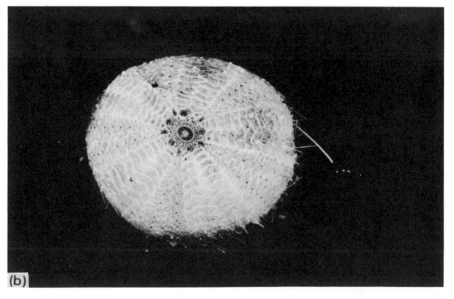

Fig. 12.18b. The same species of sea urchin, collapsed after dredging and preservation. and preservation.

Fig. 12.19a. Close-up in the Santander Canyon at 1985 m showing foraminiferan tubes and the siphon of a buried sipunculan in the centre. Lens and fields of view as Fig. 12.9.

Fig. 12.19b. Enlargement of part of black and white stero half of Fig. 12.19a, showing siphon and area swept. Enlarged 5 times compared with Fig. 12.19a.

some weight is taken off, as for example when a camera frame rests on the bottom after each exposure, the wire coils up. Alternate tensing and release in this way results in snags and kinks that delay recovery of the camera system and may lead to the discarding of several hundred metres of wire each time. A possible solution would lie in provision of a separate sheave for hauling, and a large drum on which the wire is wound under low tension. A similar system was used for the main deep-sea winch of the *Albatross* 35 years ago (Jerlov *et al.* 1957) and was copied for later vessels, so that the technology for this sort of development is also with us today.

A significant problem for deep-sea bottom photography is still that of locating the site and showing where the photographs have been taken. This is critically important for work in the canyons along the continental slope. Geophysical expeditions, and the major biological expeditions to the hydrothermal vents (Smithey and Hessler, this volume), have access to various forms of sonar beacons, which are first positioned accurately by Satellite Navigation, and then used for local position-finding to within a few tens of metres (Ballard 1975; Spiess *et al.* 1976). In contrast, low-budget biological surveys may not have access even to a single radar-responding mooring, and have to rely on land-based navigational aids (e.g. Decca Navigator) or on infrequent Satellite Navigation fixes. Neither of these systems have repeatable accuracy. Decca can vary from day to day and from hour to hour in the Bay of Biscay, even when two-chain fixing is employed. Satellite Navigation computers can give good fixes at intervals of an hour or more, depending on time and season. However, in between fixes these computers rely on dead-reckoning calculations based on the ship's log readings (Fig. 12.20). Even with a two-dimensional electronic log the

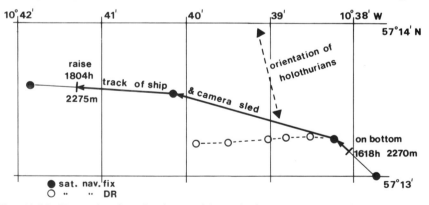

Fig. 12.20. Example of navigation problems during camera operations. The thick line shows the assumed path of the camera sled between fixes by satellite. The broken line shows the navigation computer dead-reckoning positions between accurate fixes. The large holothurians seen in this sled traverse (see Fig. 12.7) were all orientated the same way, suggesting a steady flow of bottom water.

accuracy of the plot is low during the slow drifting and towing of camera systems, and it is often better to rely on direct interpolation between accurate fixes to allocate positions of photographs. Plots kept by Decca rarely agree with Satellite Navigation, which adds a further measure of uncertainty. It is hoped that the situation will improve in future with the placing into orbit of more synchronous satellites, or a greater availability of sonar beacons.

## References

Atkinson, K. B. and Newton, I. (1968). Photogrammetry. In *Photography for the scientist* (ed. C. E. Engel), pp. 273–98. Academic Press, London.

Ballard, R. D. (1975). Improving the usefulness of deep sea photographs with precision tracking. *Oceanus* 18, 40–43.

Blacker, R. W. (1973). Photography in fisheries research. *Med. & Biol. Illustr.* 23, 31–41.

—— and Woodhead, P. M. J. (1965). A towed underwater camera. *J. mar. biol. Ass. U.K.* 45, 593–7.

Boutan, L. (1900). *La photographie sous-marine et les progrès de la photographie.* Schleicher Fr., Paris.

Buchanan, G. L. (1975). Sea-floor photography: equipment and techniques. *Oceanus* 18, 11–16.

Chardy, P., Guennegan, Y., and Brannelec, J. (1980). Photographie sous-marine et analyse des peuplements benthiques essais en rade de Brest. *Contr. Oceanologique de Bretagne*, 32 pp.

Coffman, J. E. and Laikin, M. (1979). Patz—an underwater LLL TV camera with internal zoom, pan and tilt. *Proc. 15th A. Conf. mar. Technol. Soc., New Orleans, 1979*, 45–51. Marine Technology Society, Washington.

Conan, G., Roux, M., and Sibuet, M. (1981). A photographic survey of a population of the stalked crinoid *Diplocrinus (Annacrinus) wyvillethomsoni* (Echinodermata) from the bathyal slope of the Bay of Biscay. *Deep-Sea Res.* 28A, 5441–53.

Darwin, C. (1881). *The formation of vegetable mould through the action of worms, with observations on their habits.* John Murray, London.

Dayton, P.K. and Hessler, R. R. (1972). Role of biological disturbance in maintaining diversity in the deep sea. *Deep-Sea Res.* 19, 199–208.

Edgerton, H. E. (1967). The instruments of deep-sea photography. In *Deep-sea photography* (ed. J. B. Hersey), pp. 47–54. Johns Hopkins Press, Baltimore.

Ewing, M., Vine, A., and Worzel, J. L. (1946). Photography of the ocean bottom. *J. opt. Soc. Am.* 36, 307–21.

—— Worzel, J. L., and Vine, A. C. (1967). Early development of ocean bottom photography at Woods Hole Oceanographical Institution and Lamont Geological Observatory. In *Deep-sea photography* (ed. J. B. Hersey), pp. 13–39. Johns Hopkins Press, Baltimore.

—— and Davis, R. A. (1967). Lebensspuren photographed on the ocean floor. In *Deep-sea photography* (ed. J. B. Hersey), pp. 359–94. Johns Hopkins Press, Baltimore.

Felix, D. (1980). Some problems in making nodule abundance estimates from sea-floor photographs. *Mar. Mining* 2, 293–302.

Gehret, E-C. (1981). Ektachrome E-6 process. *Brit. J. Photogr.* 28 August, pp. 889–90 and 4 September, pp. 910–11.

Goeden, G. B. (1981). A towed instrument package for fisheries research in Great Barrier Reef waters. *Fish. Res., Amsterdam* **1**, 35–44.

George, J. D. (1980). Photography as a marine biological research tool. In *The shore environment, Vol. 1: Methods.* (eds. J. H. Price, D. E. G. Irvine, and W. F. Farnham), pp. 45–115. Academic Press, London.

Glover, T., Harwood, G. E., and Lythgoe, J. N. (1977). *A manual of underwater photography.* Academic Press, London.

Grandvau, B. F., Michel, J. L., and Duranton, R. A. (1979). Epaulard—an acoustically remote controlled vehicle for deep ocean survey. In *Mar. Technol. 79: Ocean Energy*, pp. 357–9. Marine Technology Society, Washington.

Guennegan, Y. and Rannou, M. (1979). Semidiurnal rhythmic activity in deep-sea benthic fishes in the Bay of Biscay. *Sarsia* **64**, 113–16.

Hansen, B. (1972). Photographic evidence of a unique type of walking in deep-sea holothurians. *Deep-Sea Res.* **19**, 461–2.

Harvey, E. N. (1939). Deep-sea photography. *Science* **90**, 187.

Hayward, C. G. (1978). A systems approach to underwater data correlation and interpretation. In *Proc. 4th A. MTS/IEEE combined conf.*, pp. 678–81. Marine Technology Society, Washington.

Heezen, B. C. and Hollister, C. (1964). Deep-sea current evidence from abyssal sediments. *Mar. Geol.* **1**, 141–74.

—— —— (1971). *The face of the deep.* Oxford University Press, New York.

Hersey, J. B. (1967). The manipulation of deep-sea cameras. In *Deep-sea photography* (ed. J. B. Hersey), pp. 55–67. Johns Hopkins Press, Baltimore.

Hessler, R. R., Ingram, C. L., Yayanos, A. A., and Burnett, B. R. (1978). Scavenging amphipods from the floor of the Philippine Trench. *Deep-Sea Res.* **25**, 1029–47.

Holme, N. A. and Barrett, R. L. (1977). A sledge with television and photographic cameras for quantitative investigation of the epifauna on the continental shelf. *J. mar. biol. Ass. U.K.* **57**, 391–403.

Hopkins, R. E. and Edgerton, H. E. (1961). Lenses for underwater photography. *Deep-Sea Res.* **18**, 312–7.

Isaacs, J. D. (1969). The nature of oceanic life. *Scient. Am.* **221**, 147–62.

—— and Schwartzlose, R. A. (1975*a*). Biological applications of underwater photography. *Oceanus* **18**, 24–30.

—— —— (1975*b*). Active animals of the deep-sea floor. *Scient. Am.* **233**, 84–91.

James, P. N. (1976). Cable-free data retrieval from the deep sea. *Sea Technol.* **17**, 22–3.

Jerlov, N. G., Koczy, F., Kullenberg, B., and Michaelson, M. (1957). Winches and laboratories. *Repts Swedish Deep-Sea expedition* **1**, 145–59.

Johnson, E. R. F. (1939). Undersea cinematography. *J. Soc. Motion Picture Enginrs* **32**, 3–17.

Kidd, R. B. and Huggett, Q. J. (1981). Rock debris on abyssal plains in the Northeast Atlantic: a comparison of epibenthic sledge hauls and photographic surveys. *Oceanologica Acta* **4**, 99–104.

Kitchell, J. A. (1978). Deep-sea foraging behaviour: its bathymetric potential in the fossil record. *Science* **200**, 1289–91.

Knapp, R. T. (1947). Special cameras and flash lamps for high-speed underwater photography. *J. Soc. Motion Picture Enginrs* **49**, 64–82.

Laban, A., Pérès, J. M., and Picard, J. (1963). La photographie sous-marine profonde et son exploitation scientifique. *Bull. Inst. océanogr. Monaco* **60**, 1–32.

Laubier, L. and Sibuet, M. (1977). Campagnes BIOGAS 3 Août 1972 – 4 Novembre,

1974. *Publications du CNEXO: Resultats des campagnes à la mer* , No. 11, 78 pp.

Laughton, A. R. (1957). A new deep-sea underwater camera. *Deep-Sea Res.* **4**. 120–5.

Lemche, H., Hansen, B. , Madsen, F. J., Tendal, O. S., and Wolff, T. (1976). Hadal life as analysed from photographs. *Vidensk. Meddr. dansk. naturhist. Foren.* **139**, 263–336.

Lonsdale, P. and Hollister, C. D. (1979). A near-bottom traverse of the Rockall Trough: hydrographic and geologic inferences. *Oceanologica Acta* **2**, 91–105.

—— and Spiess, F. N. (1977). Abyssal bedforms explored with a deeply towed instrument package. *Mar. Geol.* **23**, 57–75.

Luyendyk, B. P. and Macdonald, K. C. (1977). Physiography and structure of the inner floor of the FAMOUS rift valley: observations with a deep-towed instrument package. *Bull. geol. Soc. Am.* **88**, 648–63.

Machan, R. and Fedra, K. (1975). A new towed underwater camera system for wide range benthic surveys. *Mar. Biol.* **33**, 75–84.

Menzies, R. J., George, R. Y., and Rowe, G. T. (1973). *Abyssal environment and ecology of the world oceans.* John Wiley, New York.

Mertens, L. E. (1970). *In-water photography: theory and practice.* John Wiley-Interscience, New York.

Owen, D. M. (1967). A multishot stereoscopic camera for close-up ocean bottom photography. In *Deep-sea photography* (ed. J. B. Hersey), pp. 95–105. Johns Hopkins Press, Baltimore.

Patterson, R. B. (1975). Future developments in deep-sea imaging. *Oceanus* **18**, 17–23.

—— and Brundage, W. L. (1965). Deep sea photographic search techniques. *Trans. ocean Sci. and Engng. Conf., MTS and ASLD* **2**, 1178–97. Marine Technology Society, Washington.

Paul, A. Z. (1976). Deep-sea bottom photographs show that benthic organisms remove sediment cover from manganese nodules. *Nature, Lond.* **263**, 50–51.

Piper, D. Z. and Fowler, B. (1980). New constraint on the maintenance of manganese nodules at the sediment surface. *Nature, Lond.* **286**, 880–3.

Rehikoff, D. (1976). Underwater photogrammetry. Survey of man-made structures. *Sea Technol.* **17**, 33–5.

Rice, A. L., Aldred, R. G., Billett, D. S. M., and Thurston, M. H. (1979). The combined use of an epibenthic sledge and a deep-sea camera to give quantitative relevance to macro-benthos samples. *Ambio*, Special Rept. **6**, 59–72.

—— —— Darlington, E., and Wild, R. A. (1982). The quantitative estimation of the deep-sea megabenthos; a new approach to an old problem. *Oceanologica Acta* **5**, 63–72.

Robinson, J. (1978). An underwater color viewing system—what it can and will do. *Mar. technol. Soc. J.* **12**(3), 28–34.

Rowe, G. T., Keller, G., Edgerton, H., Staresinic, N., and MacIlvaine, J. (1974). Time-lapse photography of the biological re-working of sediments in Hudson submarine canyon. *J. sed. Petrol.* **44**, 549–52.

Shipek, C. J. (1967). Deep-sea photography in support of underwater acoustic research. In *Deep-sea photography* (ed. J. B. Hersey), pp. 89–94. Johns Hopkins Press, Baltimore.

Siapno, W. D. (1975). TV in deep ocean surveys. *Oceanus* **18**, 48–52.

Singleton, R. J. and Cole, A. G. (1972). Underwater camera system for deep-sea bottom photography. *N.Z. Jl. mar. freshw. Res.* **6**, 185–93.

Southward, A. J., Robinson, S. G., Nicholson, D., and Perry, T. J. (1976). An

improved stereocamera and control system for close-up photography of the fauna of the continental slope and outer shelf. *J. mar. biol. Ass. U.K.* **56**, 247–57.

Spiess, F. N. (1974). Recovery of equipment from the ocean floor. *Ocean engng* **2**, 243–9.

—— Lowenstein, C. D., Boegeman, D. E., and Mude, J. D. (1976). Fine scale mapping near the deep sea floor. *Proc. Conf. Engineering in the ocean environment, MTS and IEEE, Washington, DC, 1976. Marine Technology Society, Washington*.

Stanley, D. J. and Taylor, P. T. (1977). Sediment transport down a seamount flank by a combined current and gravity process. *Mar. Geol.* **23**, 77–88.

Tendal, O. S. and Hessler, R. R. (1977). An introduction to the biology and systematics of Komokiacea (Textularina , Foraminiferida). *Galathea Repts* **14**, 165–94.

Thiel, Hj. (1970). Ein Fotoschlitten für biologische und geologische Kartierungen des Meeresbodens. *Mar. Biol.* **7**, 223–9.

Thorndike, E. M. (1967). Physics of underwater photography. In *Deep-sea photography* (ed. J. B. Hersey), pp. 43–5. Johns Hopkins Press, Baltimore.

Uzmann, J. R., Cooper, R. A., Theroux, R. B., and Wigley, R. L. (1977). Synoptic comparison of three sampling techniques for estimating abundance and distribution of selected megafauna: submersibles vs. camera sled vs. otter trawl. *Mar. fish. Rev.* **39** (12), 11–19.

Vadus, J. R. and Busby, R. F. (1979). Remotely operated vehicles—an overview. *Proc. 15th A. Conf. Mar. Technol. Soc., New Orleans, 1979*, 120–9. Marine Technology Society, Washington.

Wigley, R. L. and Emery, K. O. (1967). Benthic animals, particularly *Hyalinoecia* (Annelida) and *Ophiomusium* (Echinodermata), in sea-bottom photographs from the continental slope. In *Deep-sea photography* (ed. J. B. Hersey), pp. 235–49. Johns Hopkins Press, Baltimore.

—— and Theroux, R. B. (1970). Sea bottom photographs and macrobenthos collections from the continental shelf off Massachusetts. *Spec. Scient. Repts U.S. Fish. Wildl. Serv. (Fisheries)*, 613, 3 pp.

Wingham, P. J. (1977). The use of variable body forces to control the depth of towed submersibles. *Ocean Engng* **4**, 57–74.

# 13 The use of photography in deep-sea benthic biology at the Institute of Oceanographic Sciences

*A. L. Rice and E. P. Collins*

## Introduction

Still photography has been used in deep-sea biological studies for three main purposes. First, as a 'sampling' technique, both qualitative and quantitative, analogous to such tools as grabs, sledges, and trawls, but clearly with quite different capabilities and limitations. Second, as a means of obtaining information which cannot be provided by more conventional samplers; for instance, the appearance, attitude, and orientation of individual organisms in life, the spatial relationships of groups of organisms, and the tracks and traces they leave (lebensspuren). Third, in a time-lapse mode to record sequential events over periods of hours, days, or weeks.*

Since 1975 the benthic biology group at the Institute of Oceanographic Sciences (IOS) has employed photography for all three of these uses, mainly for transect photography in combination with an epibenthic sledge, but also as a time-lapse system in conjunction with large fish traps and, latterly, with a non-trapping system which photographs the sea-bed and at the same time records the near-bottom current speed and direction. None of this is particularly novel, but apart from the expected problems of electronic failures in cables, connectors, and components, largely attributable to mechanical damage or extremes of pressure, temperature, and humidity, the experience has presented us with several unforeseen difficulties—and a few pleasant surprises.

## The photographic system

Since the initial aim was to use photography to monitor the behaviour and efficiency of an epibenthic sledge, we needed a compact and relatively light system which could be mounted on the sledge without significantly interfering with its performance. The first trials were made with a 16-mm IOS camera which had originally been developed for geological studies (see Aldred, Thurston, Rice, and Morley 1976). However, because of the small frame size this system did not produce acceptable photographs of the sea-

---

*The use of photography from manned submersibles is a rather special case, since here the technique is generally used to amplify or to record direct observations. Nevertheless, the data so obtained can almost always be assigned to one or other of these categories.

bed and could be used only to monitor the gear. Consequently, a 35-mm camera (IOS Mk IV) was developed to fit into a standard IOS pressure housing (Collins 1984).

The camera (Fig. 13.1) has a 38-mm, f/3.5 lens, fully corrected for operation through a plane window into seawater, and a maximum capacity of 15 m (400 frames) of standard film. Since the camera is intended primarily for use at depths beyond the limit of penetration of significant natural light, no provision is normally made for a shutter mechanism.

The time base for the control circuitry was initially provided by an astable, multi-vibrator employing 'Nor-gates' as inverters. Such a system is temperature sensitive and to cope with long-term deployments at low temperatures (see below) it was replaced by a crystal-controlled oscillator, the output being channeled through a chain of binary counter stages. The system is designed to cycle at any one of seven pre-selected intervals from 15 s to 16 min, with a 'hold-off' facility operated through an external switch.

On receiving a pulse from the time base, the unit immediately triggers the flash and energizes an LED display which back projects onto the film either the elapsed time since switch-on or the frame number. One second later the

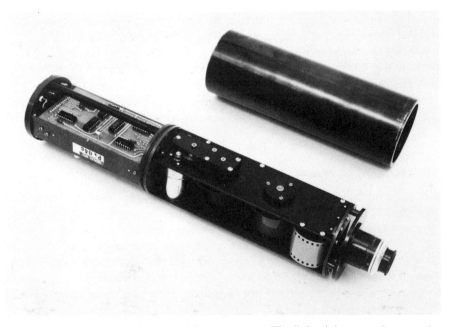

Fig. 13.1. IOS Mk IV underwater 35-mm camera. The light-tight cover fits over the film transport section of the camera and is sealed on an O-ring between this section and the control circuitry and power section. The overall length of the unit is 394 mm.

motor drive is powered up for a single frame transport cycle, the whole operation taking 12 s to complete.

The camera, together with its rechargable power cells and control circuitry, fits into a pressure housing 76 mm in internal diameter and 533 mm long. A plane acrylic plastic conical frustrum window with an inner diameter of 29 mm and a thickness of 22 mm is mounted in one end of the pressure housing. The complete unit weighs 8 kg in air and 4 kg in water.

The flash unit consists of a commercially available controlled level electronic flash modified to fit, together with its own power unit, within a short pressure housing with the same internal diameter as the camera housing. This unit weighs 4.4 kg in air and 2.2 kg in water.

**Transect photography**

The epibenthic sledge on which the camera system has been carried for all of the transect photography consists of a 2.3 m wide steel frame to the back of which is attached one or more nets. The frame of the original sledge (see Aldred *et al.* 1976) was 0.6 m high and carried only a single net or series of nets designed to sample organisms living in, on, or immediately above the sediment. The camera was mounted beneath the leading two cross-members of the frame, directed forwards and downwards at an angle of 14° so that the lens was some 45 cm above the bottom and its optical axis impinged upon a flat sea-bed about 1.5 m ahead of the sledge. Because of the fall-off in light intensity and the acute camera angle, only the lower three-quarters of each frame was usable for estimating megafaunal densities or spatial distributions. From test photographs of a grid in a water-filled tank, this usable area proved to be a trapezium 2 m deep and with an area of 2.6 m² (Fig. 13.2) when the sledge was standing on a flat surface.

This arrangement was used from 1976 to 1978 in a series of hauls to depths of 6500 m off the north-west African coast and to about 4000 m in the Porcupine Seabight to the south-west of Ireland. Numerous excellent photographs were obtained, providing valuable information not only on the appearance, detailed distribution and lebensspuren of the animals photographed, but also indicating the presence of organisms which might not otherwise have been noticed in the catches (Fig. 13.2).

However, a recurrent problem during this period was the sensitivity of the system to changes in orientation of the sledge as it moved across the sea-floor. Photographs obtained when the gear was obviously nose-up or nose-down were readily identified and excluded from the analyses, but with such a shallow camera angle even small changes in the attitude of the sledge significantly altered the area covered by each photograph. Such changes were difficult to recognize and to measure, and the reliability of the quantitative results was therefore seriously reduced. This problem was

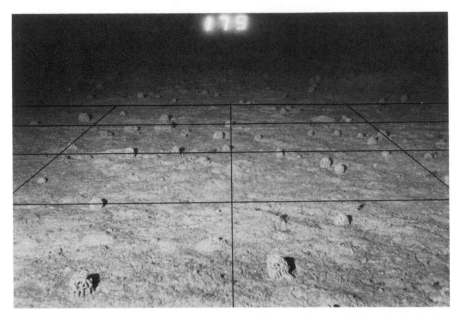

Fig. 13.2. Photograph obtained with the original epibenthic sledge with the usable area marked off in 50 × 50 cm squares. This photograph, which was obtained at a depth of 3860 m off the north-west African coast, includes several specimens of the xenophyophore, *Reticulammina labyrinthica*, which were broken into small, and not immediately recognizable, fragments in the catch.

particularly obvious on a series of exposures obtained during two short hauls across the top of the Josephine Seamount at a depth of 200 m made during *Discovery* cruise 79 in October/November 1976. Each of these hauls terminated abruptly after less than 10 min on the bottom when the weak-link in the towing system parted, presumably as a result of the gear hitting some major obstruction, but in each case the sledge had passed through dense populations of gorgonians and had obtained some excellent photographs (Fig. 13.3). We expected to be able to estimate the population density and the detailed spatial distribution of the gorgonians from these photographs, but the variations in the camera angle made this impossible.

    Largely as a result of this difficulty, the sledge was re-designed so that the frame height was doubled and a suprabenthic net was added to sample organisms living clear of the sea-bed (see Rice, Aldred, Darlington, and Wild 1982). This allowed the camera to be raised so that the lens is now about 80 cm above the sea-bed, and orientated more nearly vertical, at an angle of about 30° to the horizontal (Fig. 13.4). The re-orientation reduced the usable area covered by each frame to about 1 m² (Fig. 13.5) but it has improved the resolution and decreased the sensitivity to changes in the

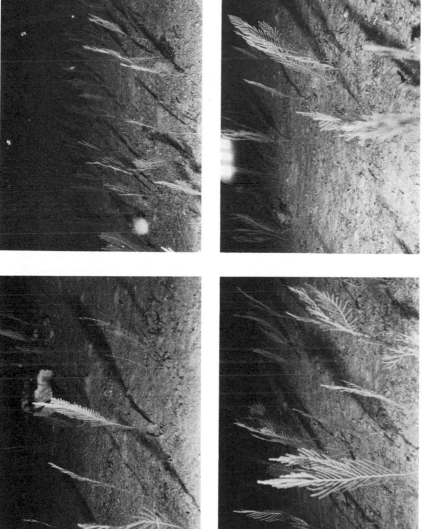

Fig. 13.3 Photographs obtained during haul 9115#4 on the Josephine Seamount at a depth of 200 m. The large gorgonians are mostly *Callogorgia verticillata*, with smaller colonies of *Nicella granifera*, *Calyptrophora josephinae* and, possibly, *Swiftia pallida*. These photographs show the marked effect of variations in the orientation of the camera.

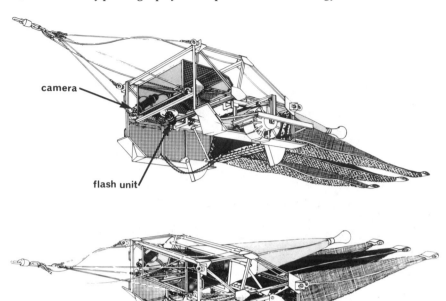

Fig. 13.4. The latest IOS epibenthic sledge showing the positions of the camera and flash unit. Upper diagram, attitude in midwater: lower diagram, attitude on the sea-bed.

sledge angle. Since 1978 about forty-five hauls have been made with this new system in the Porcupine Seabight at depths ranging from about 400 m to 4100 m. The 3000 or so photographs obtained during these hauls, and the similar number taken with the shallower camera angle, have provided several types of information. First, a comparison of the population densities of megafaunal organisms calculated from the photographs with those estimated from the sledge catches has demonstrated that the sledge is capable of providing quite reliable quantitative samples of at least some species, particularly the surface-living holothurians and echinoids. Second, the photographs have demonstrated equally clearly that some megafaunal organisms, such as the pennatulids, are very poorly sampled by the sledge so that the catches are quite unrepresentative (Rice, Aldred, Darlington, and Wild 1982). Third, the photographs have provided data which could not have been obtained from the sledge alone. These include information on the spatial distribution of organisms taken in large numbers in the catches (see Billett and Hansen 1982) and an indication of the population structure of those organisms which were not sampled adequately. For instance, two

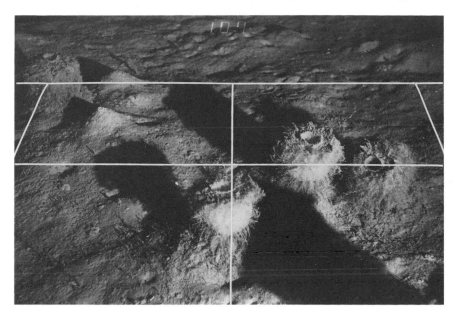

Fig. 13.5. Photograph obtained with the current epibenthic sledge with the usable area marked off in 50 × 50 cm squares. This photograph, obtained at a depth of about 1200 m in the Porcupine Seabight, shows the hexactinellid sponge, *Pheronema* sp.

hauls taken in areas where the pennatulid *Kophobelemnon stelliferum* (O. F. Müller) was abundant caught very small numbers of the animals from which it would have been difficult to determine the nature of the sampled population. From the much larger numbers of pennatulids appearing on the photographs it is clear that while one of these populations consists entirely of juvenile animals with less than 20 polyps, the other is dominated by much larger individuals with up to 40 or more polyps (Fig. 13.6).

Despite the relatively monochrome nature of the deep-sea benthic environment, colour photography has certain advantages in distinguishing hues as well as tones (see Southward and Nicholson, this volume). Consequently, Ektachrome 200 film has been used on a small number of hauls with the epibenthic sledge. However, when used with the earlier low camera-angle. the exposure latitude of the film was too restricted to cope with the range of illumination, resulting in under-exposed backgrounds and over-exposed foregrounds. Much better results have been obtained with the steeper camera and flash angle, but the limited advantages of colour film are outweighed by the ease and convenience of shipboard processing of black and white film, and Ilford FP4 (ASA 125) is therefore used routinely.

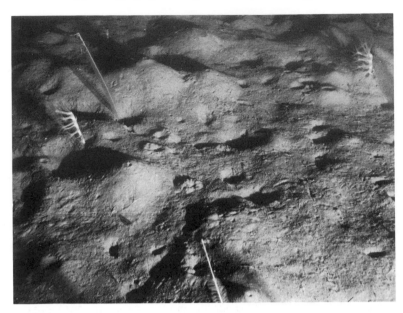

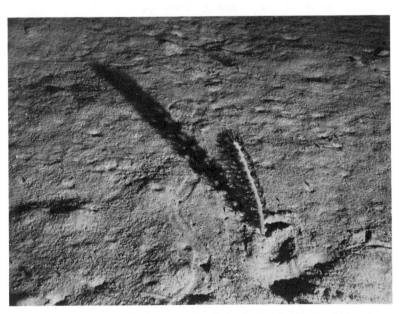

Fig. 13.6. Typical photographs from two hauls in the Porcupine Seabight. At station 50609 (upper) the photographs were dominated by small *Kophobelemnon stelliferum* with 10–20 polyps, while at 50610 (lower) the photographed specimens were much larger with up to 40 or more polyps. In neither case did the epibenthic sledge sample the pennatulid populations adequately.

**Time-lapse photography**

1. *Fish trap*

The camera has been used successfully in three deployments of a large rectangular fish trap approximately 3 m long, 1.5 m wide, and 1.2 m high. In the first deployment, at 4855 m in the Horseshoe Abyssal Plain (see Thurston 1979), a free-fall system with an acoustically operated release was used. Following the failure of the fish trap to leave the sea-bed on a second deployment the subsequent fish-trap casts, at 3852 m and 1017 m in the Porcupine Seabight, were made with a surface mooring. In each case the camera and flash were mounted inside one end of the trap taking photographs at 8 min intervals of the bait and of the endwall of the trap which carried the entrance. The trap remained on the bottom for about 26 h at the deepest station and for about 50 h at each of the others.

The camera system worked reasonably satisfactorily during each of these trap-sets and, particularly in the deepest one, produced useful information on the rate of arrival of scavenging amphipods at the bait (Thurston 1979). However, two unforeseen problems were experienced during this deployment. First, deformation of the acrylic window under the high pressure at the deployment depth interfered with the optical system of the camera resulting in a loss of definition in the photographs taken on the bottom (Fig. 13.7). This proved to be due to inaccurate machining causing a difference in angle of about 2° between the tapered faces of the window and the housing. This resulted in a concentration of the bearing forces near the inner end of the window and a consequent distortion of the air-acrylic interface. Second, during the 26 h on the sea-bed the self-oscillating timing circuit drifted as a result of the low ambient temperature (about 2.5 °C) to become about 30 min fast by the time the trap began its ascent. This prompted the subsequent use of a crystal-controlled oscillator which is not sensitive to such temperature changes.

2. *Bathysnap*

The most recent development in the use of underwater photography at the IOS has been in time-lapse studies of the sea-floor to measure rates of animal activities and changes in bottom topography over periods ranging from a few hours to around six months. Both the IOS Mk. IV system and the 16-mm unit have been adapted for this mode of operation, in both cases with the cameras mounted on free-fall structures equipped with acoustically controlled 'pop-up' command units.

A major problem with such time-lapse photography is the high power requirements to operate the system over such long deployment periods. To overcome this a solid state control circuit has been devised to enable the camera circuit to be powered up on demand for a predetermined period of

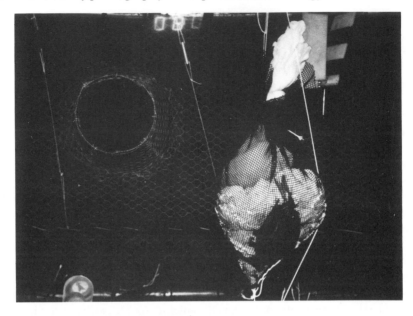

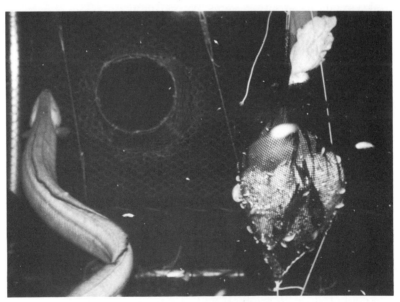

Fig. 13.7. Photographs obtained during a fish-trap deployment at 4855 m in the Horseshoe Abyssal Plain. The upper photograph was taken shortly after the trap left the surface while the lower one was taken on the bottom, the loss of definition resulting from deformation of the acrylic window of the camera housing (see text). The fish, which was not present in the trap on recovery, is probably the synaphobranchid eel *Synaphobranchus (Histiobranchus) bathybius*.

30 s, that is sufficient to reach a fully changed state, after which the camera receives a trigger pulse and is then totally shut down again until a further command is received from the independent time base. This technique virtually removes the power supply problem, the duration of the system being mainly governed by the shelf life of the batteries employed.

For biological studies the camera is mounted in the same orientation relative to the sea-floor as in the current epibenthic sledge on a structure (Bathysnap) which also incorporates a current meter to record the near-bottom current speed and direction (Lampitt and Burnham 1983). This system has so far been deployed successfully six times in the Porcupine Seabight at depths ranging from about 500 m to 4000 m and for periods on the bottom ranging from about 5 h to 117 h, taking photographs at intervals of up to 16 min.

Having overcome the power problem, the limiting factor is now the film capacity of the camera, currently 400 frames on standard 35 mm film. This can be more or less doubled using one of the new thin-based films that are now coming on to the market, but with the preferred interval of 16 min between exposures this would still provide a maximum duration of only about 200 h. Efforts are now being made to increase the capacity, one possibility being to adopt a cine format which would again approximately double the number of exposures which can be obtained. The resulting smaller frame size (approx. 24 × 18 mm) might, of course, involve an unacceptable reduction of definition, but this may in turn be countered by using a fine grain film.

**Acknowledgements**

We are grateful to many of our colleagues at IOS for their assistance with various aspects of this paper. Our thanks are also due to Dr M. Grasshoff, Forschungsinstitut Senckenberg, Frankfurt, for identifying the gorgonians in the Josephine Seamount photographs.

**References**

Aldred, R. G., Thurston, M. H., Rice, A. L., and Morley, D. R. (1976). An acoustically monitored opening and closing epibenthic sledge. *Deep-Sea Res.* **23**, 167–74.

Billett, D. S. M. and Hansen, B. (1982). Abyssal aggregations of *Kolga hyalina* Danielssen and Koren (Echinodermata: Holothuroidea) in the north-east Atlantic Ocean: a preliminary report. *Deep-Sea Res.* **29**, 799–818.

Collins, E. P. (1984). Recent developments in deep-sea photography at I.O.S. In *Underwater Photography. Scientific and engineering applications* (ed. P. F. Smith), pp. 247–56. Van Nostrand Reinhold, New York.

Lampitt, R. S. and Burnham, M. P. (1983). A free fall time lapse camera and current

meter system (Bathysnap), with notes on the foraging behaviour of a bathyal decapod shrimp. *Deep-Sea Res.* **30**, 1009–17.

Rice, A. L., Aldred, R. G., Darlington, E., and Wild, R. A. (1982). The quantitative estimation of the deep-sea megabenthos; a new approach to an old problem. *Oceanologica Acta* **5**, 63–72.

Thurston, M. H. (1979). Scavenging abyssal amphipods from the north-east Atlantic Ocean. *Mar. Biol.* **51**, 55–68.

# 14 Megafaunal distribution at deep-sea hydrothermal vents: an integrated photographic approach

*W. M. Smithey, Jr. and R. R. Hessler*

## Introduction

The discovery, in 1977, of the life surrounding deep-ocean hot springs at the Galapagos rift provided a unique opportunity and challenge for photographic analysis of these communities. Unlike soft mud bottoms, where most of the fauna is concealed from the camera's view, the bare rock at the Galapagos site clearly revealed the large and concentrated life living upon it. Just as the Galapagos vents held much promise for photographic analysis, they held no hope for the traditional methods employed in the investigation of soft bottom fauna. Such devices as trawls, dredges, and corers were useless in the severe ridgecrest terrain.

The vent fauna is highly localized around the upwelling water. Within these localized communities abrupt faunal changes accompany the steep environmental gradients where warm water mixes with ambient bottom water. The small area of the sites combined with their complicated structure meant that direct observation of the sites rather than remote sampling would be the most effective approach.

The Deep Submergence Vehicle *Alvin*, a decidedly non-traditional tool, has proved very valuable in the exploration of ridgecrests (Ballard 1975; Corliss and Ballard 1978). This paper describes the *Alvin*'s various photographic systems and their use in the 1979 biological investigation of the communities at the Galapagos rift. A quantitative camera, the *Alvin* manipulator-held stereocamera, is described and the laboratory analysis of the photographs discussed.

Analysis of the many photographs taken at the Galapagos site revealed flaws in the approach to documenting the distribution of the fauna. For the 1982 biological investigation at the 21° N, East Pacific Rise site, we describe a vertically oriented, low-altitude survey camera designed to meet these objections.

## On-board photographic systems

Photographs have played an integral role in the exploration of mid-ocean spreading centres. In particular, surface ship-towed systems such as the Scripps Institution of Oceanography *Deep Tow* and Woods Hole Oceanographic Institution's *Angus* have done extensive photo-reconnaissance of

the areas (Normark 1976; Lonsdale 1977; Ballard 1980). Both systems take many large areal photographs over extended periods of time. The precipitous ridgecrest topography limits how closely even the heavily-armoured *Angus* sled can approach. As a result, while these systems are quite capable geological tools, only the most conspicuous of the megafauna (those animals large enough to sample photographically) are recorded.

In contrast, the *Alvin* submersible, operated by the Woods Hole Oceanographic Institution, can be guided nimbly through these rocky areas and set down on the bottom to photograph, gather samples, or to perform experiments. The *Alvin* is 7 m long and carries two scientists and an operator within its 2-m personnel sphere. Launched and recovered from the catamaran R/V *Lulu*, it can dive to 4000 m, working easily at the average 2600 m ridgecrest depth.

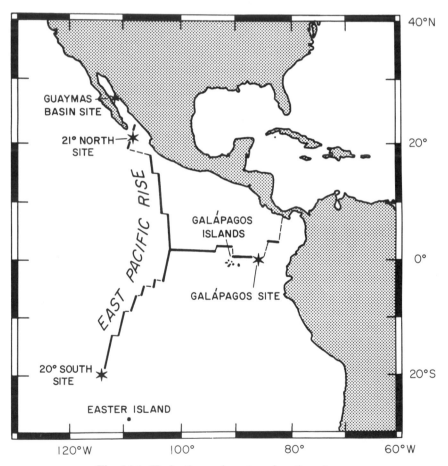

Fig. 14.1. Hydrothermal vent exploration sites.

*Alvin*'s two established on-board photographic systems were used on the 1977 visit to the Galapagos (Fig. 14.1). A pair of 33 m-capacity (800 frames), 35-mm cameras, fitted in pressure-resistant cases and mounted in the bow of the submarine automatically record the scene immediately in front of the sub (Fig. 14.2). Although mounted as a stereo pair, they can also be used in series, with the second camera being activated as the film of the first is exhausted. The cameras use 28-mm plane port corrected lenses and are typically loaded with ASA 200 transparency film. A single 200 watt-second strobe mounted to the side of the cameras provides illumination. Additionally, the submarine has three viewing ports through which the two diving scientists can photograph subjects of interest with hand-held 35-mm SLR

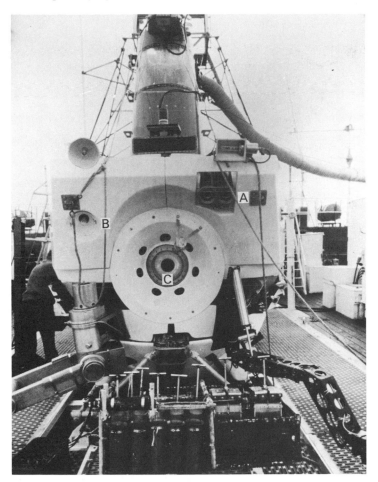

Fig. 14.2. Head on view of the Alvin showing twin 33 m capacity, 35-mm cameras (A), 200 watt-second flash head (B), and pilot's viewport (C).

cameras (Fig. 14.3). These are also loaded with ASA 200 transparency film, and light is provided by strobes located near each porthole.

### The arm stereo camera

A dual approach provided acceptable, albeit qualitative, information on the distribution of the very largest animals. (The hull-mounted cameras can be used in quantitative surveys where the terrain is flat (Grassle, Sanders,

Fig. 14.3. Arm stereo camera. Twin 36-exposure, 35-mm cameras in deep-sea housings (A), 50-second strobe (B), the central probe/thermistor in foreground (C). Also shown is the port observer's viewport (D) with strobe (*above left*) and observation lights (*right*).

Hessler, Rowe, and McLellan 1975; Smith and Hamilton 1983). Acquisition of data on size, area, or volume demands a different approach. For the biological visit to the Galapagos in 1979 the *Alvin* manipulator-held stereo-camera (or simply the 'arm stereo') was fabricated to meet the need for quantitative data. Drawing on the shallow-water methods of Torlegård and Lundälv (1974), J. F. Grassle and the junior author designed a suitable stereo rig.

The arm stereo uses two 36-exposure deep-sea cameras mounted in parallel, 32.5 cm apart. A single 50 watt-second strobe, mounted above and between the two cameras, provides illumination (Fig. 14.3). The twin 28 mm, plane port corrected lenses are focused at 1 m. This close focus ensures that the true colour of the subject is maintained, contrast stays high, and even small animals are recorded. Both 200 ASA and 64 ASA transparency films were used. On some deployments the trade-off between depth of field and fine-grained emulsion was met by loading one camera with the fine-grained emulsion and the other with the medium-grained emulsion.

A 1 m long probe is mounted between the cameras to act as a viewfinder and to place the camera accurately at the proper distance from the subject. By attaching a precision thermistor to this probe, additional environmental information is recorded. Temperature is a conservative property of deep-sea water so that a temperature above ambient indicates that vent water is present. Following the temperature gradient allows the determination of a vent opening itself. The vent water's role in the primary production at the vents is well established (Karl *et al.* 1980; Felbeck 1981). The combination of temperature data with a close-up photographic record yields detailed information about the distribution and abundance of vent fauna with reference to the primary controlling feature of the environment—the vent water.

The arm stereo was deployed on 14 dives and recorded 400 stereo pairs at the Galapagos site (Plate 4b). More recently, 75 stereo pairs of exceptionally high quality were taken during three dives at the 21°N site. On our first expedition, we were fortunate to have photography experts and a mobile processing laboratory from the *National Geographic Society*. They provided valuable advice on camera settings, as well as top-quality film developing in the field.

**Laboratory analysis**

Stereoscopic pairs of photographs contain all the information required to obtain scale, provided the camera separation is known and the optical axis of the two cameras are parallel (Van Sciver 1972). With the use of carefully built 'metric' underwater cameras and precision analysis of the photographs with a stereocomparator, accuracy of 1:1000 is possible (Turner 1981). The

Fig. 14.4. The *Alvin* basket camera. Twin flash heads (A) connected to 200 watt-second strobe electronics fitted in a pressure case (B). Vertical, 33 m capacity, 35-mm camera fitted with an uncorrected 16-mm lens (C).

term metric camera is a general one applicable to a camera which has been designed as a survey camera and possessing a well-defined inner orientation. The picture format is normally large (typically 70 mm or larger) and the film is flattened in the focal plane at the instant of exposure (Adams 1980). Because of the *Alvin*'s payload restrictions and depth requirements, cameras using 35-mm film were used. Although the twin cameras are high-quality, both are non-metric.

By measuring displacement of an object appearing in stereo images relative to a known coordinate (the frame edge), and the width or height of the object as it appears in the photograph, its size can be calculated using the following formula (modified from Van Sciver 1972):

$$S = \frac{s'X}{x'_1 - x'_2},$$

where $S$ = size (width or height) of the unknown object, $s'$ = size (width or height) of the unknown object as measured on the film, $X$ = distance

between camera axes, and $x'_1 - x'_2 =$ the displacement of the object, as measured from the frame edge, between two photographs. The precision of metric cameras, although enviable, exceeds that required to compute numerical abundance and size of the vent megafauna. Further, the expense of the specialized equipment was considered too high to justify such precision. If somewhat lower resolution is acceptable the various measurements stipulated above can be made using a standard stereo dissecting microscope and camera lucida, the sort of hardware likely to be found in most biological laboratories. With these tools, the scale of a precision stage micrometer is transferred, at the appropriate magnification, to drawing paper. Unmounted transparencies are positioned on the scope stage and the enlarged scale is superimposed. By choosing objects in the centre of the photograph (where aberration is lowest) and consistent placement of the scale within the microscope field of view, measurements with an accuracy of 1:50 are possible.

A similar scheme is used to compute abundance. Although each photograph included an area in excess of $1 m^2$, a smaller area with 25 cm sides was used for analysis. This smaller area was chosen to maximize the accuracy of the areal measurements in the extreme vent topography. The square was calculated, drawn to scale, and superimposed on the unmounted transparency through the camera lucida. Macrofaunal types and positions as well as prominent topographic features are transferred schematically within the $25 cm^2$ area generating 'hard copy'.

This trilateral approach yields substantial information on the distribution, size, and abundance of the Galapagos megafauna (Hessler and Smithey 1984). However, there are clearly flaws and omissions in this approach. The two most serious concern the terrain and the limited work sites as well as bias induced by the fact that the camera is aimed at subjects of particular interest by the diving scientists.

## The Disneyland effect

The inherent bias introduced by the submersible's operations in ridgecrest topography can be compared to that which confronts a tourist attempting to document objectively a visit to Disneyland. Just as for a diving scientist, the tourist's task is to compile a balanced impression, using photographs, of what the park is really like. To be fair, the tourist should be burdened with a set of restrictions comparable to a submarine and its captive scientists. Both the aperture and the focus of the camera should be fixed and the tourist forced to drive 100 km from the park to change film. Also, he must visit the park on a foggy night and have only 6 hours to complete the task.

The tourist, like the submersible-bound scientist, is limited in his mobility: barriers and park employees ensure that the tourist does not stray

from the beaten path, just as ridgecrest topography imposes restrictions on landing spots for the submarine. Each, then, is deprived of certain areas to photograph; this alone seriously compromises objectivity.

Even the most jaded scientist finds the spectacular life at vent sites endlessly fascinating, so he photographs those scenes which tend to catch his eye. Similarly, our tourist is not likely to photograph merely asphalt during his visit, even though much of the park is covered by it.

All this is not meant to be completely critical of the tourist (or, for that matter, of the intrepid scientist). If someone is interested in Disneyland, he will learn much from the photographs of the various attractions. Though most certainly biased, such pictures do provide significant information. Photographs by the diving scientist tell much about animal densities and distributions, but because the photographs are not random samples, they give no information on typical conditions or total (or even relative) abundance of life at the vents.

Both the tourist and the scientist would benefit from larger-scale photographs taken in some quantitative survey pattern that included the sites of the smaller-scale photographs. The tourist's photographs could be matched to larger photographs taken from the air of the entire park. The scientist, although deprived of such large-scale images by the properties of water, could use well-located photographs of an area as large as is possible. Using this larger framework, each should be better able to judge the context of the more restricted shots.

### The Alvin basket camera

For the 1982 visit to the 21°N, East Pacific Rise vents (Fig. 14.1), we installed a low-altitude, wide-angle, vertically-oriented survey camera on the *Alvin* basket. In addition, we designed inexpensive devices to permanently mark sites of the arm stereo photographs and other activities.

The *Alvin* basket camera is mounted on the basket at the front of the submarine and oriented perpendicular to the sea-floor (Fig. 14.4). A 33 m (800–frames) capacity deep-sea camera fitted with a 16-mm, uncorrected lens records the view. A 200 watt-second strobe with twin flash heads wired in parallel provides illumination. As utilized at 21°N, the system was optimized for heights of 2–4 m. The basket camera was used three times, yielding nearly 2000 photographs (Fig. 14.5).

A data frame is superimposed on the lower left corner of each frame. This frame includes the time and date as well as an identifying code number. The more complete data recording system of the submarine includes depth, height, heading, and time. This information is continuously recorded onto a data imaging system superimposed onto the submarine's video display. By synchronizing the submarine's clock with the basket camera's clock, all the

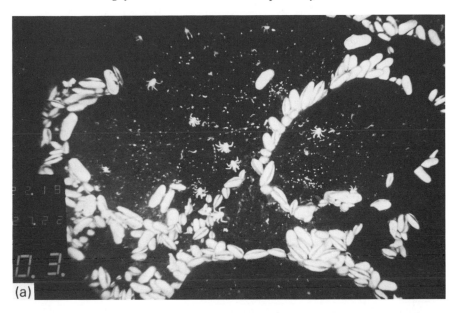

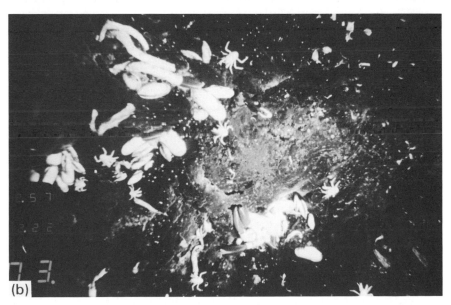

Fig. 14.5. *Alvin* basket camera photographs taken at 21°N. (a) About 3 m above the bottom. *Calyptogena magnifica* line warm water fissures with the galatheid crab *Munidopsis* sp. and undescribed serpulid polychaetes and gastropods covering the basalt. (b) About 2 m above the bottom. The giant tube worm *Riftia pachyptila* clumps at sites of exiting warm water. Also pictured are *Calyptogena magnifica*, *Munidopsis* sp., and undescribed serpulid polychaetes.

Fig. 14.6. Arm stereo photograph of an *in situ* marker. Embossed and painted letter code and four-colour, reflective tape code (at end of each arm) are shown.

above information can be transferred to the basket camera photographs from the dives' video tapes.

*In situ* markers (Fig. 14.6) were developed to mark the site of each series of arm stereo photographs or other sites of interest. The markers are constructed of PVC and measure 25 cm across. Each marker is identified in two distinct ways: the central cube has an embossed, painted letter, and each radiating arm has a four-colour, reflective tape code. This dual code allows identification of the markers in several ways. At close distances the letter is easily read. Because it is melted into the central cube, it will be discernible well into the future. Even if the markers are fouled, the letter will survive and can be read if the marker is recovered. The four-colour code of reflective tape is readable from some considerable distance and photographs especially well when marginally lit by reasonably coherent light. Clear, shrink-wrap tubing was applied over the tape to ensure its permanence.

**Summary**

Much of the fauna of deep-sea hydrothermal vents is conspicuous. Large

size of individual animals coupled with the lack of obscuring sediment makes these communities particularly appropriate for photographic analysis. The jumbled ridgecrest terrain, however, makes photography a particularly difficult task.

The *Alvin* manned submersible has proved a suitable platform for photography in these areas. By using two quantitative camera systems in tandem to characterize the distribution of vent megafauna, some of the restrictions imposed by the terrain and submersible have been overcome.

### Acknowledgements

We thank the pilots of the *Alvin*, Ralph Hollis, George Ellis, and Robert Brown for their skill in interfacing cameras with the submarine. The work is supported by Grants OCE 78–10460 and OCE 80–24901 from the National Science Foundation. Contribution No. 41 of the Galapagos Rift Biology Expedition.

### References

Adams, L. P. (1980). The use of short range stereophotogrammetry in the study of the morphology of the shoebill. *Photogramm. Rec.* **10**(55), 73–84.

Ballard, R. D. (1975). Photography from a submersible during Project FAMOUS. *Oceanus* **18**(3), 31–9.

—— (1980). Mapping the Mid-Ocean Ridge. *Proc. 1980 Offshore Technol. Conf. May 5–8*, 55–64.

Corliss, F. B. and Ballard, R. D. (1978). Oasis of life in the cold abyss. *Natn. geogr. Mag.* **152**(4), 441–53.

Felbeck, H. (1981). Chemoautotrophic potential of the hydrothermal vent tube worm, *Riftia pachyptila* Jones (Vestimentifera). *Science* **209**, 336–8.

Grassle, J. F., Sanders, H. L., Hessler, R. R., Rowe, G. T., and McLellan, T. (1975). Pattern and zonation: A study of the bathyal megafauna using the research submersible *Alvin*. *Deep-Sea Res.* **22**, 457–81.

Hessler, R. R. and Smithey, Jr., W. M. (1984). The distribution and community structure of megafauna at the Galapagos Rift hydrothermal vents. In *Hydrothermal processes at sea floor spreading centers, NATO Conference Series, Series IV: Marine Science* (eds. P. A. Rona, K. Bostrom, L. Laubier and K. L. Smith, Jr.), pp. 735–70. Plenum Press, New York.

Karl, D. M., Wirsen, C. O., and Jannasch, H. W. (1980). Deep-sea primary production at the Galapagos hydrothermal vents. *Science* **207**, 1345–7.

Lonsdale, P. (1977). Clustering of suspension-feeding macrobenthos near abyssal hydrothermal vents at oceanic spreading centers. *Deep-Sea Res.* **24**, 857–63.

Normark, W. R. (1976). Delineation of main extrusion zone of the East Pacific Rise at latitude 21°N. *Geology* **4**, 681–5.

Smith, C. R. and Hamilton, S. C. (1983). Epibenthic megafauna of a bathyal basin off southern California: Patterns of abundance, biomass and dispersion. *Deep-Sea Res.* **30**, 905–28.

Torlegård, A. K. and Lundälv, T. L. (1974). Under-water analytical system. *Photogramm. Engng* **40**(3), 287–93.

Turner, J. (1981). The progress of photogrammetry in precise subsea measurement. *Underwater Systems Design*, April/May 8–10.
Van Sciver, W. J. (1972). Scale determination of unrecognized undersea objects by stereographic photography. *J. Mar. technol. Soc.* **6**(4), 14–6.

# Index